To Jonathon,

I hope this book gives you the best possible start in your new job, + also many happy hours looking back on previous World Cups! I'm sure there will be some good trivia to test me on in here!

Thank you for everything + all your help, working with you has been an absolute pleasure + great fun, which is the most important bit!

Good luck + take care

Peter x

October 2017

Jacqueline,

I hope this book gives you the best possible start in your new job & also some happy hours looking back on previous Work days. I'm sure there will be some good times to look me a.o. back.

Thank You for everthing & all your help working with you has been an absolute pleasure & a great joy which is the most important bit!

Good luck & take care

Christine

THE
WORLD CUP IN
100 OBJECTS

First published in 2017 by Andre Deutsch
an imprint of Carlton Publishing Group
20 Mortimer Street
London W1T 3JW

10 9 8 7 6 5 4 3 2 1

Text copyright © Carlton Publishing Group 2017

All rights reserved. No part of this publication may be reproduced or transmitted in any form or by any means, electrical or mechanical, including photocopy, recording or any information storage retrieval system without permission in writing from the publisher.

ISBN 978 0 233 00519 5

Project Editor: Chris Mitchell
Design: Katie Baxendale and Luke Griffin
Picture Research: Paul Langan
Production: Lisa Cook

Printed in Dubai

THE WORLD CUP IN 100 OBJECTS

A HISTORY OF THE WORLD'S GREATEST FOOTBALL TOURNAMENT

IAIN SPRAGG

Published in association with the
NATIONAL FOOTBALL MUSEUM

ANDRE DEUTSCH

CONTENTS

Introduction 6

1930 World Cup 12

1934 World Cup 24

1938 World Cup 32

1950 World Cup 40

1954 World Cup 50

1958 World Cup 64

1962 World Cup 76

1966 World Cup 84

1970 World Cup 98

1974 World Cup 110

1978 World Cup 124

1982 World Cup 138

1986 World Cup 152

1990 World Cup 164

1994 World Cup 176

1998 World Cup 188

2002 World Cup 202

2006 World Cup 214

2010 World Cup 226

2014 World Cup 238

Index 252

INTRODUCTION

The FIFA World Cup has come a long way since a modest thirteen nations congregated in the Uruguayan capital of Montevideo to contest the inaugural instalment of the competition in the summer of 1930. Just 4,400 spectators were on hand to witness France's victory over Mexico in the rudimentary Estadio Pocitos in one of two simultaneous opening fixtures, and the embryonic event generated scant coverage outside of South America itself.

Today, the World Cup has become a sporting behemoth, watched by a television audience numbering in the billions, more even than the Summer Olympics. The latest edition of the tournament in 2014 saw nearly three and a half million supporters attend the 64 matches in Brazil. The qualifying tournament alone for the 2014 finals saw a staggering 207 national teams participate, a record for any sporting event ever staged.

The seemingly inexorable growth of the competition since 1930 has at times been marred by controversy, not least recent allegations about corruption in the process to select host countries, but the tournament has proved remarkably resilient to any setbacks on and off the pitch through the decades and remains the pinnacle of the beautiful game.

The birth of the World Cup was not a swift one. The Fédération Internationale de Football Association was founded as far back as 1904, but it took the game's governing body 26 years to make its proposed global tournament a reality and, had it not been for the vision and steely determination of Frenchman Jules Rimet, the organization's third and longest-serving president, the World Cup might never have come to fruition.

○○○
Above: *(From left to right) Protective cover for a 1930 World Cup winner's medal; 2010 winner's medal; 1950 winner's medal; 1994 FIFA Fair Play medal ; 1966 winner's medal.*

○○○
Above: *(From left to right) Bobby Moore's 1970 shirt vs Brazil; Helmut Haller's 1966 final shirt; Pele's 1958 final shirt; Diego Maradona's "Hand of God" shirt.*

The early twentieth century was an era of rapid expansion for the game as football spread its wings further and further afield. The formation of FIFA attested to that, although the Olympics had already stolen a march on the World Cup with its own international football competition appearing at the second modern Games in 1900 in France. Only three teams – Great Britain, the hosts and Belgium – took to the field in Paris, but all the same FIFA were still playing catch-up.

By 1914 they had reluctantly agreed to recognize the Olympic tournament as a "world football championship for amateurs" and assumed responsibility for managing the event; but, following his election in 1921, Rimet set his sights firmly on creating a competition beyond the umbrella of the Games that his organization could call its own.

Nine years later in Uruguay his dream became a reality and, as the lustre of Olympic football slowly dimmed with each successive staging of the Games, the World Cup grew in stature, reach and reputation.

The 1930 finals in Montevideo were unchartered territory for Rimet's fledgling tournament. Every FIFA-affiliated country was invited to compete, but the long oceanic journey required to reach Uruguay proved prohibitive to potential European entrants, and it took the president's personal intervention to persuade Belgium, France, Romania and Yugoslavia to make the arduous trip.

Since then, it has been staged twenty times up to 2014, and the World Cup has been won by the hosts six times, with the first incidence of home advantage paying dividends being 1930, as Uruguay overcame neighbours Argentina 4–2 in the final to earn the distinction as the game's first-ever world champions.

Experimental as it was, the maiden World Cup was nonetheless deemed a considerable success by FIFA, and four years later the finals came to Europe, when Italy hosted. Dictator Benito Mussolini cast a long shadow on proceedings as he hijacked the tournament in a brazen propaganda coup, the first in a long line of instances of the blurring of the line between football and politics at subsequent finals, but the competition ultimately survived his intervention.

Italy were the champions on home soil in 1934, as they were again four years later in France, and it was only the outbreak of World War Two that interrupted the competition's development. The Azzurri's triumph in 1938 came at the expense of Hungary in Paris in the final in what has proved to be first of only two successful attempts to defend the title.

The hostilities sent the competition into a twelve-year-long hibernation, but it re-emerged in Brazil in rude health.

The 1950 finals are unique in World Cup history in that they were the only edition of the tournament not to feature a final as such. The format of the early competitions was a movable feast, and in 1950 organizers decided to forgo a final and instigated in its place a four-team second-round group stage, the winner of which would lift the trophy.

Hosts Brazil, Uruguay, Spain and Sweden were the quartet of hopefuls who progressed to the decisive round-robin phase and, after the opening two rounds of games, the European duo had failed to record a victory between them, rendering Brazil's clash with Uruguay in Rio de Janeiro the pivotal match and, ironically, a final in all but name.

A partisan crowd of over 173,000 crammed into the Maracanã to witness what they believed would be Brazil's coronation as champions, but Uruguay rather spoiled the party with a 2–1 victory to emulate the achievements of their 1930 predecessors. Uruguay captain Obdulio Varela was the man to lift the silverware in Rio after the final whistle and in doing so became the first skipper to hold aloft the Jules Rimet Trophy, the silverware having only been officially renamed in honour of the eponymous FIFA president two years earlier.

The 1950 tournament was also significant as it marked the first appearance of England in the finals. The Three Lions were conspicuous by their absence at the three pre-War editions of the World Cup, stubbornly maintaining that their annual Home Championship against Scotland, Wales and Ireland was a more meaningful competition, but the game's oldest football association was finally on board in 1950 and dispatched a squad to Brazil.

England's humiliating 1–0 defeat to the USA in Belo Horizonte in the group stages however did little to endear the competition to its newest converts.

Switzerland played host to 16 sides in 1954 – a format which would endure up to the finals in Argentina 24 years later – and the Alpine nation provided the stage for the emergence of one of the tournament's perennial big beasts as West Germany beat Hungary in the final in Bern.

Four years later Sweden took centre stage and as the tournament progressed, it became the story of two outstanding players. The first was an unknown 17-year-old by the name of Pelé who dazzled throughout the finals until Brazil became champions for the first time. The second was French striker Just Fontaine, who scored 13 times in six appearances in Sweden. No player before or since has been on target more times in finals football.

By the 1960s the World Cup had become a fixture on the sporting calendar to rival any other event and as broadcasters were able to beam more and more live images of the action into homes, its popularity increased exponentially.

The 1966 final between England and West Germany at Wembley, a match famed for Geoff Hurst's controversial third goal for the Three Lions and the host's dramatic 4–2 triumph in extra time, was watched by 32.3 million people. It remains the largest ever television audience recorded in the UK, while the 1970 finals in Mexico were the first during which viewers could enjoy matches in colour.

Brazil were champions for a third time in 1970, the first tournament staged outside Europe or South America, and their sublime 4–1 victory in the final in the Azteca over Italy saw the Seleção claim the Jules Rimet Trophy on a permanent basis. The former FIFA president had died fourteen years earlier, but Rimet had stipulated during his long tenure as the leader of the governing body that the trophy that bore his name would be gifted rather than loaned to any side able to register a hat-trick of World Cup triumphs.

Above: *(From top to bottom) The ball from the 1930 World Cup final; 1966 World Cup final ball; 1986 official match ball; 1970 official match ball.*

It was therefore a new piece of silverware, commissioned by FIFA, that Germany captain Franz Beckenbauer lifted in the Olympiastadion in Munich four years later after his side had defeated the Netherlands in the final. Victory gave Die Mannschaft a second crown as they joined an elite club of two-time champions alongside Uruguay and Italy, while Brazil remained proudly on their own with their three successes.

The World Cup took another significant step forward in 1982, when FIFA expanded the finals in Spain from sixteen to twenty-four teams. The bold move offered more opportunity for the game's lesser lights to qualify for the quadrennial tournament and it undoubtedly engendered a more global feel to proceedings in Spain as Algeria, Cameroon, Honduras, Kuwait and New Zealand all made their debuts.

Despite the newcomers, the 1982 finals saw Italy emulate Brazil in lifting the World Cup for a third time. The Azzurri's success was the result of their unswerving team ethic but collective responsibility gave way to individual brilliance in 1986 as Diego Maradona almost single-handedly won the trophy for Argentina.

There have been many virtuoso performances in World Cup history, but Maradona's displays in Mexico were arguably the most beguiling example of one player's genius transcending an entire tournament as the midfielder dazzled from the first fixture to the final.

England supporters might disagree with such idolatry given his infamous "Hand of God" in the quarter-finals against the Three Lions inside the cavernous Azteca, but Maradona's impact in Mexico was undeniably sublime.

Italy emulated Mexico as two-time hosts four years later. For the first time the same two sides fought their way through to the final as they had done at the last tournament, but this time West Germany beat Argentina in Rome's Stadio Olimpico to avenge their heartbreak in Mexico City.

Italia 90 was the fourteenth instalment of the World Cup. Each and every edition had been played out in either Europe or South America and, when FIFA turned its thoughts to the

Above: *(From left to right) Commemorative postcard from Mexico 1970; commemorative postcard from 1958; postcard of the Estadio Azteca; press ticket from the opening game of USA 1994.*

destination of the next finals, the organization broke new ground when it decided to take the tournament to the USA.

There were certainly reservations about the choice. Unlike the United States, all twelve previous nations chosen to stage the competition had boasted a considerable football heritage and, by its own admission, the governing body was taking something of a leap into the unknown in opting for America in 1994.

It was a gamble that paid off in spectacular style. Just short of 3.6 million people attended the 52 matches during the finals, an average of 68,991 supporters per game, making USA 94 the most successful-ever tournament in terms of attendance.

A crowd of 94,000 watched the final between Brazil and Italy at the Rose Bowl in California, and the assembled spectators witnessed history being made as the game was settled by a penalty shootout for the first time. The Seleção triumphed from the spot to win a fourth title as Italy's Roberto Baggio became the first in an increasingly long litany of unfortunate players to finish on the losing side in a final after failing to score from twelve yards out.

Change was again in the air in 1998, when FIFA decided the worldwide football fraternity had grown to such an extent that the tournament must be yet more inclusive, and so the finals in France welcomed a record thirty-two teams to the fray. The hosts sparked a nationwide party when they beat Brazil in the final, a million people thronged to the Champs-Élysées in Paris to join in the celebrations, and the World Cup had its seventh different winner.

The advent of the twenty-first century saw further reinvention and rejuvenation of the competition. In 2002 Asia followed in the footsteps of South America, Europe and North America when it became the fourth continent to stage the finals. For the first time, joint hosts were chosen in the shape of Japan and South Korea and the finals headed east to a rapturous reception, an average crowd of over 42,000 per game and a riot of colour and noise.

Brazil emerged victorious in Asia, beating Germany 2–0 in the final in Yokohama, and in the process became the most successful side in World Cup history with a record-breaking fifth title.

The tournament also reflected the increasingly shifting sands of power within the world game. For the first time five different continents were represented in the quarter-finals, while few had predicted hosts South Korea's and Turkey's progress all the way to the last four.

In 2006 Germany provided a more traditional setting than Asia had four years earlier – as well as an old-order winner in the shape of Italy – but 2010 was all about new horizons and new champions as Spain finally ruled the roost in South Africa 76 years after their first attempt to lift the coveted trophy.

Egypt had become the first African team to play in the finals when they qualified in 1934 for the tournament in Italy, but the continent's wait to stage the competition was a prolonged one and came to an overdue conclusion only when FIFA ruled it would entertain bids from African countries alone for the right to host in 2010.

Spain's success was equally belated after eleven previous appearances in the finals in which they had failed to go beyond the quarter-finals, and, in beating the Netherlands in the final in Johannesburg's Soccer City, Vicente del Bosque's side became the first European country to claim football's greatest prize outside their own continent.

The 2014 finals had been awarded to Brazil. South America had not staged the competition since Argentina had played host in 1978 and, although it did not follow the script written by the home nation, the Seleção departing at the semi-final stage after a crushing 7–1 defeat against Germany in Belo Horizonte, it was a hugely successful tournament and deferred only to USA 94 in terms of spectator numbers.

It was, however, the global coverage of the finals that underlined the phenomenal growth of the competition since its first tentative steps in Uruguay 84 years earlier. An estimated 3.2 billion people tuned in to watch the thirty-two days of football in South America and just over a billion watched the final itself as Germany beat Argentina in extra time in the Maracanã, courtesy of a goal from substitute Mario Götze. Victory for Joachim Löw's side also had a historical resonance as it was the first triumph for Germany following the reunification of the country twenty-four years earlier.

Ultimately, the World Cup has survived scandals and political disputes, boycotts and earthquakes since Rimet first envisaged a global stage for the beautiful game, and, with the finals heading to Russia in 2018 and Qatar in 2022, the tournament continues to push the traditional boundaries of football. Rimet would surely be proud of what has become of the phenomenon he set in motion in Uruguay all those years ago.

○○○

Right: A replica of the replacement trophy created when the original Jules Rimet was given to Brazil as a reward for their third World Cup win.

THE 1930 FIFA WORLD CUP

The beautiful game's eagerly anticipated, inaugural World Championship saw 13 national sides assemble in Uruguay in the summer of 1930 to compete for the honour of lifting the World Cup for the first time. The South American hosts emerged victorious from a tournament that was to transform international football for ever.

SETTING SAIL FOR SOUTH AMERICA

It was on the eve of the 1928 Olympic Games that FIFA's Congress finally voted to stage football's maiden World Cup. Two years later, three of Europe's intrepid quartet of contenders began their long journey to the Uruguayan capital Montevideo onboard the SS *Conte Verde* ocean liner.

The prospect of a global, international football tournament had been raised as early as 1904, when FIFA was founded, but it was not until more than 25 years later that the idea became a reality, when the game's governing body announced Uruguay had been chosen ahead of Italy, the Netherlands, Spain and Sweden to stage this groundbreaking competition.

The fact that Uruguayan Football Association agreed to foot the travel and accommodation bill for all the competing teams, as well as build a new stadium for the occasion, doubtless swung the argument persuasively in its favour and, with no qualification process in place, invitations were duly despatched for the impending tournament.

A total of 12 countries accepted Uruguay's clarion call. The South American contingent of Argentina, Chile, Brazil, Bolivia, Peru and Paraguay, as well as the USA and Mexico, faced relatively modest journeys to reach the finals, but, for France, Yugoslavia, Romania and Belgium, a significantly more arduous trip of almost 7,000 miles lay ahead.

The Yugoslavs decided to sail on the MS *Florida*, but the French, Romanians and Belgians opted to travel together and, on 21 June 1930, the *Conte Verde* set off from the Italian port of Genoa with the Romania team on board. A brief stop at Villefranche-sur-Mer saw them joined by their French counterparts and the Belgians jumped on when the ship pulled in at Barcelona. The Brazil squad were picked up much later when the *Conte Verde* finally reached Rio de Janeiro.

The assembled footballers, however, were not the only passengers of note, FIFA president Jules Rimet also

boarded at Villefranche-sur-Mer, carrying in his suitcase the World Cup trophy that would, 16 years later, bear his name, and he was accompanied by three of the referees chosen to officiate at the finals. Other celebrities of the day included Fyodor Chaliapin, a Russian opera singer, the American dancer Josephine Baker and Dacia Maraini, the Italian writer.

The ship dropped anchor in Montevideo on 4 July, Europe's finest being greeted to a rapturous reception from 10,000 enthusiastic Uruguayans. After a fortnight at sea, the stage was set for football's first World Cup.

○○○

Right: Posing on deck with Uruguayan flags upon arrival in Montevideo, the French team were one of only four European sides to compete in the inaugural 1930 finals.

Below: The SS Conte Verde *proved a leisurely if slow form of transport for the French, Yugoslavian, Romanian and Belgian squads en route to Uruguay and the first World Cup.*

"It was a really tough trip because in those days the only way you could get there was by boat. Raoul Caudron, who was the coach said to me, 'You've got to keep the players busy on the boat, keep them in shape'. And so I became their fitness coach on the trip."

FRANCE MIDFIELDER EDMOND DELFOUR

RIMET'S CUP RUNNETH OVER

1930

The inception of the inaugural World Cup tournament necessitated the commissioning of a new trophy to be presented to the eventual champions. Parisian sculptor Abel Lafleur was the man tasked by Jules Rimet with the design, and he drew on Greek mythology for his inspiration.

Symbolism is as powerful in sport as it is in religion or politics and, as the World Cup of 1930 approached, Rimet was acutely aware that the competition was lacking silverware – or, more accurately, something suitably golden for the climax of the tournament – and the FIFA president turned to his compatriot Lafleur for help.

The sculptor would later add to his tenuous sporting links by representing France, albeit unsuccessfully, in the art competitions of the 1932 Olympic Games in Los Angeles, and he was renowned for his work based on the female form.

To fulfil Rimet's request, Lafleur plundered ancient history and based his design on Nike, the Greek goddess of victory. A winged figure representing Nike held a decagonal cup while the four sides of the white/yellow marble base featured gold plates on which the names of World Cup winners were to be etched after each tournament. The trophy stood 35 centimetres high and weighed 3.8 kilograms. Crucially, the golden "silverware" was in fact sterling silver coated in gold.

Uruguay captain José Nasazzi was the first footballer to proudly lift Lafleur's creation aloft after his team (nicknamed La Celeste) beat Argentina (La Albiceleste) in the final in 1930; but the fate of the iconic sculpture – originally dubbed "Victory", then known as the World Cup and then, in 1946, renamed the Jules Rimet Trophy – is unclear.

It was stolen, and famously recovered by a plucky canine by the name of Pickles just before the 1966 World Cup in England, but rumours persist that it first went missing in the late 1950s and was quietly replaced with a replica by the West German football association. Brazil were permanently handed the trophy – original or otherwise – in 1970 after their third World Cup triumph, but it has not been seen since a burglary at the Brazilian FA headquarters in Rio de Janeiro in 1983. Local police concluded that it had been melted down, and closed the case.

In 1997 a "replica" of the Jules Rimet Trophy commissioned by the English FA in 1966 as a precaution in the wake of the original's theft was sold at auction for £254,500. The initially anonymous buyers turned out to be FIFA because, by its own admission, the game's governing body believed it was in fact Lafleur's work.

ooo

Above: *Famed French football administrator Jules Rimet was FIFA's third and longest-serving President, holding the post for 33 years.*

Right: *The iconic World Cup trophy designed by Abel Lafleur for the 1930 finals. Nine victorious captains lifted the silverware, the last, Brazil's Carlos Alberto, in Mexico City in 1970.*

"The gold of the trophy is symbolic for the World Cup becoming the world's greatest sports event."

JULES RIMET

LAURENT'S ENDURING LEGACY

1930

The inaugural FIFA World Cup kicked off on 13 July in Montevideo with two simultaneous matches – France against Mexico in Group 1 and the Group 4 clash between the USA and Belgium – signalling a dramatic race to become the first-ever goal scorer in the finals.

France failed to win the World Cup in 1930. Les Bleus didn't qualify for the semi-finals, either, despite their resounding 4–1 victory over Mexico in the Estadio de Pocitos, the home of Club Atlético Peñarol, in their opening game. But, while the team's performances were decidedly disappointing, there was one Frenchman who left an inedible mark on the inaugural tournament.

His name was Lucien Laurent. An inside-right for French side Sochaux, he was an amateur when he set sail

for Uruguay in 1930 and, although he played just twice in South America, Laurent nonetheless secured his place in World Cup folklore with a stunning strike against the Mexicans.

Laurent's historic contribution came just 19 minutes into the clash in the Uruguayan capital, a match beset by flurries of snow in what was wintertime in the southern hemisphere. French goalkeeper Alex Thépot began the attack from the back; the ball was moved to right-winger Ernest Libérati; and it was Laurent who found himself in the right place at exactly the right time to volley home Libérati's cross from twelve yards out with his right foot. The World Cup had its first goalscorer.

Whether news of the historic moment filtered across Montevideo to where the USA and Belgium were locking horns is unclear, but, just six minutes after Laurent had written his name in the record books, American left-winger Bart McGhee broke the deadlock at the Estadio Parque Central. History, however, is written by the victors, and McGhee's place in the World Cup story has largely been forgotten.

Laurent returned to France following Les Bleus' premature exit from the competition and went back to his job with the car manufacturer Peugeot. He continued playing until 1945 and won a total of ten caps for France, but his career was interrupted during World War Two, when his treasured World Cup shirt was stolen from storage.

He died in 2005 at the grand old age of 97, his considerable longevity ensuring he was the only surviving member of the squad of 1930 who was on hand to witness France lift the World Cup for the first time in 1998, watching from the stands of the Stade de France as Les Bleus dispatched Brazil 3–0 in the final.

"Back then I couldn't have imagined the significance the goal would have. I remember when I got home, there was just a tiny mention in one of the papers. Football was in its infancy."

LUCIEN LAURENT

○○○
Opposite: *Frenchman Lucien Laurent, the scorer of the first ever goal in World Cup history in 1930 when he beat Mexican goalkeeper Oscar Bonfiglio in Montevideo.*

Above: *A page from the official 1930 World Cup souvenir programme, published after the tournament to celebrate the first instalment of FIFA's new global competition.*

AGONY FOR LA ALBICELESTE

The maiden FIFA World Cup final was an all-South American affair as Uruguay and Argentina met in Montevideo. Both sides were unbeaten en route to the showpiece game, both had enjoyed thumping 6–1 triumphs in the semi-finals, but only one could be crowned world champions.

The date was 30 July 1930. The gates of the recently completed Estadio Centenario were opened six hours before kickoff to allow the 68,000 crowd time to congregate inside – security staff conducting rigorous searches in the process for firearms and other weaponry they feared may be smuggled in – and the stage was set for the first World Cup final.

The build-up was dominated by a minor diplomatic skirmish as both Uruguay and Argentina insisted they would provide the match ball and FIFA was forced to step in and mediate, insisting the Argentinian ball would be in play for the first 45 minutes before Uruguayan leather was introduced for the second half.

Impasse resolved, the final kicked off at 2.15 in the afternoon local time, and it took the home side a mere twelve minutes to breach the Argentina defence, when La Celeste outside-right Pablo Dorado, who was sporting a rather fetching beret for the occasion, scored. La Albiceleste, however, came roaring back, to the dismay of the partisan home crowd, with strikes from Carlos Peucelle and Guillermo Stábile, the tournament's top scorer with eight, and Argentina headed to their dressing room at half-time with a 2–1 advantage.

According to newspaper reports the following day, Uruguay captain José Nasazzi was incandescent with his team at the break and a chastened La Celeste emerged for the second half transformed. They levelled the match in the 57th minute through Pedro Cea and, eight minutes later, went ahead courtesy of Santos Iriarte's goal.

Argentina were on the ropes and Uruguay delivered the coup de grâce a minute from time when centre-forward Héctor Castro, a distinctive figure in the final having lost an arm in a childhood carpentry accident, beat goalkeeper Juan Botasso to seal a famous victory.

Uruguay, winners of the football competition at both the Paris 1924 and Amsterdam 1928 Olympic Games – when only amateur players could participate – were now the champions of the whole football world. As Nasazzi became the first man to lift the World Cup, the party in Montevideo began.

> "At 2–1, I thought we'd done it, that there was no way we could lose. In my whole life I've never felt such a bitter pain as losing that final."
>
> **ARGENTINA'S FRANCISCO VARALLO**

○○○
Left: *An unused ticket from the 1930 World Cup final between Uruguay and Argentina in the Estadio Centenario, a historic match which attracted a crowd of 68,346.*

Above: *Misery for Argentina as, top to bottom, Pedro Cea, Santos Iriarte and Hector Castro score the second-half goals to give Uruguay their 4–2 victory in the first World Cup final.*

AFTER THE FINAL WHISTLE …

1930

The crowning of Uruguay as the first world champions was far from the end of the story of the 1930 FIFA World Cup, as both South American countries experienced dramatically contrasting emotions in the wake of a tournament that had already transformed the football landscape.

La Celeste's victory over Argentina in the final was unsurprisingly the catalyst for scenes of unbridled celebration throughout Uruguay. The government declared a national holiday to mark the team's triumph and every member of the squad was given a house as a reward for his efforts. For several days the streets of Montevideo were thronged with crowds enthusiastically waving the national flag, and, in what was also the centenary of the country's birth as an independent state, the sense of national pride was palpable.

In Argentina, however, there was a volatile mixture of anger and despair. The Argentine Football Association broke off relations with its Uruguayan counterpart and after having witnessed the battered and bruised state of the players on their return home, there was widespread criticism in the media of the alleged thuggery of the Uruguay team.

Worse followed when supporters decided to vent their frustration on the streets. There were, according to contemporary reports, "several minor riots, in which shots were fired, in Buenos Aires [while] late at night about 100 demonstrators assembled in front of the Uruguayan Consulate and threw stones."

The immediate aftermath of the final also had potentially serious consequences for the match referee, Belgium's John Langenus. Famed for officiating in a shirt and tie and his trademark knickerbockers, Langenus evidently feared the ire of the fans of the losing side and agreed to take charge only on condition that he and his linesmen be escorted from the pitch under the protection of mounted police.

Things didn't go exactly according to plan, however, and, as he blew his whistle for full time, the Estadio Centenario witnessed a pitch invasion and, rather than wait for his equine escort, Langenus melted into the crowd and made good his escape.

He wasn't quite out of the woods yet, though. He fled directly to the harbour in Montevideo and to the SS *Duilio*, the ship scheduled to convey him back to Europe, but thick fog delayed departure and the Belgian was forced to spend the next 24 hours making himself as inconspicuous as possible before the captain was finally able to weigh anchor.

○○○

Left: Pedro Cea (second left) slides in to divert the ball past Argentina goalkeeper Juan Botasso to equalise for Uruguay early in the second half.

Right: One of the two balls used during the 1930 World Cup final. Argentina's ball was in play for the first 45 minutes in Montevideo while Uruguay did the honours in the second half.

"I liked the final game because it was a tough one,
as I believe football should be, a game for strong and healthy men."

JULES RIMET

COPPA DEL MONDO • COUPE DU MONDE • WORLD'S
CUP • WELTMEISTERSCHAFT • COPA DEL MUNDO

ITALIA

A. XII

F.I.F.A.
F.I.G.C.

CAMPIONATO MONDIALE DI CALCIO

27 MAGGIO
10 GIUGNO

THE 1934 FIFA WORLD CUP

The second, expanded instalment of FIFA's new global tournament, the 1934 World Cup was staged in Italy and saw qualification introduced for the first time. Sixteen teams duly reached the inaugural European finals, but, as in Uruguay four years earlier, it was the host nation who eventually emerged triumphant.

EUROPE TAKES CENTRE STAGE

1934

The success of the first World Cup in South America was unquestioned and, when FIFA embarked on preparations for what it hoped would be a successful sequel, football's governing body found itself inundated with 32 nations eager to be involved in the second edition of the competition.

When Italy (nicknamed the Azzurri) outmanoeuvred Sweden in the race to host the 1934 World Cup, pledging to spend a hefty 3.5 million lire of public money on staging the tournament, it signalled a seismic shift in the European attitude to the embryonic championship.

Four years earlier only a modest quartet of the continent's sides had agreed to undertake the long journey to Uruguay to compete; but, with the fields of play significantly closer to home in 1934, 12 of the 16 teams who qualified for the finals hailed from Europe. The USA joined the fray once again; Egypt assumed the mantle as Africa's first representatives; while Brazil and Argentina carried the torch for South America.

The reigning champions Uruguay were conspicuous by their absence. La Celeste may have revelled in their victory over Argentina in the final of 1930 but they had neither forgiven nor forgotten the Azzurri's failure to attend the tournament, and, in retaliation, they steadfastly refused to make a reciprocal trip to Italy. The decision means Uruguay remain the only team in World Cup history not to have defended their title.

There was no sign of any of the British nations, who were seemingly preoccupied with more domestic matters, having resigned from FIFA in 1928. "The national associations of England, Scotland, Wales and Ireland have quite enough to do in their own International Championship," insisted the FA's Charles Sutcliffe, "which seems to me a far better World Championship than the one to be staged in Rome."

Sutcliffe, however, was being rather disingenuous. Unlike in the 1930 tournament, during which all the matches were held in Montevideo, the Italian World Cup was in fact staged in eight different cities, and for the first time live radio commentary of the action was broadcast to listeners in 12 of the competing countries. The World Cup was already becoming bigger and bolder.

The format was a straight knockout competition. The first round of matches saw both Brazil and Argentina condemned to an early exit by debutants Spain and Sweden respectively, but it was Italy who stole the headlines with their 7–1 demolition of the Americans in Rome.

Curiously, the Azzurri required two bites of the cherry to despatch Spain in the quarter-finals, beating Amadeo García's side 1–0 in a replay, before edging out Austria 1–0 in the last four. The hosts had, as the script demanded, made it through to the final and would face Czechoslovakia after a hat-trick from forward Oldřich Nejedlý in the semi-finals against Germany.

○○○

Left: As tournament hosts, expectations on Vittorio Pozzo's Italy side were high even though the Azzurri were making their World Cup debut.

Right: The official handbook of the 1934 World Cup, the first to be staged in Europe and the first which required teams to qualify for the finals.

FEDERATION INTERNATIONALE DE FOOTBALL ASSOCIATION

World's Cup

Coupe du Monde

Weltmeisterschaft

Copa del Mundo

Coppa del Mondo

1934.

ROMA 1934

IN THE HEAT OF THE NIGHT

1934

Played on the evening of 10 July as the temperature in Rome hit an energy-sapping 40°C, the 1934 FIFA World Cup final was the first to be decided in extra time. The Azzurri came within nine minutes of disaster on home soil but they ultimately snatched victory from the jaws of defeat.

The Italian public's appetite for the World Cup in 1934 was voracious before a ball had been kicked, but, by the time manager Vittorio Pozzo had guided his team through to the final, albeit precariously in the knockout stages, anticipation had become fevered nationwide expectation.

Only Czechoslovakia stood in their way. The Czechs were devotees of what was dubbed the "Danubian school" of football, a style of play heavily reliant on short passing and high individual skill levels, and their approach had reaped rich rewards as Karel Petrů's side eliminated Romania, Switzerland and Germany en route to their decisive meeting with the hosts at the Stadio Nazionale del PNF on a sultry night in the Italian capital.

Both teams were captained by their respective goalkeepers – Italy by Juventus's Gianpiero Combi, playing his 47th and what proved to be his last international, Czechoslovakia by the equally experienced František Plánička – and a predictably partisan crowd of 55,000 gathered in Rome to watch what they hoped would be the serene coronation of the Azzurri as world champions.

The first half in Rome was a stalemate, but Czechoslovakia contrived to spoil the party after the restart when winger Antonín Puč beat Combi 19 minutes from time with a low drive. An increasingly desperate Italy strove for the equaliser but were almost out for the count when inside left František Svoboda beat Combi only to see his effort rebound off the woodwork. The Azzurri had been reprieved and they made the most of their good fortune in the 81st minute, when outside left Raimundo Orsi unleashed a swerving effort that Plánička could not stop, and the home team were on equal terms.

Extra time was as tense as it was exhausting for both

sides in the Roman heatwave, but Italy proved the stronger of the two teams and it was Bologna centre-forward Angelo Schiavio who became a national hero with the winner in the 95th minute. Italy were champions and Europe had its first World Cup winners.

As with many of the finals that were to follow, however, the 1934 Roman encounter was not without controversy as the Czechs claimed Swedish referee Ivan Eklind was suspiciously friendly with Italy's Fascist dictator Benito Mussolini. It was unsurprisingly an accusation roundly rejected by Azzurri supporters.

○○○

Left: Italy were pushed all the way in Rome in the 1934 World Cup final but eventually emerged triumphant thanks to an Angelo Schiavio goal in extra time.

Above: An official 1934 World Cup wall chart featuring the first round fixtures and potential routes to the final.

"We were cheated out of victory. Eklind was in Mussolini's box. We didn't know what was discussed there but we had an inkling. The man stopped clean passes and overlooked bad fouls. This man was anything but impartial."

FRANTIŠEK PLÁNIČKA

THE SHADOW OF "IL DUCE"

1934

Politics and sport have long been uneasy bedfellows and the 1934 FIFA World Cup was a tournament played out against a backdrop of Benito Mussolini's blatant attempts to hijack proceedings in Italy and propagate his National Fascist Party propaganda.

Mussolini was not a great devotee of the beautiful game. The Italian dictator was, however, acutely aware that sport could nonetheless be turned into political capital, and, from the moment FIFA decided to award the World Cup to Italy and the eyes of the world focused on the country, "Il Duce" was determined to use the competition to portray his Fascist regime in a positive light.

Mussolini was omnipresent during the tournament. He attended every Azzurri game accompanied by his sons, and every stadium was adorned with huge propaganda posters featuring images of Hercules, his foot placed on a football and arm outstretched in the fascist salute.

As Italy and Czechoslovakia entered the National Stadium of the National Fascist Party in Rome for the final, a military band played a selection of Fascist hymns and the crowd waved handkerchiefs and vociferously cried out "Duce! Duce!" It had become as much a political rally as it was a football match.

There were also widespread, albeit unproven, rumours that Il Duce had bribed the tournament's referees to ensure the Azzurri would not suffer any embarrassing disappointments and progress smoothly to the final.

Mussolini had one final propaganda trick up his sleeve, and, anticipating the potential and priceless photo opportunity of presenting the World Cup to a victorious Italian captain in the capital in the full glare of photographers from across the world, the dictator commissioned another trophy to be made. The "Coppa Del Duce" was quickly created.

A bronze sculpture six times bigger than the official trophy, the Coppa Del Duce depicted footballers in front of the "fasces" – the symbol of the Fascist party – and, following the Azzurri's victory over the Czechs in the final, Mussolini duly presented it to goalkeeper Gianpiero Combi. The triumphant Italian squad were subsequently rewarded for their efforts with a signed picture of the Il Duce and the Fascist party *Medaglia d'oro* (gold medal), one of the highest honours in the country.

The Azzurri's success on the pitch was mirrored by Mussolini's pervasive efforts off it to promote Fascism and, while the 1934 World Cup was undoubtedly a step forward for the game in terms of global exposure, it will also always be remembered as Il Duce's tournament.

> "An event as colossal as this could only have been organised by Benito Mussolini's Italy."
>
> LO SPORT FASCISTA NEWSPAPER

○○○

Right: Italian dictator Benito Mussolini ensured he extracted as much propaganda value as possible from the 1934 World Cup finals.

Opposite Page: The "Coppa Del Duce", commissioned by Benito Mussolini, dwarfed the official World Cup trophy and symbolised the Fascist hijacking of the tournament.

FIFA
FFFA

dh
DESMÉ
PARIS

COUPE DU MONDE
1938

IMP. J-E. GOOSSENS LILLE-PARIS

THE 1938 FIFA WORLD CUP

Staged in France, as the storm clouds of the impending World War Two gathered ominously across Europe, the third FIFA World Cup was held over 15 days and saw Italy successfully defend their title as world champions after a hugely entertaining victory over Hungary in the final in Paris.

A BLACK DAY FOR THE BEAUTIFUL GAME

1938

A total of 15 teams assembled in France in June 1938 to contest the third instalment of the FIFA World Cup, but, while Brazil and Hungary in particular lit up the tournament with their innovative style of play, it was Italy's quarter-final against France in the Stade de Olympique de Colombes that dominated the news agenda.

It was at times impossible to disentangle politics and football during the World Cup of 1938. Europe was beset by ideological division and hostility and, the tournament was impacted even before a ball was kicked in France when Austria, who had qualified for the finals after beating Latvia, withdrew following Germany's annexing of its neighbour earlier in the year.

There were widespread demonstrations at both Germany's and Italy's first-round games in protest at their respective fascist regimes back home, and, although Germany (Die Mannschaft, meaning The Team) did not linger long in the tournament after losing out to Switzerland in a first-round replay at the Parc des Princes, the Azzurri continued to attract the ire of the French public.

> "When our players raised their hands to give the fascist salute … we predictably met with a solemn and deafening barrage of whistles, insults and remarks. How long that rumpus lasted I couldn't say. We had just put our hands down and the violent demonstration started again."
>
> **ITALY MANAGER VITTORIO POZZO**

Things came to an ugly head when the defending champions were drawn against the hosts in the last eight in Paris. Both teams had played their opening fixtures in their traditional blue shirts and FIFA decreed that lots would be drawn to determine who would have to find an alternative strip for the impending quarter-final showdown.

Italy pulled the short straw and, according to contemporary but unsubstantiated reports, the order came directly from Benito Mussolini that the Azzurri would play in *maglia nera*, the infamous black shirts inextricably associated with the National Fascist Party in Italy. It was an unashamedly inflammatory move given the background to the competition, and one that was predictably met with outrage by the majority of the 59,000-strong crowd inside the Stade de Olympique de Colombes. The Italians merely fanned the flames when they gave the Fascist salute before kickoff.

Supporters of Les Bleus and anti-Fascists alike prayed for a French victory in Paris that day but the Azzurri proved too strong for manager Gaston Barreau's team, and the black-shirt bandwagon rolled on, courtesy of goals from Gino Colaussi and Silvio Piola (two) in a 3–1 victory.

The host nation's elimination was met with a mixture of dismay and disgust in the French media the following day, but the Italian dream of becoming the first side to retain the World Cup remained alive.

○○○

Left: The quarter-final clash between hosts France and Italy produced four goals but the action on the pitch was largely overshadowed by events before kick-off.

Above: The Azzurri incensed French supporters in the Stade de Olympique de Colombes and the wider nation by giving the Fascist salute.

CONTINENTAL CULTURE CLASH

1938

With the 1938 FIFA World Cup reaching its denouement with a mouthwatering final in the French capital between the controversial defending champions Italy and the free-scoring Hungarians, the tournament was destined for a thrilling conclusion to proceedings and, potentially, history in the making.

Only two nations have claimed consecutive World Cup triumphs. It's a statistic that reflects the tournament's fiercely competitive as well as unpredictable nature, and, in 1938, the Azzurri's route to the final was blocked in the last eight, first by France and then by Brazil in the semi-finals. It was an itinerary that would test the defending champions in the extreme.

The Brazilians were certainly a team to be feared and in Vasco da Gama striker Leonidas they possessed the tournament's leading scorer and the man whose hat-trick had sealed the South Americans' pulsating 6-5 extra-time victory over Poland in the first round.

Manager Adhemar Pimenta, however, made a fatal selectorial error for the semi-final and left out Leonidas. Confusion reigned as to whether the prolific forward was injured or being rested for the final, but, without their primary goal threat, Brazil could not pierce the Italians' well-marshalled defence until the 87th minute of their meeting at the Parc Lescure in Bordeaux and they were beaten 2-1 by the reigning champions.

The Azzurri were through to the final once again and this time they were confronted by Hungary, a team whose technical and elegant brand of football had already cut a swathe through all opposition. They were a side whom many believed capable of toppling the Italians, who played in a distinctly more prosaic and physical style.

The Hungarians were simply untouchable en route to the showpiece match in Paris: Asia's first finalists, the Dutch East Indies, were demolished 6-0 in the first round; they dispatched Switzerland 2-0 in the last eight; and they put Sweden to the sword in the semi-final at the Parc des Princes, striker Gyula Zsengellér netting twice in a 5-1 triumph to

ooo
Above: The two captains, Giuseppe Meazza of Italy, left and Hungary's Györgi Sárosi, shake hands before the 1938 World Cup final in Paris.

Opposite: The French Football Federation's official review of the 1938 World Cup.

take his burgeoning tally for the tournament to five.

The pre-match build-up to the final predictably focused on the impending contest between Hungary's attacking invention and Italy's miserly rearguard, which had conceded only three times in three fixtures. It would, the supporters of both sides predicted, be the proverbial battle between the unstoppable force and the immovable object.

The Azzurri, however, almost failed to make it to the match at Stade de Olympique de Colombes in Paris when the team bus was inadvertently brought to a halt on its way to the ground by the sheer weight of people on the capital's streets. Italy manager Vittorio Pozzo ordered the driver to return to the team hotel and plot an alternative route and, at the second time of asking, the champions made it to the stadium.

The stage was set for the second consecutive all-European final and what would prove to be one of the most gripping contests in World Cup history.

THE MAGIC OF MEAZZA

1938

The 1938 FIFA World Cup final saw Hungary trade early blows in their showdown with Italy in Paris, only for the defending champions to display their mettle with an irresistible first-half onslaught, orchestrated by their mercurial captain Giuseppe Meazza, which shattered Hungarian hopes of glory.

Played on the afternoon of 19 June 1938, the final of the World Cup saw 45,000 fans descend on the Stade de Olympique de Colombes on the outskirts of the French capital, and, for those among the crowd who clamoured for a deluge of goals on the game's greatest stage, the match proved to be an undisputed classic.

The final was a mere six minutes old when the Azzurri struck. The ubiquitous Meazza, one of two survivors from Italy's 1934 triumph, initiated the thrust, and inside-right Gino Colaussi was on hand to supply the finishing touch with a glorious volley.

Italy's lead, however, lasted for only 120 seconds as Hungary roared back into contention, Pál Titkos – a man who went on to become both secretary to the Hungarian Football Association and latterly the national team manager – beating Azzurri keeper Aldo Olivieri with a powerful shot that flew into the back of the net.

It was briefly a contest firmly in the balance, but Italy rallied and produced a 20-minute spell of sublime football that ultimately won them the World Cup and earned the side plaudits, even from those who vehemently disapproved of their public displays of support for Benito Mussolini's regime.

In the 16th minute, Meazza was once again the creative force as Italy conjured up an intricate four-pass move in the Hungarian penalty box which ended with Lazio striker Silvio Piola netting and 19 minutes later the Azzurri stretched into a 3–1 lead when Colaussi beat Antal Szabó for a second time. Meazza was once again the man pulling the strings.

The second half saw pragmatism get the better of Italy's ambition as they strove to get over the winning line, but there was still time for two more goals. Hungary captain György Sárosi made it 3–2 in the 70th minute, a strike that gave his side hope of staging a famous comeback; but Piola's second goal of the match eight minutes from time, a fierce left-footed drive from 12 yards, extinguished the flames of Hungary's fightback.

Italy were 4–2 victors and world champions for a second time in four years, in the process giving Vittorio Pozzo a second World Cup triumph as Azzurri manager. No one knew at the time it would be the last tournament for a dozen years, but, as the full-time whistle sounded, the jubilant Italian players in the Stade de Olympique de Colombes were unconcerned what the future held for the game's elite competition.

○○○

Left: A ticket for the 1938 World Cup final in Paris between defending champions Italy and Hungary, the second successive exclusively European climax to the tournament.

Right: Azzurri captain Giuseppe Meazza collects the World Cup after his inspirational individual display for Italy in the final in the Stade de Olympique de Colombes.

"In those twenty minutes of spectacular play (in the final) they forgot their political and ethnic prejudices."

ITALY DEFENDER PIETRO RAVA

IV CAMPEONATO MUNDIAL DE FUTEBOL

· TAÇA JULES RIMET ·

JUNHO DE 1950
BRASIL

THE 1950 FIFA WORLD CUP

After a twelve-year hiatus because of World War Two - resulting in the the cancellation of the 1942 and 1946 instalments of the competition - the return of the FIFA World Cup was a cause for considerable celebration in the football fraternity. Brazil played host but it was neighbours Uruguay who emerged as the first postwar world champions.

THREE LIONS JOIN THE PARTY

1950

A total of 13 teams – six from Europe, five from South America and those of Mexico and the USA – congregated in Brazil in 1950 for the fourth edition of the FIFA World Cup. There was, among their number, just one nation making its tournament debut: Walter Winterbottom's England side.

The first three World Cups, in Uruguay, Italy and France, were widely acknowledged as significant strides forward for the beautiful game, but the British nations – England, Scotland, Wales and Northern Ireland – had all been conspicuous by their collective absence. The four oldest football associations in the world had yet not deigned to play and the sense that the competition was incomplete without their participation persisted.

In 1946, however, the British quartet ended their 17-year self-imposed exile from FIFA and rejoined the game's governing body. The *rapprochement* paved the way for the British sides to become part of the family and it was agreed that the Home Championship of 1949–50 would double up as a qualifying group for the World Cup. The winners as well as the runners-up would both make the trip to Brazil.

England were the eventual champions, their 1-0 victory over Scotland at Hampden Park in April 1950 sealing the title, and the FA duly began preparations to send manager Walter Winterbottom and the squad to South America to fly the flag for England at the World Cup for the first time.

Scotland came second in the Home Championship to earn qualification, but George Graham, the secretary of the Scottish Football Association (SFA), had publicly announced that Scotland would go to a World Cup only if they were the reigning British champions. The Scotland captain, George Young, made an impassioned plea to Graham to change his position, but it fell on deaf ears and the Scots stayed at home.

FIFA subsequently offered Scotland's place in the finals to France, but the 1938 hosts declined the invitation at the eleventh hour, citing the prohibitive amount of travel they faced to complete their proposed Group 4 fixtures. Turkey also withdrew from the tournament, unable to cover the cost of the journey to South America.

England, however, were on their way and, as the players boarded the plane for Brazil in June 1950, their first World Cup foray was about to begin.

○○○

Right: *A metal lapel badge commissioned to commemorate the 1950 World Cup in Brazil, the second time the finals were staged in South America.*

Opposite: *The cap awarded to Stanley Matthews ahead of England's clash with Spain in Rio de Janeiro, a match they lost 1-0, confirming their early exit.*

"It was a very long and tiring journey. I know we stopped off in Africa. Things were very different. There were few England fans there and not many English reporters."

ENGLAND GOALKEEPER BERT WILLIAMS

HUMILIATION IN BELO HORIZONTE

1950

England's reputation preceded Walter Winterbottom's team in the build-up to the 1950 FIFA World Cup, but hopes of the team making a major impact on their maiden tournament were catastrophically derailed following a disastrous Group 2 clash with the USA in Brazil.

England's arrival at their first World Cup was as bizarre as it was overdue. The players were greeted in Brazil by men in gas masks spraying pesticide on their plane but their unconventional welcome seemed not to deter the team unduly and they kicked off the tournament with a comfortable 2–0 victory over Chile in Rio de Janeiro.

Four days later, the squad were in Belo Horizonte for their second Group 2 engagement and what was a first-ever fixture against the USA. The bookmakers made the Americans 500–1 underdogs for the match and, with a team of amateurs who variously earned their living as a funeral director, postman, paint-stripper, dish-washer and knitting machinist, the game was the definition of a David-and-Goliath clash. Even the USA manager, Scotsman Bill Jeffrey, was convinced the English would prevail, and declared before kickoff, "We ain't got a chance against your boys."

All was not well in the England camp, however. They spent the night before the match sleeping in an aircraft hangar and there were further problems when Winterbottom clashed with the official England selector, a Grimsby fish merchant by the name of Arthur Drewry. Winterbottom wanted to recall the talismanic and vastly experienced outside-right Stanley Matthews, who had not been in the team for the Chile game, but Drewry refused to change a winning side and Matthews was consigned to the bench once again.

Staged in the Estádio Independência in Belo Horizonte, the match began with England firmly on the front foot, but they failed to translate their dominance into goals, and in the 37th minute disaster struck as the USA tore up the script and scored.

A speculative long-range effort from America's left-half Walter Bahr initially seemed to pose little danger, but, as goalkeeper Bert Williams came to collect, Haitian-born centre-forward Joe Gaetjens dived headlong in the area and found the back of the net with a glancing header.

England bombarded the USA goal in the second half but it was to no avail and Jeffrey's side clung on for what many still consider the greatest upset in World Cup history. The English newspapers certainly struggled to believe the result and there are apocryphal stories that they assumed telegrams proclaiming a 1–0 victory to the States were the result of a typing error and erroneously reported that the Three Lions had triumphed 10–1.

England lost their final Group 2 game, a 1–0 defeat to Spain in Rio, and their World Cup adventure was abruptly over almost as soon as it had started.

> "We went to Rio pretty well unprepared. We had a couple of weeks together but we were immature by the standards we had to face."
>
> WALTER WINTERBOTTOM

Opposite: USA striker Joe Gaetjens scored only one goal during his brief international career but it was an iconic strike which had disastrous repercussions for England's World Cup prospects in Brazil.

Above: The match ball from England's infamous loss to the USA in Belo Horizonte in 1950.

THE DE FACTO FINAL

(1950)

The first World Cup finals in which players wore numbered shirts and the only one not to include a de facto final match, the 1950 tournament also featured a bizarre group-stage format that resulted in the 13 competing countries in Brazil being presented with starkly contrasting routes to the latter stages of the competition.

When the organisers of the 1950 World Cup met to determine how the finals would be shaped, they had before them the names of 15 qualified nations. It was of course far from an ideal number for a symmetrical solution to the staging of the tournament, but the Brazilian administrators were unperturbed and decided on three four-team groups and another – Group 4 – featuring just three sides.

The late withdrawals of both France and India, however, suddenly reduced the number of entrants to 13, and, with no time to go back to the drawing board and reschedule the entire tournament, they were reluctantly forced to keep faith with their original format.

The outcome was that, while Groups 1 and 2 still boasted four teams, Group 3 was now a three-way contest

between Sweden, Italy and Paraguay, while Group 4 was a simple and rather odd head-to-head battle between South American rivals Uruguay and Bolivia.

The winners of each group would then qualify for a four-team, second – Final Group – phase. There was to be no final per se, and the new world champions would be crowned unceremoniously after the completion of the second-round fixtures.

Spain, Uruguay, Sweden and hosts Brazil all duly progressed to the final round, but their respective workloads were far from equitable. Both Spain and Brazil played three times in the first group phase, while Sweden were required to be on the pitch for a modest 180 minutes. Uruguay barely broke sweat as they booked their place at the business end of the tournament, an 8-0 demolition of Bolivia in Belo Horizonte enough to secure their safe passage.

With two South American and two European countries in the final round, the tournament finally found a degree of symmetry, but, although Spain held Uruguay 2-2 in their opening game in São Paulo, La Celeste and the Brazilians revelled in the familiar conditions of their own continent and, after the first two set of fixtures, the European hopefuls had accumulated one solitary point between them and were out of contention.

Only Brazil, searching for their maiden World Cup triumph, and Uruguay, the champions 20 years earlier, could now lift the trophy, and, in a strange twist of fate, the two sides were due to face each other in the last game of the competition.

The organisers may not have scheduled a final but the football gods had nonetheless conspired to ensure the tournament would climax with exactly that.

○○○
Left: *Lithograph in orange, containing a still from the film of the 1950 World Cup finals, Campianato Mondiale di Calcio: un film incom.*

Above: *Uruguay's Ghiggia puts the ball past the Spanish goalkeeper to take the lead. Despite Spain managing to come back for the draw, both European sides in the final round were out before the last game.*

"THE MARACANA BLOW"

1950

Brazil believed their coronation as the best side on the planet was a *fait accompli* as they prepared for the pivotal clash with Uruguay in Rio de Janeiro. Newspapers hailed the home team's achievements even before kickoff, but La Celeste rejected their role as sacrificial lamb to lift the FIFA World Cup for a second time.

"These are the world champions", ran the caption beneath a picture of Flávio Costa's Brazil in *O Mundo* on the morning of their match against Uruguay. It was certainly a confident claim but one that was to backfire spectacularly on a side dreaming of becoming the country's first-ever World Cup winners.

Uruguay captain Obdulio Varela was evidently not impressed and is said to have bought as many copies of the paper as he could carry, laid them out on the floor of his hotel bathroom and then urged his teammates to urinate on the incriminating article. La Celeste were the smaller and less populous neighbour to Brazil, but they were not going to go down without a fight.

The crowd inside the Maracanã for the game is officially recorded by FIFA as 173,850, but contemporary estimates put the attendance closer to 200,000 at the newly constructed stadium, and, as Brazil ran out wearing white shirts with a blue collar – they would not adopt their iconic yellow strip until 1954 – the noise was deafening.

The hosts had scored 21 goals in six games en route to Rio, but they found the Uruguayan defence far more stubborn than what had come before, and, despite dominating, Brazil could find no way through in the first 45 minutes and it was scoreless at the break.

It took Brazil just two minutes of the second half, however, to break the deadlock, Zizinho and Ademir carving out the chance from which Friaça scored, but Uruguay refused to be bowed and they equalised in the 66th minute, when Juan Alberto Schiaffino converted from an Alcides Ghiggia cross.

Although a draw would still have seen Brazil crowned champions, the next goal would be decisive and against all expectation it was the visitors who got it, Ghiggia beating goalkeeper Moacir Barbosa at his near post with just 11 minutes remaining.

The crowd – not to mention the whole nation – were reduced to a stunned silence as Uruguay held on for a famous 2-1 victory and lifted the trophy, now officially known as the Jules Rimet Trophy to commemorate the 25th anniversary of Jules Rimet's FIFA presidency.

The shock result was dubbed "Maracanazo", or "The Maracanã Blow" and still resonates in Brazil today, a term applied to a defeat for the national side at the stadium.

> "Only three people have ever silenced 200,000 people at the Maracanã with a single gesture: Frank Sinatra, Pope John Paul II and me."
>
> ALCIDES GHIGGIA

○○○
Left: *Although he did not play against Brazil in Rio, Uruguay squad member William Martinez still collected a coveted winner's medal in 1950 after La Celeste's shock victory.*

Above: *Hosts Brazil wore their then traditional white for their pivotal clash with Uruguay at the Maracanã but it proved an uncharacteristically dark day in the country's football history.*

THE 1954 FIFA WORLD CUP

A tournament that yielded a then record 136 goals in only 26 games, the 1954 FIFA World Cup saw 16 teams assemble in Switzerland to participate. Reigning Olympic champions Hungary were the undisputed favourites but Gusztáv Sebes's Magical Magyars were denied glory in the final by the heroics of Sepp Herberger's West Germany side.

FOOTBALL'S ALPINE ADVENTURE

1954

Swiss preparations for the 1954 FIFA World Cup was eight years in the making following the decision to award the country the finals as early as 1946, reward as FIFA's home for its 50 years in existence. European entrants dominated the finals with 12 of the 16 teams hailing from the continent, the quartet of Brazil, Uruguay, Mexico and South Korea flying the flag for the wider football family.

The fifth instalment of the World Cup across six Swiss venues saw the game's governing body once again reinvent the format of the tournament. The four groups of four teams certainly looked familiar but, before qualification was complete, FIFA decreed that each group would feature two seeded teams who would play the group's two unseeded ones. As the group heavyweights would not face the other, it meant that teams played only twice in the first stage.

It was an innovative if not universally popular decision. FIFA selected Austria, Brazil, England, France, Hungary, Italy, Spain and Uruguay as the eight seeds, but their plans were rather thrown into chaos when Turkey had the temerity to eliminate the Spanish in a qualification play-off. A rethink was urgently required, FIFA opting for the simplest solution available when it elevated the Turks to seeded status.

Four matches kicked-off simultanously on 16 June to open the tournament. Brazil's 5-0 victory over Mexico in Geneva was undoubtedly the most eye-catching performance and dominant result of the four, but it was on the following day that the tournament witnessed the team everyone feared in action, Hungary demolishing debutants South Korea 9-0 in the Hardturm Stadium in Zürich to vividly underline their intimidating attacking potency.

Three days later, the Hungarians were at their lethal best again as they put West Germany to the sword in Basel, striker Sándor Kocsis netting four times in an 8-3 triumph to take his tournament tally to seven in two appearances, and Gusztáv Sebes's team were through to the quarter-finals in devastating style.

The West Germans, however, recovered sufficiently from their Hungarian nightmare to beat Turkey 7-2 in a play-off and went through to the knock-out phase, albeit having played an extra game.

They were joined in the last eight by Brazil, who finished level on three points with Yugoslavia in Group 1, but went through as pool winners at the expense of Aleksandar Tirnanić's team after lots had to be drawn.

Defending champions Uruguay topped Group 3 with an unblemished record and without conceding a single goal, and were joined by runners-up Austria, while England and hosts Switzerland finished first and second, respectively, in Group 4, the latter beating Italy 4-1 in another play-off.

The 16 teams were now eight and knock-out football was about to begin.

○○○
Left: Official World Cup mascots were still 12 years away – England's World Cup Willie was the first – but enterprising businessmen cashed in with mementoes such as this ceramic footballer figurine holding a ball.

Above: Eventual winners in 1954, West Germany had to get through a play-off against Turkey to reach the quarter-finals. Horst Eckel (middle) hit a post with this shot, but the Germans still went on to triumph 7–2.

THE BATTLE OF BERNE

1954

The most eagerly anticipated of the four quarter-finals of the 1954 World Cup, Hungary's meeting with Brazil was supposed to be a classic, the Magical Magyars' attractive total football against the South Americans' natural flamboyance. But the beautiful game sadly turned ugly as the match descended into chaos and violence.

A crowd of 40,000 descended on the Wankdorf Stadium on 27 June 1954 to watch Hungary play Brazil. It was a fixture that had captured the imagination of neutral and partisan supporters alike, and those fortunate to have secured a ticket took their seats expecting a football extravaganza. What unfolded over the next 90 minutes in Berne, however, was not in the script.

The match began innocuously enough. The Hungarians surged into an early two-goal lead with strikes from Nándor Hidegkuti in the fourth minute, the second coming from Sándor Kocsis just three minutes later, but Brazil got a foothold in the match in the 18th minute, when they were awarded a penalty, Djalma Santos on target from the spot to beat Gyula Grosics in the Hungarian goal.

The protagonists headed to their respective dressing rooms at half-time with no further scores, but it was in the second period that the game became increasingly fractious and eventually deteriorated into little more than an unedifying mass brawl.

The catalyst for the fighting came on the hour mark when Hungary were awarded a penalty. Mihály Lantos stepped forward to convert but, almost as soon as the ball hit the back of the net, Brazilian journalists and officials invaded the pitch in protest and had to be forcibly removed by Swiss police.

It was the cue for a seemingly relentless series of fouls from both sets of players. In the 71st minute, the ill feeling became undisguised violence and Hungary's József Bozsik and Brazil's Nilton Santos were both sent off after trading blows. Djalma Santos was seen chasing Zoltán Czibor around the pitch and, four minutes from time, English referee Arthur Ellis expelled Brazil's Humberto Tozzi for taking a kick at Gyula Lóránt. In addition to the three dismissals, Ellis awarded a total of 42 free kicks and also booked four players.

His final whistle in Berne brought little relief from the mayhem. Brazil's Pinheiro was hit on the head by a bottle thrown from the Hungarian bench, allegedly by the injured Ferenc Puskás, while the South American players stormed the Hungarian dressing room after the game to continue hostilities.

The Hungarians won the match 4–2 and progressed to the last four, but the result seemed largely irrelevant after the disgraceful scenes, which are still known today as the "Battle of Berne".

○○○
Above: *The notorious last eight clash between Hungary and Brazil in Berne was one of the most acrimonious and ill-tempered in the history of the World Cup.*

Right: *Referee Arthur Ellis's official match report after the ugly scenes in the Wankdorf Stadium.*

- 9 -

d) **Incidents of the match Brazil v. Hungary, on 27th June, 1954**

We should ask you to note the decision approved by the Emergency Committee at its meeting of 25th September with regard to the above-mentioned incidents, which reads as follows:

After having studied the reports on the incidents which occurred during and after the match Brazil v. Hungary, the

Executive Committee

states:

- that according to the reports of the referee and the linesmen and according to those of the officials of the F.I.F.A. who attended the match, the two teams missed a sporting attitude of fair-play thus obliging the referee to send the Brazilian players Barbozza Tozzi Humberto and Nilton Santos and the Hungarian player J. Boszik off the field;

- that according to the reports of the organs in charge of maintaining order at the Wankdorf Stadium, incidents between players and officials of the Hungarian and Brazilian delegation occurred after the match in and around the stand which necessitated the intervention of the police;

- that the accusations against the President of the F.I.F.A., the referee and the authorities of the F.I.F.A. and the Swiss F.A., contained in the letter of the head of the Brazilian delegation, were not only not justified, but displaced;

- that the Organising Committee of the F.I.F.A. took a decision about the steps to be taken against the above mentioned players so that the Executive Committee must not deal with this matter;

- that the attitude of certain players during the match Hungary v. Brazil compromised the good reputation of the 5th World Championship - Jules Rimet Cup 1954;

- that, fortunately, the other 25 matches were played in a remarkable sporting attitude which has blotted out the bad impression of 27th June;

- that the moral condemnation of the deplorable events which occurred during and immediately after the match Brazil v. Hungary and the regret that the players and other persons of the two delegations so seriously missed the rules of sportsmanship and fair-play must weigh as heavy as any material sanctions.

.//.

"I thought it was going to be the greatest game I'd ever see. Whether politics and religion had something to do with it, I don't know, but they behaved like animals. It was a disgrace. My only thought was that I was determined to finish it."

REFEREE ARTHUR ELLIS

STAGE FIT FOR THE FINAL

1954

The centrepiece of the 1954 FIFA World Cup staged in Switzerland, the second incarnation of the Wankdorf Stadium in the north of Berne hosted five fixtures during the tournament and witnessed two of the competition's most significant and memorable matches.

A football stadium has stood in the Wankdorf quarter of Berne since the city's BSC Young Boys club commissioned local architects to design the team a new home in 1925. Construction of the ground, with a capacity of 22,000, took seven months, although in November 1925 it hosted its first international match when Switzerland played Australia.

The club repeatedly enlarged and updated the stadium throughout the 1930s and 1940s, but, when the Swiss FA won the race to stage the World Cup, the ground was nonetheless deemed unfit for purpose and the bulldozers were called in to demolish it and rebuild.

The "second" Wankdorf Stadium that emerged was a suitably modern venue that could accommodate 64,000 supporters, 8,000 seated and the other 56,000 standing. It was inaugurated shortly before the World Cup began and Berne braced itself for the imminent arrival of the World Cup bandwagon.

The ground's first game of the tournament on 16 June saw reigning world champions Uruguay ease to a 2–0 victory over Czechoslovakia. West Germany were in town 24 hours later, beating Turkey 4–1, while the stadium's third and final group-phase fixture saw England emerge 2–0 winners against Switzerland.

It was, however, the two knockout-stage games played out at the Wankdorf Stadium that saw the ground etch its name in World Cup folklore.

The first was the infamous "Battle of Berne", the ill-tempered and ill-disciplined quarter-final clash between Hungary and Brazil. The second was the fairytale story of the final between West Germany and the Hungarians, dubbed the "Miracle of Berne", which saw Sepp Herberger's side famously rip up the form book to beat Ferenc Puskás and Co. and lift the Jules Rimet Trophy for the first time.

The World Cup final and West Germany's 3–2 win cemented the stadium's iconic reputation and, even after the tournament had become an increasingly distant memory, the ground continued to host high-profile matches, including the 1961 European Champions Cup final between Benfica and Barcelona and the European Cup Winners' Cup final of 1989 in which Barcelona beat Sampdoria.

The "second" Wankdorf Stadium, however, was to serve as the home of the Young Boys for a relatively short 47 years, as it was demolished in 2001 to make way for the current Stade de Suisse, which was opened in the summer of 2005, and was one of the venues for the 2008 UEFA European Championship, which was jointly hosted by Switzerland and Austria.

ooo

Left: West Germany's resounding 4-1 victory over Turkey in Group 2 was the second fixture to be staged at the rebuilt Wankdorf Stadium.

Right: An original architect's drawing for the new 64,000-capacity Wankdorf Stadium in the Swiss capital which was built in time for the 1954 World Cup finals.

"THE MIRACLE OF BERNE"

1954

The 1954 FIFA World Cup final was a match that all but the most optimistic West German supporters believed would be won by the free-scoring and seemingly unstoppable Hungarians. For the second final in succession, however, it was the underdog rather than the favourites who would ultimately lift the Jules Rimet Trophy.

The omens for a shock West German victory going into the final were far from encouraging: Hungary were unbeaten in their previous 31 international matches; they were the reigning Olympic champions; they'd smashed home 25 goals in four fixtures en route to the final; and, most ominously of all, they had dismantled the Germans 8-3 in the group stages only 18 days earlier.

The Magical Magyars, it seemed, could not lose, and, to compound Germany's sense of foreboding, Hungary welcomed back the talismanic Ferenc Puskás for the concluding game of the tournament. The "Galloping Major" had missed the victories over Brazil and Uruguay through injury and, although doubts persisted whether he was fully fit for the final, he was restored to the starting line-

> "It still hadn't sunk in when we were stood together listening to the national anthem afterwards. We were all holding hands, such was the deep friendship throughout the entire squad."
>
> GERMANY'S JUPP POSIPAL

up. His return meant Hungary would field the same XI as had spectacularly dismantled Germany in Basel, while Sepp Herberger kept faith with six of his psychologically scarred team from their 8–3 humiliation.

Rain greeted the two sets of players as they ran out at the Wankdorf Stadium, and from a German perspective the wet conditions were welcome. Herberger's team were wearing new Adidas boots featuring a then innovative screw-in studs system, which meant they could play in longer studs for better grip without having to change their favourite boots. It was only a scrap of good news for the rank outsiders but encouraging, nonetheless.

Hungary began the final, however, in irrepressible style and were in front after only six minutes, Puskás making a mockery of the question marks over his fitness; and, 120 seconds later, they doubled their advantage when Zoltán Czibor capitalised on a mistake by keeper Toni Turek.

West Germany seened to be heading for another drubbing, but they rallied and inside-right Max Morlock netted in the tenth minute. The goal gave the scoreboard a degree of respectability and, when Helmut Rahn equalised eight minutes later, the German players began to dream of springing one of the greatest shocks in World Cup history.

The next 66 minutes in Berne yielded no goals, and extra time was beckoning until Rahn dramatically grabbed his second goal, and West Germany's third, with a left-footed drive. Puskás has an equaliser ruled out by the linesman and, against all expectation, Herberger's side held out. West Germany were world champions and the "Miracle of Berne" was complete.

○○○
Left: The odds were stacked against West Germany in the final in 1954 but goals from Max Morlock and Helmut Rahn (2) sealed a shock victory for Sepp Herberger's side.

Above: A ticket for the 1954 final between West Germany and Hungary at the Wankdorf Stadium, a match which drew a crowd of 62,500 in Berne.

HAIL TO THE CHIEF

1954

The mastermind behind West Germany's improbable World Cup triumph of 1954 and the emergence of the country as an undisputed superpower of the global game, Sepp Herberger was famed both for his exhaustive attention to detail and his idiosyncratic turn of phrase.

The story of Herberger's long and ultimately triumphant reign as the manager of Die Mannschaft began as early as the 1930s, while the final chapter was not written until 1964, when the man affectionately dubbed "The Chief" by his players finally stood down at the age of 67.

Herberger was capped three times by his country as a striker in the 1920s, but it was in his subsequent role as manager that he became a national hero, building a formidable post-war team who became world champions in what was only Germany's third World Cup appearance.

He was appointed manager in 1936, succeeding Dr Otto Nerz, in the wake of Die Mannschaft's disappointing display at the Berlin Olympics. The outbreak of World War Two interrupted his grand plan to put Germany on the football map, but, when hostilities ended, he returned in earnest to his role and his mission to claim the Jules Rimet Trophy. FIFA's decision to exclude Germany from the 1950 World Cup merely delayed his date with destiny.

Herberger was rarely seen without a notebook, in which he kept extensive information on opponents, their players and their tactical systems, while under his leadership West Germany became a side renowned for strength, physical power and fighting spirit. It was an approach that, allied with his ability to motivate players and get the best out of individuals, reinvented the national team.

He was also famous for his unique, albeit oblique, way with words. "The game lasts for 90 minutes" was one of his most legendary lines, while "The ball is round" and "After the game is before the game" were other expressions he coined that amused and confused the media and his side's supporters in equal measure.

He spent a total of 20 years in post before retiring in 1964, making way for Helmut Schön, his gift to the nation being Germany's enduring place among football's elite. He was awarded the National Order of Merit First Class in 1962 and was posthumously inducted into the German Sports Hall of Fame in 2008; but his team's triumph against all the odds in Switzerland in 1954 will for ever be his greatest legacy.

○○○

Left: The idiosyncratic but hugely successful Sepp Herberger (front right) won the World Cup with West Germany 18 years after he had been appointed manager.

Right: Karl Mai played in midfield for West Germany under Sepp Herberger. His suitcase contained his official suit and various personal mementoes.

"I prefer to keep a certain distance from the success. It's a fantastic feeling when a team pays back your faith in them with a performance like that. It was a wonderful experience."

SEPP HERBERGER

WALTER'S WARTIME REPRIEVE

1954

West Germany's triumph in the 1954 World Cup final saw Fritz and Ottmar Walter become the first-ever siblings to be crowned world champions. For Fritz, however, victory over Hungary in Berne brought a bittersweet feeling following his experiences during World War Two.

The sight of Fritz Walter lifting the Jules Rimet Trophy was a cathartic one for West Germany. The country was still slowly recovering from the ravages of war, and victory for the team in the final was a cause for celebration in a difficult era. For Die Mannschaft's captain, however, Hungarian heartbreak in the Wankdorf Stadium after West Germany's shock 3-2 win was a reminder of the debt of gratitude he owed to the country he had just defeated.

Like so many of his football peers, Walter had put his career on hold during World War Two and served in the German air force. At the end of the conflict in 1945, his base surrendered to the Americans, only to be handed over Russian soldiers, and he was shipped off to a Ukrainian detention centre.

Deportation to an infamous Siberian gulag, where life expectancy was short, was the fate of the majority of captured German personnel, but fate intervened when Hungarian prison guards recognised Walter – he had played for Germany in Budapest three years earlier – and changed his paperwork. Walter was not sent to Siberia and instead was allowed to return to his home in Kaiserslautern. Nine years later, he led Germany to victory over Hungary.

Walter did not escape the war unscathed. He contracted malaria, a condition he would suffer with for the rest of his life, and struggled to play matches in hot, humid conditions as a result. It did not escape the notice of the German fans that the 1954 World Cup was played in a cooling rain, conditions they fondly referred to as "Fritz Walter weather".

His connection with Hungary did not end with his reprieve in 1945 or the final of 1954. In 1956, the Hungarian Uprising against Soviet rule left many of the national team's players in exile and it was Walter who stepped in to help manage the country that had probably saved his life.

The semi-final of the 1958 World Cup against France was the last time Walter represented West Germany, retiring from football the following year. He died in 2002 at the age of 81, but lived long enough to see his one and only club Kaiserslautern rename its ground the Fritz-Walter-Stadion in his honour.

> "The embodiment of fair play and sportsmanship during his footballing career, he remained an inspiration to future generations."
>
> DAILY TELEGRAPH OBITUARY

Opposite: Fritz Walter, left, and Ferenc Puskás, exchange pennants before the start of the 1954 World Cup final, watched by referee William Ling.

Above: West Germany shirt from the 1954 World Cup final, the first of the country's three victories before reunification in the early 1990s.

THE 1958 FIFA WORLD CUP

A second successive tournament to be staged in Europe, the 1958 FIFA World Cup, hosted by Sweden, witnessed the explosive emergence of a prodigiously talented 17-year-old by the name of Pelé as Brazil finally lifted the coveted Jules Rimet Trophy for the first time.

THE DRAGON BREATHES FIRE

1958

Sweden became the fourth European country to play host to the FIFA World Cup in 1958. Fifteen nations headed to Scandinavia and 12 different venues were used for the finals. Argentina was back after a 24-year self-imposed exile, while all four British Home Nations qualified for the first time, meaning Northern Ireland, Scotland and Wales joined the Soviet Union as first-time finalists.

When FIFA met to debate the destination of the sixth World Cup, Sweden's bid to stage the finals was the only one on the table. Mexico, Argentina and Chile had all made tentative expressions of interest, but failed to follow through with concrete proposals; and, in June 1950, the game's governing body confirmed the Swedes would be throwing football's biggest party in eight years' time.

Brazil, Argentina and Paraguay provided the South American challenge, while Mexico, making their fourth tournament appearance, were the other non-European nation in attendance. None of the African, Asian or Oceania confederations were represented.

The organisers abandoned the contentious experiment of four years earlier, where teams were seeded played only two first-round group matches. The four teams in the four groups would this time face their three rivals, with each group's top two advancing to the quarter-finals. Countries tied for second and third in the group would, once again, have a play-off to decide which one played in the last eight.

Group 1 saw West Germany, the reigning champions, progress safely to the knockout phase, but a play-off was required to separate Northern Ireland and Czechoslovakia, the Irish winning 2–1 after extra time in Malmö to book their place in the last eight.

It was more straightforward in Group 2, with France and Yugoslavia both finishing on four points. Les Bleus' better goal average – 1.57 to 1.17 – ensured that Albert Batteaux's team entered the quarter-finals as group winners.

Hosts Sweden dominated Group 3 dropping only one point, but there was drama in the battle for the runners-up place as debutants Wales and Hungary, finalists four years earlier, finished locked on three points.

The play-off match was held in the Råsunda Stadium in Solna on the outskirts of Stockholm, and, although the golden Hungarian generation of Ferenc Puskás, Sándor Kocsis et al., was no more, it still ranked as a major upset when Jimmy Murphy's Wales side emerged victorious.

Hungary took the lead in Solna with a first-half goal from Lajos Tichy, but Wales made light of their World Cup inexperience with goals after the restart from Swansea Town inside-right Ivor Allchurch and Tottenham Hotspur winger Terry Medwin to reach the quarter-finals at the first time of asking.

Neither England nor Scotland won a match and both – England after losing a play-off against the Soviet Union – went home after the group stage.

ooo

Above: (Top) Commemorative postcard from the quarter-final in Malmö. (below) This postcard was produced for the final at the Råsunda Stadium.

Left: A pennant from Malmö, one of the ten Swedish venues to stage matches in the 1958 World Cup; West Germany played three games there.

THE WONDER OF PELÉ

1958

Brazil arrived in Sweden in 1958 aiming to improve on their heart-breaking runners-up finish as the 1950 tournament hosts and a quarter-final exit in 1954. The Seleção failed to hit the heights in their opening two Group 4 matches, but their fortunes dramatically changed when manager Vicente Feola decided to gamble and throw a teenage Pelé into the fray.

It would be erroneous to argue that Edson Arantes do Nascimento was a complete unknown before the 1958 World Cup. Pelé had made his international debut against Argentina the previous summer in a 2-1 defeat at the Maracanã, scoring Brazil's only goal at the tender age of 16 years and nine months, but his growing reputation was mainly confined to those *au fait* with South American football.

He arrived in Sweden nursing a knee injury. Without the teenager in their line-up, Brazil beat Austria 3-0 in their opening group game, but it was far from the convincing performance the final scoreline suggested and, when the Seleção were held to a 0-0 stalemate by England in Gothenburg three days later – the World Cup's first ever goalless draw – there was growing sense of disquiet about the side's indifferent form in Sweden.

Brazil faced the Soviet Union in their final Group 4 game, and Feola made his decisive move for it, recalling both Pelé and Garrincha for the showdown in Gothenburg's Ullevi stadium, deploying an innovative 4-2-4 formation. The 17-year-old seized his chance in considerable style, setting up strike partner Vavá for the second goal in a 2-0 victory. The South Americans were through to the last eight, and Pelé had already made his mark on his maiden tournament.

The youngster got even better as Brazil grew in confidence and marched imperiously towards the final. He was the only player to score in the quarter-final clash with surprise package Wales in Gothenburg and, at the age of 17 years, seven months and 27 days, he became the World Cup's youngest-ever goal scorer. It is a record that still stands today.

The Seleção tackled France in the last four in Solna and once again it was the brilliant teenager from Minas Gerais who dominated proceedings, grabbing a sensational hat-trick in the space of 23 second-half minutes. Brazil had been hanging on to a 2-1 lead before he struck and his goals set up the 5-2 defeat of Les Bleus and confirmed his phenomenal potential. It is no surprise that nobody younger has ever registered a World Cup treble.

Brazil were through to the final and now the whole world was talking about the young sensation – he played his club football for São Paulo giants Santos – and whose four tournament goals had come in just three appearances. Only the hosts could deny Brazil and Pelé their date with football destiny.

ooo

Above: Pelé's first World Cup goal decided the 1958 quarter-final against Wales in Gothenburg; he added three in the semi-final and two in the final.

Right: The shirt Pelé wore when, as a 17-year-old in June 1958, he became the youngest player ever to score in a World Cup final.

"When I saw Pelé play, it made me feel
I should hang up my boots."

JUST FONTAINE

RAYNOR'S SURPRISE SEMI-FINAL PACKAGE

1958

Brazil's increasingly impressive progress to the denouement of the 1958 FIFA World Cup meant it fell to Sweden (the Blågult) and West Germany to battle it out for the right to face the Seleção in the final. Victory over the reigning champions would see George Raynor's team be the fourth host nation – after Uruguay, Italy and Brazil – to reach the last game of their own tournament.

Despite enjoying home advantage, Sweden went into the World Cup finals more in hope than anticipation. The hosts had failed to qualify for the tournament four years earlier and, although memories of their impressive third-place finish in Brazil in 1950 had not yet faded, the Swedes were not considered leading title contenders.

The good news was the Swedish FA's decision to allow the country's exiled professional footballers, most notably inside-right Gunnar Gren and midfielder Nils Liedholm, to play in the tournament, and, although their progression to the last four – dispatching the Soviet Union in the quarter-finals – delighted the country, the prevalent, neutral view was that the Swedish fairytale would come to an abrupt end against West Germany.

A crowd of 49,471 packed the Ullevi stadium in Gothenburg for the showdown with the 1954 world champions and, when FC Cologne winger Hans Schafer drew first blood for the Germans in the 24th minute, it appeared as though Sepp Herberger's side would indeed have too much power for the home side.

Sweden, however, needed only eight minutes to restore equality, Inter Milan winger Lennart Skoglund beating German keeper Fritz Herkenrath, and the Ullevi erupted with a reinvigorated sense of optimism.

There were no more goals before the break, and in the second half both sides found creating clear scoring chances difficult. What proved to be the pivotal moment of the match arrived on the hour mark, when German defender Erich Juskowiak lost his discipline, kicked the knee of Kurt Hamrin and was promptly sent off.

Sweden made the most of their numerical superiority in the closing 30 minutes. Gren gave them the lead with just nine minutes remaining, and it was Hamrin who delivered the *coup de grâce*, six minutes later, with one of the most impudent goals in World Cup history.

The Fiorentina winger seemed to be having nothing on his mind except running down the clock as he ambled towards the touchline, but, as the Germans desperately pressed, he produced a sudden and unexpected injection of pace, which took him past three defenders and into the danger area. Herkenrath came out but Hamrin beat the keeper at his near post with an insouciant chip and Sweden were 3-1 winners.

> "The greatest football memory of my life is of the 1958 World Cup."
>
> KURT HAMRIN

Left: West Germany's reign as World Cup champions came to an end after a 3-1 defeat to Sweden in Gothenburg in the semi-finals.

Above: The front and reverse of a postcard signed by the enitre West German squad. The photograph shows a relaxed side at their training camp.

SELEÇÃO HUMILIATE THE HOSTS

1958

The climax of the 1958 FIFA World Cup took place on 29 June at the Råsunda Stadium and, after 90 minutes of frenetic action, the match yielded a record of seven goals, witnessed both the youngest and oldest players ever to score in a final and ultimately saw Brazil become the first side ever to be crowned champions outside their own continent.

It had been raining for 24 hours by the time Sweden and Brazil kicked off the World Cup final on a Sunday summer's afternoon just north of Stockholm. Optimistic home supporters hoped the characteristically northern European conditions would favour their team, but it was the Brazilians who showed that they truly were a team for all seasons.

Sweden duly made a dream start to proceedings when skipper Nils Liedholm pierced the South American defence as early as the fourth minute. At the age of 35 years and 263 days, he remains the oldest man ever to find the back of the net on football's greatest stage of all.

His goal meant Vicente Feola's team were behind in a game for the first time in the tournament, but Swedish hopes that their captain's strike would deliver a significant psychological blow were unfounded. Just five minutes later, the Seleção were on level terms when Vavá met Garrincha's cross with exquisite timing to beat Swedish goalkeeper Kalle Svensson for the equaliser.

The home side failed to heed the warning, and, in the 32nd minute, it was Garrincha and Vavá who irresistibly combined again, the former supplying another pinpoint cross for the latter, and at half-time it was 2-1 in Brazil's favour.

As it had in the semi-final against France, the second-half belonged almost exclusively to Pelé with his first goal, a 55th-minute volley. It was another hat-trick of sorts for Pelé, the World Cup's youngest goalscorer, the youngest to bag a hat-trick and, at the age of 17 years and 249 days, the youngest to score in the final itself.

Brazil surged further ahead when left-winger Mário Zagallo made it four, and, although striker Agne Simonsson restored a degree of respectability for the hosts with ten minutes remaining, the final word inevitably went to Pelé in the final minute as he linked up deftly with Zagallo before powering home a header to make it 5–2 to the Seleção.

The favourites were, at the sixth attempt, world champions. As the players set off on a lap of honour around the Råsunda Stadium, carrying the Swedish flag in tribute to the tournament hosts, and watched by King Gustav VI, the World Cup was at the beginning of an unprecedented and captivating era of Brazilian dominance.

ooo

Above: Brazil endeared themselves to Swedish fans in Stockholm after winning the World Cup and carrying the hosts' flag around the Stadium.

Left: A special medal presented by Sweden's King Gustav Adolf VI to Karl-Oskar Svensson after his 73rd and last international, the 1958 World Cup final.

> "When Pelé scored the fifth goal in that final, I have to be honest and say I felt like applauding."
>
> SIGVARD (SIGGE) PARLING, SWEDEN DEFENDER

THE LITTLE NAPOLEON

1958

France striker Just Fontaine lit up the 1958 FIFA World Cup with a phenomenal 13 goals in only six matches – a prolific record that earned him the Golden Boot and has never been eclipsed – but it was his mercurial compatriot Raymond Kopa who was crowned the Player of the Tournament.

Born Raymond Kopaszewski in 1931, his journey from a teenager working in the coal mines of northern France to the pinnacle of the world game was not an easy one. By his own admission, the youngster from a Polish immigrant family was desperate to escape a life of subterranean toil and he was determined football would provide his way out.

He realised his dream in 1949 (he was a schoolboy when the family shortened their surname), when he signed professional forms for Angers, but Kopa was destined for even greater things and, whether it was on international duty with his adopted France or in the famous white shirt of Real Madrid, the attacking midfielder proceeded to establish himself as one of the greatest talents of his or any other generation.

Kopa won his first cap for France against West Germany in October 1952 and was part of the squad that stumbled at the 1954 World Cup in Switzerland. Four years later in Sweden, however, France were on fire, scoring 23 goals in six matches, and it was Kopa pulling the creative strings.

Dubbed "Little Napoleon" by the Spanish newspaper *Marca*, Kopa scored three goals of his own in the tournament, but Fontaine's record-breaking haul of 13 owed much to his vision, technical ability and, most of all, appetite for dribbling.

Kopa's Player of the Tournament award was followed later in the year by the coveted Ballon D'Or, awarded by the renowned *France Football* magazine, and his reputation as one of the game's most outstanding creative influences was sealed.

At club level, Kopa signed for Madrid from Reims in 1956 and, in his three seasons at the Santiago Bernabéu, he helped the club secure three successive European Cup triumphs and two La Liga titles. He re-signed for Reims in 1959, claiming two French league titles, before hanging up his boots in 1967.

His considerable achievements were recognised three years later, when he became the first French footballer to be awarded the country's *Légion d'Honneur*. In 2004 Kopa was named as one of the 125 greatest living players selected by Pelé to celebrate FIFA's 100th anniversary, while in 2010 he was the recipient of the annual UEFA President's Award.

> "I loved to dribble. Dribbling was my key ability, where I could really make a difference. The media and public at first thought I dribbled too much. But what could I do – this was my main weapon, my way to play the game."
>
> RAYMOND KOPA

Left: Midfielder Raymond Kopa was the Player of the Tournament in the 1958 World Cup as France secured a third-place finish in Sweden.

Above: The last of Kopa's three World Cup goals in 1958 was a penalty against West Germany as France won 6–3 in the third-place play-off.

CAMPEONATO MUNDIAL DE FUTBOL
WORLD FOOTBALL CHAMPIONSHIP
CHAMPIONNAT MONDIAL DE FOOTBALL
COUPE JULES RIMET

CHILE 1962

THE 1962 FIFA WORLD CUP

Returning to South America after a 12-year absence, the build-up to the 1962 FIFA World Cup in Chile was overshadowed by a devastating natural disaster, but it was a tournament that ultimately overcame nationwide destruction and saw an inspired Brazil squad successfully defend their crown.

TRIUMPH IN THE FACE OF ADVERSITY

1962

FIFA took the decision to award the seventh World Cup to Chile in the summer of 1956. Four years later, the country was rocked by one of the biggest earthquakes ever recorded, but the hosts refused to be bowed by the devastation and, by 1962, the nation was, almost miraculously, ready to welcome football's finest.

The Valdivia Earthquake struck on 22 May 1960, the epicentre the town of Lumaco in the middle of the country. The quake lasted only ten minutes but registered on 9.5 the Richter Scale and 50,000 people lost their lives as a result. It was a disaster on an unparalleled scale.

In the immediate aftermath, football seemed unimportant but, as time passed, the Chilean FA had to make a decision whether it could still host the World Cup. Four of the eight stadiums originally selected for the tournament had been severely damaged, but the South Americans had had to fight off fierce competition from neighbours Argentina in their bid to be awarded the finals, and were determined not to relinquish the opportunity. They communicated to FIFA they'd be ready in time.

The stadiums in Viña del Mar and Arica were hastily rebuilt. The Estadio Nacional in Santiago had survived the quake relatively unscathed, and a fourth venue was secured when the American-owned Braden Copper Company stepped forward to offer the use of its ground in the city of Rancagua. The organisers had the four grounds they needed to stage the competition.

Fifteen countries joined the Chilean hosts in May and June 1962, ten from Europe, four from South America and central Americans Mexico. Colombia and Bulgaria were sampling World Cup finals football for the first time and both managed only a single point before returning home. The only format change from 1958 was goal average, not a play-off, separating second and third in the four four-team groups, the top two progressing to the quarter-finals.

Two double-champions fell at the first hurdle. Uruguay, winners in 1930 and 1950, failed to get out of Group 1, while Italy, victors in 1934 and 1938, were eliminated after finishing third behind West Germany and Chile in Group 2.

Hungary topped Group 4 ahead of England, but the headline news from the pool stages in 1962 focused on Brazil. The reigning champions were untroubled in winning Group 3, but Pelé aggravated a groin injury in the side's second game against Czechoslovakia and, to the undoubted detriment of the tournament, the star in Sweden four years earlier did not kick another ball in anger in the competition.

○○○

Above: The devastation caused by 1960's Valdivia Earthquake in central Chile threw the fate of the 1962 World Cup into doubt.

Right: The matchball used when Brazil beat Czechoslovakia in the 1962 World Cup final was on display as São Paulo prepared for the 2014 finals.

"We have nothing, that is why we must have the World Cup. Because we don't have anything, we will do everything in our power to rebuild."

CARLOS DITTBORN, PRESIDENT OF THE 1962 ORGANISING COMMITTEE

SHAME IN SANTIAGO

1962

Although the build-up to the Group 2 clash between Chile and Italy in Santiago was nothing if not acrimonious, few could have predicted the indiscipline and violence that ensued inside the Estadio Nacional as both teams played out one of the most fractious matches in the history of the World Cup.

The decision to award Chile the 1962 World Cup was evidently not a universally popular one. The Italian media in particular were dismayed at FIFA's choice and, as the game between La Roja and the Azzurri in the Chilean capital approached, they penned a series of disparaging articles about the tournament hosts.

"Santiago is the sad symbol of one of the world's most underdeveloped places, distressed by all possible ills – malnutrition, prostitution, illiteracy, alcoholism, poverty," wrote journalist Corrado Pizzinelli. "Entire neighbourhoods are dominated by prostitution. Santiago is a poverty-stricken dump full of loose women."

Chilean newspapers responded with their own pieces labelling Italians as fascists, Mafiosi, oversexed and (in the wake of a recent doping scandal at Inter Milan) drug addicts. The mood was so ugly that the *Daily Express* predicted, "the tournament shows every sign of developing into a violent bloodbath."

Any hope the match would pass off peacefully were effectively dashed after only 12 seconds, when the first foul was committed, and the temperature soared when English referee Ken Aston sent off Italy's Giorgio Ferrini in the 12th minute for a bad foul on Honorino Landa. Ferrini refused to leave the pitch and had to be dragged off by the police.

Landa himself escaped censure for throwing a punch at an Azzurri player and Aston also overlooked a blow directed by Chile's Leonel Sánchez towards Mario David. The Englishman, however, was not feeling so lenient when David kicked Sánchez in the head and the Italian became the second player to take an early bath.

The match by now had degenerated into barely concealed chaos. Sánchez broke the nose of Italy's Humberto Maschio with a left hook, and on three separate occasions armed police had to intervene to break up fights and help Aston restore even a vestige of order.

The final whistle could not come soon enough and, when Aston was finally able to draw a line under the whole despicable affair, Chile were 2–0 winners. Few, however, cared about the scoreline, the "Battle of Santiago" was destined to be for ever remembered as one of the lowest and most unpalatable points in the history of the competition.

> "I wasn't reffing a football match, I was acting as an umpire in military manoeuvres."
>
> KEN ASTON

Left: Two Italian players were dismissed during the shameful scenes in Santiago as the Azzurri lost 2–0 to hosts Chile in a Group 2 fixture.

Above: The boots worn by Chile defender Luis Eyzaguirre in the notorious fixture in the Estadio Nacional.

THE SELEÇÃO'S CZECH MATE

1962

Inspired by the brilliance of winger Garrincha, Brazil reached the final of the 1962 FIFA World Cup unbeaten in their five games. They faced a Czechoslovakia side who had held the Seleção to a goalless draw in the group stage in Viña del Mar but were unable to emulate the feat in the rematch in Santiago.

Brazil were the red-hot favourites going into the final against the Czechs. Aymoré Moreira's side had shrugged off, in considerable style it must be said, the loss of Pelé to injury in their second match, and the outstanding form of Garrincha had filled the creative void seamlessly. The overwhelming weight of opinion was that the match was the Seleção's to lose.

Czechoslovakia, however, had qualified for the finals only after beating Scotland in extra time in a play-off and, although they did overcome Hungary (the 1954 finalists) and Yugoslavia (quarter-finalists in Sweden in 1958) in the knockout stages, it was hard to find any experts who were confidently predicting a European triumph in the Estadio Nacional on 17 June 1962.

It represented, then, a significant shock when the Czechs took the lead in Santiago in the final, midfielder Josef Masopust seizing on a speculative long ball from Adolf Scherer and beating Gilmar in the Brazilian goal. Czechoslovakia had been unable to pierce the Seleção defence in the group stages; it had taken them just 15 minutes to do so in the reunion.

As Sweden's early goal in the final four years previously had done, however, the score merely stung Brazil into action and within two minutes the match was level after the previously flawless Czech keeper Viliam Schrojf got his angles wrong and committed the cardinal sin of allowing a shot from centre-forward Amarildo to squeeze past him at his near post.

Czechoslovakia managed to successfully resist all the subsequent Brazilian attacks until half-time, but the dam broke after the break. In the 69th minute, Zito initiated another attack and then finished it with a convincing header from Amarildo's cross. The Europeans had no answer to the Seleção's superiority and the result was put beyond doubt, 12 minutes from the end, when Schrojf again was at fault, his failure to collect a lob in the penalty area allowing Vavá to make it 3–1 to the South Americans.

Vavá's goal took his tally for the tournament to four, tying him with Garrincha and four other players for the Golden Boot, but, more importantly, it sealed the victory that saw Brazil lift the Jules Rimet Trophy for the second time in four years and join Uruguay and Italy as two-time winners of the World Cup.

Left: *A ticket for the Brazil v. Czechoslovakia 1962 World Cup final in Santiago, a match the defending champions won 3–1 in front of 68,679 fans.*

Above: *Experienced Czechoslovakia goalkeeper Viliam Schrojf was uncharacteristically at fault for two of Brazil's three goals in the 1962 final.*

WORLD CUP

JULY 11 to 30
1966
ENGLAND

THE 1966 FIFA WORLD CUP

Sixteen years after England had embarked on their maiden World Cup adventure in Brazil, the country hosted the 1966 tournament. And, for the third time since the World Cup was first contested in 1930, it was the host nation who would be crowned world champions.

LONDON CALLING

(1966)

The contest to host the 1966 FIFA World Cup was a two-horse race between England and West Germany. In an echo of the final between the two nations that was to follow, The Football Association emerged victorious and preparations began to stage the beautiful game's greatest competition in the sport's spiritual home.

The English attitude to the earliest incarnations of the World Cup had been distinctly aloof. The national team, after all, had not featured in the first three tournaments – they left FIFA in 1928 and came back in 1946 – but, by 1960, and with three appearances in the finals under their belt, there was now a real appetite to consummate the relationship and stage the competition for the first time.

That hunger, however, was shared by West Germany and the two European nations lobbied long and hard in the FIFA corridors of power for the right to host the finals. FIFA announced the result in 1960: the Germans had lost narrowly, 34 votes to 27, so the World Cup was to be in England.

Despite a boycott by 16 African nations in protest at a FIFA ruling that introduced play-offs against their Asian counterparts in order to reach the finals, a record 70 countries were involved in qualification. Fifty-six fell by the wayside while the victorious 14 – including first-timers Portugal and North Korea – joined England and defending champions Brazil for the tournament proper. The FA selected eight venues for the competition, with Wembley Stadium in north London allocated both the semi-finals and the final.

The pool stages produced a fascinating mix of the predictable and the unforeseen. Group 1 saw England and Uruguay progress to the last eight without undue alarm, they had opened the tournament with a dull goalless draw, while West Germany and Argentina emerged from Group 2 as the two strongest sides.

There was, however, a seismic shock in the third pool as Brazil crashed out of the competition. The Seleção began brightly with a 2–0 victory over Bulgaria at Goodison Park but a robust 3–1 defeat to Hungary followed by a 3–1 reverse against Portugal four days later condemned the champions to a premature exit. Pelé was the victim of particularly harsh treatment and limped out in misery.

Further surprises lay in store in Group 4 in the shape of North Korea. The team had no World Cup pedigree but, after losing their opening match to the Soviet Union, they wrote one of the tournament's most unlikely fairytales, securing a draw with Chile before beating Italy 1–0 at Ayresome Park, courtesy of a famous goal from Pak Doo-Ik.

The result sent the Azzurri, the two-time champions, home early and, against all the odds, the Koreans through to the knockout stages.

ooo

Above: *World Cup Willie, the official mascot of the 1966 finals, was designed by children's book illustrator Reg Hoye, who had worked with Enid Blyton..*

Right: *A commemorative World Cup postcard addressed to German star Fritz Walter, and signed by the entire West German World Cup squad.*

87

PICKLES AND "THE POLE"

1966

When the original Jules Rimet Trophy was stolen four months before the start of the 1966 FIFA World Cup, the theft sparked a frenetic nationwide hunt. A dog named Pickles famously found the silverware but not before an intriguing, clandestine game of cat-and-mouse between England officials, the police and the thieves.

When the World Cup went missing from a glass cabinet in March 1966 after going on display at a stamp exhibition at the Methodist Central Hall in central London's Westminster, the public outcry was matched only by the acute embarrassment of the Football Association. The game's most coveted trophy had been stolen on English soil and national pride had taken a global blow.

Pickles, a mixed-breed dog owned by south Londoner David Corbett, came to the rescue a week later when he fortuitously sniffed out the trophy on the streets of Norwood and became a national hero in the process – but the story of how the Jules Rimet Trophy came to be there in the first place is one that has never been fully explained.

The cup was stolen on 20 March. The Metropolitan Poice Flying Squad – the Serious Crimes Unit of the time – were charged with the task of retrieving it and, in the days that followed, Chelsea and FA chairman Joe Mears was phoned by a man calling himself Jackson, the mysterious caller demanding £15,000 ransom for the trophy's safe return. As instructed, Mears placed a personal advertisement in the London *Evening News*, which read "Willing to do business."

Mears was also told not to tell the police but ignored the warning, and it was a DI Len Buggy, not Mears, who arranged the handover of the cash in exchange for the

> "I put the lead on Pickles and he went over to the neighbour's car. He drew my attention to a package, tightly bound in newspaper, lying by the front wheel."
>
> DAVID CORBETT

Above: The collar worn by Pickles the dog, who found the Jules Rimet trophy after it had been stolen.

cup in Battersea Park. Jackson, however, smelled a rat and tried to flee the scene, but was arrested. The trophy was nowhere to be seen.

"Jackson" turned out to be a petty criminal by the name of Edward Betchley. He admitted being the man on the phone but insisted he was merely a middleman who'd been paid £500 by someone known as "The Pole". The police never traced the enigmatic brains behind the operation.

Two days later Pickles intervened in the story and sniffed out the silverware wrapped in newspaper, but by this time the FA had already commissioned a replica Jules Rimet as a precaution. The England players proudly paraded the fake trophy on the Wembley pitch after their victory in the final, the real one being swapped by the police minutes after Bobby Moore had received it from the Queen, but after that the understandably cautious FA ensured that it was the replica that went on show at public engagements.

Pickles received numerous awards over the next few months and Corbett used the reward to move out of London. Sadly, there was no happy ending for Pickles: he died in 1967.

Left: Thanks to Pickles the dog, the England team were able to conduct their 1966 FIFA World Cup final lap of honour with the original Jules Rimet Trophy.

Above: David Corbett and his dog Pickles watch the 1966 World Cup Final at home on television.

LOST IN TRANSLATION

1966

The rivalry between England and Argentina is one of the fiercest in international football, and the seeds of what is frequently a fractious relationship were controversially sown when the two teams met at Wembley at the quarter-final stage of the 1966 World Cup.

England's clash with Argentina (La Albiceleste) at the 1962 World Cup in Chile, a 3–1 victory for Walter Winterbottom's side in Rancagua, was a match without significant incident; but the same could not be said for the rematch in London four years later as the last-eight meeting degenerated into acrimony and accusations of cheating.

More than 90,000 fans packed Wembley for the game but, rather than talk about football, they left debating one of the most controversial decisions in World Cup history after West German referee Rudolf Kreitlein sent off Argentina captain Antonio Rattin in the 35th minute. England scored the only goal of the game against the ten men late in the second half, courtesy of Geoff Hurst, and the match is still known in Argentina as the "Robbery of the Century".

Rattin was ordered off for dissent. The fact that the referee and the player did not have a common language evidently did not deter Kreitlein – he later admitted, "I do not speak Spanish, but the look on his face was enough" – and, although Rattin demanded a translator be brought onto the pitch and refused to leave for ten minutes, the German official was deaf to his protests. In the end, the irate Argentinian skipper had to be escorted off by FIFA officials.

The incident sadly set the tone for the rest of the match, which was ill-tempered and undisciplined, and at the final whistle the England manager Alf Ramsey stormed onto the pitch to stop his players swapping shirts with the opposition. "It seems a pity so much Argentinian talent is wasted," he later said. "Our best football will come against the right type of opposition – a team who come to play football, and not act as animals."

Interestingly, post-match analysis revealed that England committed 33 fouls compared to the 19 by Argentina. Much later it was also revealed that Bobby Charlton had been booked, for the only time in his career. FIFA, however, expunged the caution from his record.

England were nevertheless through to the semi-finals while La Albiceleste headed home and received a heroes' welcome on their return as the Argentinian press lambasted the result and drew comparisons with the manner of the defeat and the Falkland Islands – or the Malvinas, as the islands are known in Argentina. "First they stole the Malvinas from us and now the World Cup," read one editorial. "If we are animals, they are thieves."

ooo

Right: West German referee Rudolf Kreitlein's official report card after England's infamous quarter-final clash with Argentina at Wembley.

Below: England's match with Argentina in 1966 (Martin Peters on the ball) set an acrimonious tone for subsequent in World Cup finals meetings.

> "I showed him my captain's armband and he said, 'Out! Out!' And he sent me off. How did he understand what I was saying? He spoke German and I spoke Spanish. He's a liar."
>
> ANTONIO RATTIN

THE THREE LIONS ROAR

(1966)

Only the second World Cup final that required extra time to separate the protagonists, the 1966 showdown between England and West Germany at Wembley was a mesmerising six-goal thriller, which witnessed the first and only hat-trick ever registered in the final game of the tournament.

The first World Cup meeting between two of the giants of the European game, the 1966 final was watched by almost 97,000 spectators at Wembley and commanded a global TV audience of 400 million as England emulated the feats of Uruguay, in 1930, and Italy, four years later, to become world champions on home soil.

Both sides were unbeaten en route to the climax of the competition, conceding a miserly three goals between them, but the final saw attacking flair rather than defensive solidity in the ascendency as England and West Germany ran riot at the home of football.

Die Mannschaft drew first blood in the twelfth minute when Helmut Haller seized on a misdirected header by Ray Wilson to give the visitors an early lead; but West Germany were in pole position for only seven minutes, Geoff Hurst equalising with a glancing header from captain Bobby Moore's delivery of a free-kick, a move they had worked on in training at their club side, West Ham United.

All square at half-time, England struck again in the 77th minute when Hurst's shot was deflected and his West Ham teammate Martin Peters beat Hans Tilkowski from close range, but the hopes of a partisan Wembley crowd that the Three Lions would triumph inside 90 minutes were dashed just a minute from time when Wolfgang Weber seized on indecision in the home defence to conjure up a dramatic, last-gasp equaliser.

The tension in extra time was palpable, but it was England who held their nerve to create the all-important next score, Hurst controversially netting in the 101st minute. His shot hit the crossbar, bounced down and the referee and linesman were satisfied that the ball had crossed the line.

West Germany poured forward in the second period of additional time in an increasingly desperate search of another equaliser, but they were ultimately the victims of their own abandon in the final minute of the match. Hurst ran onto a long pass from Moore, raced towards goal and beat the badly-positioned Tilkowski with a rasping left-footed drive that screamed into the top corner to complete his historic hat-trick.

England were 4–2 winners and, after Moore had ascended the famous 39 Wembley steps to receive the cup from the Queen, the nation that had first given the world the beautiful game lifted the Jules Rimet Trophy.

"The thing I remember most about 1966 was the final whistle at Wembley. I just felt complete relief. It was like a weight had been lifted off the shoulders."

GORDON BANKS

Left: Match ball from the 1966 World Cup final at Wembley; it was only the second final to have needed extra time to settle proceedings.

Right: Tickets from the final and the third-fourth play-off between Portugal and the Soviet Union. Portugal won the play-off 2–1 to enjoy their best-ever finish.

SPECTRE OF THE GHOST GOAL

1966

The debate about Geoff Hurst's controversial third England goal in the 1966 FIFA Cup final at Wembley has raged from the moment the West Ham striker's shot hit the underside of Hans Tilkowski's crossbar and, depending on your point of view, did or did not bounce over the goal line.

Football has been littered with "ghost" goals over the decades, but perhaps the most infamous is Hurst's extra-time effort for England, a strike that, for half a century, has generated passionately divided opinion on whether the goal was legitimate or not.

Hurst rattled the West German crossbar in the 101st minute of the final at Wembley. After the ball had rebounded downwards and hit the pitch, the England players reeled away in celebration, convinced the ball had landed beyond the goal line. Their German counterparts were equally convinced the ball had *not* crossed the line and protested.

Confusion initially reigned because neither team was clear whether Swiss referee Gottfried Dienst had awarded a goal. He went across to his linesman, Tofiq Bakhramov from Azerbaijan, and, after a brief tête-à-tête, Dienst signalled, to German dismay, that England had indeed scored.

The arguments, recriminations and accusations about the decision began as soon as the final whistle sounded. The German players claimed they saw chalk dust as the ball landed, proving it must have hit the line, while England insisted that striker Roger Hunt – who had the best view of all the players – would have attempted to score from the rebound had there been any semblance of doubt the ball had not crossed.

Intriguingly, Bakhramov himself later admitted in his memoirs that he believed Hurst's effort had actually hit the back of the net rather than the net, and bounced back out. It was a startling confession but ultimately unhelpful in terms of answering the burning question.

Contemporary footage of the incident was inconclusive,

○○○
Above: *The Tofiq Bakhramov statue in Baku, Azerbaijan, was unveiled in 2004, with Hans Tilkowski, left, and Sir Geoff Hurst guests of honour.*

Right: *Geoff Hurst's fiercely-contested second goal – England's third – at Wembley in the 1966 World Cup final continues to divide opinion.*

but more modern technology has frequently been employed to attempt to finally settle the debate. In 1996 a study at Imperial College, London, used film analysis and computer simulation and surmised the ball must have been 2.5 to 6 cm short of fully crossing the line. In 2016, however, Hawk-Eye and Venatrack technology was set to work on the task, created a 3D view of proceedings and concluded Hurst's goal was correctly awarded.

The fact that the "ghost" goal did not prove to be the winner at Wembley has not diffused the argument and it certainly made something of a hero of Bakhramov in both England, where he is affectionately if erroneously known as "the Russian linesman", and his native Azerbaijan, who named the former national stadium in Baku after him and built a statue in his honour.

> "Nothing has ever been proven one way or another about that other than the linesman gave it."
>
> GEOFF HURST

THE WEMBLEY WATERSHED

1966

The euphoria that greeted England's triumph in the 1966 FIFA World Cup final was matched only by the deep sense of German disappointment after the match. Between 1970 and 2014, however, Die Mannschaft would appear in six more finals – winning three – while England would be conspicuous by their absence on the game's greatest stage.

A staggering 32.3 million people watched the World Cup final on television in Britain. It remains the biggest audience in history in the UK and, as the victorious England squad returned to the Royal Garden Hotel in Kensington on the evening of 30 July, the country celebrated their feat enthusiastically.

The players' party was somewhat overshadowed by the Football Association's archaic decision to seat the wives and girlfriends in a separate room as the men ate, but, such patriarchal pettiness aside, it was a day that was to change the lives of the England squad for ever, if not the future fortunes of the national team.

The manager, Alf Ramsey, was knighted the year after masterminding the team's victory, while both Bobby Charlton and Geoff Hurst became Knight Bachelors, the former in 1994, the latter four years later; and, although captain Bobby Moore tragically lost his battle with cancer in 1993 at the age of 51, his inspirational contribution to the

THE FOOTBALL ASSOCIATION

World Championship Jules Rimet Cup

BANQUET

in honour of
F. I. F. A.
and
The Teams Competing in
The Finals

ROYAL GARDEN HOTEL
LONDON

Saturday, 30th July, 1966

cause is commemorated by a bronze statue of the great man outside the new Wembley Stadium.

In 2010 the entire 1966 team were induced *en masse* into the English Football Hall of Fame.

For German football in contrast, the final was a cause for reflection rather than celebration, and, when Helmut Schön and his side returned home, the German Football Association showed considerable foresight and decided to keep faith with the defeated manager.

Schön in turn retained the majority of his players, and nine of the side from Wembley, including captain

Uwe Seeler, Franz Beckenbauer and Helmut Haller, reappeared in the finals in Mexico four years later. The continuity proved crucial, and Schön repaid his employers emphatically, avenging the team's defeat in 1966 by knocking out England in the quarter-finals in Mexico before steering Die Mannschaft to glory at the 1972 European Championship and then victory over the Netherlands in the 1974 World Cup.

England parted company with Ramsey seven years after his finest hour, after the team had failed to quailfy for the 1974 World Cup, ironically hosted by West Germany, and, since his reign, the Three Lions and his successors have struggled to make their mark on the global game.

In many ways the 1966 World Cup was a watershed for the two nations, but rather than the winners, England, it was the losers, West Germany – and, post-unification Germany – who would ultimately emerge the stronger for the experience.

○○○

Above: Front page of the menu from the official, Football Association-hosted post-match banquet in London to celebrate the World Cup final.

Left: The shirt worn by Helmut Haller at Wembley in 1966. His 12th-minute opener was one of 13 international goals Haller scored for West Germany.

mexico 70

IX football world championship

may 31 – june 21

THE 1970 FIFA WORLD CUP

The first tournament to be held outside the continents of Europe or South America, the 1970 FIFA World Cup in Mexico was also the first time a rapidly expanding global television audience was able to follow the action in colour. Brazil made it a hat-trick of triumphs to permanently claim the Jules Rimet Trophy.

BREAKING NEW GROUND IN CENTRAL AMERICA

1970

The decision to award Mexico the World Cup was not a universally popular one within FIFA, but initial misgivings about the host nation dissipated as the Central Americans hosted a hugely entertaining tournament. It featured a series of iconic matches between the game's global heavyweights.

Only Mexico and Argentina submitted formal bids to host the 1970 tournament. With five successive appearances in the finals, Mexico were by now firmly part of the family, while Argentina's participation since 1930 had been sporadic; but concerns persisted whether the high altitudes and sweltering temperatures of the proposed Mexican venues would be conducive to good football.

The vote to determine the host nation took place in Tokyo in November 1964. The doubts about Mexico's suitability had been allayed sufficiently to win the day and, although seven countries abstained, the central Americans received 56 votes to Argentina's 32, so the honour of hosting the World Cup was theirs.

The ninth edition of the competition featured five stadia, the centrepiece being the imposing 110,000-capacity Azteca in Mexico City. A total of 75 countries began qualification, hoping to join the hosts Mexico and the reigning champions England in the finals. The conclusion of qualifying saw many of the usual suspects – Brazil, West Germany, Italy and Uruguay – confirm their places, but there were also World Cup debuts for El Salvador, Israel and Morocco.

The four groups of four were ultimately to prove predictable in terms of the traditionally bigger countries progressing to the knockout stages, but the pool phase was not without incident and drama.

The most surprising result came in Group 2 at the Estadio Luis Dosal in the city of Toluca, when Italy faced Israel. The Azzurri, two-times world champions, were unbeaten in their opening two fixtures, a 1–0 victory over Sweden and a goalless draw with Uruguay, and were expected to brush aside the Israelis, but their opposition proved more stubborn than anticipated, and the World Cup newcomers held out for a goalless draw.

There was also almost a seismic shock in West Germany's opening fixture of Group 2, a team featuring Franz Beckenbauer and Gerd Müller, playing Morocco at the Estadio Nou Camp in León.

Few predicted anything but a German procession, but the north Africans hadn't read the script and took an improbable lead in the 21st minute, when striker Houmane Jarir beat Sepp Maier. Germany did not equalise until the second half through captain Uwe Seeler, and they were heavily indebted to the predatory instincts of Müller and his face-saving, 80th-minute winner.

It was the start of a prolific run of form for the Bayern Munich striker in Mexico and one that would eventually see him crowned the tournament's leading marksman.

Left: Juanito was the official mascot of the 1970 tournament. The Mexico finals was the first World Cup not staged in Europe or South America.

Above: The iconic 1970 World Cup Telstar ball, the first to be emblazoned with the manufacturer's name; a new era of commercialism was born.

"THE SAVE OF THE CENTURY"

1970

An eagerly-anticipated clash between the 1962 World Cup winners and the defending champions, Brazil's Group 3 rendezvous with England at Estadio Jalisco in Guadalajara will for ever be remembered for the sublime brilliance of England goalkeeper Gordon Banks.

From the moment the draw for the group stages of the tournament was made, the world was talking about Brazil versus England. It was a fixture that captured the imagination far beyond the two sides' own supporters and, although it yielded only one goal, it was a match that would have graced any final in any era.

The Seleção had warmed up for the encounter with a 4-1 demolition of Czechoslovakia four days earlier, while the Three Lions were 1-0 winners over Romania in the group opener; and, as the two sides took to the Estadio Jalisco pitch on 7 June, a crowd of 66,843 had assembled to witness what promised to be a titanic tussle between the South American and European giants.

Boasting a revered and feared front five of Jairzinho, Pelé, Gérson, Tostão and Rivelino, Brazil had an embarrassment of attacking riches, but, although England had just one survivor in their back four from their 1966 Wembley triumph, that man was Bobby Moore, and the captain was in glorious form in Guadalajara.

Behind Moore stood Banks, and it was his incredible stop from a Pelé header in the first half that lit up the Estadio Jalisco. Jairzinho supplied the cross, Pelé rose majestically above the defence and powered a thunderous downward header towards the goal. The ball seemed destined to ripple the net, but Banks defied logic to scamper across his goal and improbably claw the ball out and then over his crossbar. The crowd had just witnessed "the save of the century".

Even Moore and Banks, however, were powerless to stop Brazil finding a way through in the second half. The breakthrough came on the hour, when Tostão burst into the area and found Pelé. The magical Number 10 laid it deftly off for Jairzinho, and Banks was finally beaten by a thunderbolt drive.

England poured forward in search of an equaliser. Alan Mullery hit the crossbar while substitute Jeff Astle dragged a close-range effort agonisingly wide; but, despite the valiant fightback, the Seleção held out for a memorable 1-0 victory.

Both sets of players embraced and swapped shirts at the final whistle, an acknowledgement of the epic 90 minutes of football they had just produced. Brazil remained unbeaten but English disappointment was tempered by the knowledge that the champions still had their destiny in their own hands and could still qualify for the quarter-finals.

> "It's funny but when I leave this planet, that save in 1970 is what I'll be known for rather than winning the Cup in 1966. Pelé was already shouting 'goal' because it looked for all the world to be going in. It's amazing how people still talk about it."
>
> GORDON BANKS

Above: Bobby Moore's shirt, worn against Brazil in Guadalajara, and swapped with Pelé after the final whistle in an iconic World Cup moment.

Left: Bobby Moore tussles with Pelé during their enthralling match up in the group stages.

ANGLO-GERMAN RIVALRIES RENEWED

1970

West Germany had to wait four years for the opportunity to avenge the heartbreak of defeat to England in the 1966 World Cup final. Their chance finally came in Mexico in the quarter-finals in León's Estadio Nou Camp, a contest that once again would dramatically go to extra time.

The meeting between the two sides, managed by Helmut Schön and Sir Alf Ramsey respectively, was not in fact the first time the teams had met since their famous Wembley showdown. West Germany had beaten England 1-0 in a friendly in Hanover in the summer of 1968, but the Germans yearned for revenge on the game's biggest stage.

Ten players from the 1966 final – five on either side – lined up for the rematch in Mexico but the headline selection news before kickoff was the loss of talismanic England goalkeeper Gordon Banks, a victim of food poisoning, and Ramsey handed Chelsea's Peter Bonetti his World Cup finals debut as cover.

The game began with England in the ascendency and this translated into the opening goal in the 31st minute, when Alan Mullery beat Sepp Maier. England doubled their advantage four minutes into the second half, courtesy of Martin Peters, and the reigning champions appeared poised to stroll serenely into the last four.

The inimitable Franz Beckenbauer was the catalyst for the West German fightback, beating Bonetti in the 68th minute with a shot that the inexperienced – at least in international terms – keeper should have saved. Two minutes later, Ramsey took the fateful decision to substitute the influential Bobby Charlton, winning his 106th and what proved to be final cap for his country. It was a switch that many believe transformed the momentum of the match.

Die Mannschaft surged forward and, eight minutes before the end of the 90, they levelled with an effort from captain Uwe Seeler. There were no further scores and extra time loomed.

England were convinced they had regained the lead when Hurst hammered home Francis Lee's cross, but his effort was disallowed, although it was not clear whether the score was chalked off for offside or a foul in the build-up.

West Germany's winning goal came in the 108th minute. Substitute Jürgen Grabowski supplied the cross, Hannes Löhr got his head to it and it was Gerd Müller who found space to unleash an unstoppable volley from close range. It was Der Bomber's eighth goal of the tournament.

There was no way back for England. The defending champions were out and West Germany had gone some way to expunging the painful memories of defeat four years earlier.

> "That tournament (in 1970) still means more to me even than 1974. We had an outstanding team then."
>
> GERD MÜLLER

Left: Gerd Müller's extra-time winner in León's Estadio Nou Camp was his eighth in Mexico. He finished the tournament as top scorer with ten.

Above: The complete pre-tournament 30-man England squad, complete with World Cup trophy, collected in the World Cup Soccer Stars sticker book.

AGONY AND ECSTASY IN THE AZTECA

1970

Fresh from their cathartic victory over England in the quarter-finals, West Germany faced Italy in the last four at the cavernous Azteca. It was a match that burned slowly for 90 minutes, only to explode spectacularly into life in extra time, earning the clash the epitaph the "Game of the Century".

Die Mannschaft had just three days to recover from their extra-time efforts against England before they tackled the Azzurri. The Italians also had only 72 hours' grace between fixtures, but Ferruccio Valcareggi's team had not had to exert themselves unduly in dispatching hosts Mexico 4–1 in the last eight and, as a result, Italy went into the semi-final the fresher of the two.

Against this backdrop, it came as little surprise when the Azzurri struck first and early in Mexico City, Roberto Boninsegna drilling a low shot past Sepp Maier in the eighth minute. Italy had their noses in front and, despite two strong appeals for penalties from West Germany and a series of near misses, they clung stubbornly to their advantage.

The German cause was not enhanced by the shoulder injury suffered by Franz Beckenbauer – Der Kaiser would finish the match wearing a sling – and, as the 90 minutes inside the Azteca were nearly up, the Azzurri could have been forgiven for turning their thoughts to the final.

What they had doubtless not accounted for, however, was defender Karl-Heinz Schnellinger, a man who plied his club trade in Italy with AC Milan, surging forward in stoppage time and levelling proceedings with the only goal of his international career.

Events in extra time were as pyrotechnic as they were rapid. Gerd Müller gave Germany the lead for the first time four minutes into the first period, but Italy were back on terms three minutes later, when defender Tarcisio Burgnich volleyed home a deflected Gianni Rivera free kick.

The Azzurri recaptured the advantage moments before the teams swapped ends, when Gigi Riva supplied

a superb finish to a counterattack, only for West Germany to claw their way for the second time in the match, Müller doubling his personal tally five minutes into the second period to leave the contest precariously poised at 3–3.

Just one minute later, the Italians delivered the *coup de grâce*. Boninsegna provided the impetus and Rivera the decisive finish, and, in the moist breathless 30 minutes of international football conceivable, the Azzurri were through to the final.

The contest, dubbed "Game of the Century", remains the only match in World Cup finals history to have produced five extra-time goals.

ooo

Above: With five goals in extra time, the crowd of 102,444 inside the Azteca witnessed one of the most dramatic denouements in World Cup history.

Left: West Germany's Franz Beckenbauer bravely finished the titanic semi-final tussle with Italy in Mexico City with his right shoulder in a sling.

> "If we had to play in the final against Brazil after our extra-time games against England and Italy, we would lose by five. This way, we get to go home as the happy heroes in defeat."
>
> UWE SEELER

TRIUMPHANT TREBLE FOR THE SELEÇÃO

1970

The ongoing debate about the greatest international team of all time will never be definitively resolved but the Brazil side of 1970 laid a convincing claim to the crown in Mexico with a flamboyant display of spellbinding football which swept away Italy in the final.

The 1970 World Cup final was a historic one in more than way. Pelé's opener in Mexico City's Azteca Stadium was his country's 100th goal since the inaugural tournament four decades earlier; the Seleção's 4-1 masterclass against the Azzurri saw Mario Zágallo become the first man ever to lift the Jules Rimet Trophy as player and subsequently manager; while victory gave Brazil an unprecedented hat-trick of world titles.

Even such significant milestones, however, were eclipsed by the effervescent yet, at the same time, languid manner in which Brazil played in the final. The Seleção were simply unplayable and the Azzurri were bystanders for much of what unfolded in front of more than 107,000 spectators in the Mexican capital.

Pelé's opener in the 18th minute was merely the appetizer as the great man towered above the Italian defence in the air and thundered home a header into the bottom corner. Against the run of play, the Europeans equalised before half-time after miscommunication in the Seleção defence allowed Roberto Boninsegna space, but it proved a temporary respite for Ferruccio Valcareggi's team.

Brazil were irresistible in the second 45 minutes. It was 2-1 when Gérson, unleashed a venomous left-footed drive from outside the area, which screamed past Enrico Albertosi in the Italian goal. Two became three in the 71st minute as a result of incisive attack, Gérson's exquisite long ball finding Pelé, who in turn headed across goal for Jairzinho to finish from close range, but the Seleção saved the best for last and their fourth goal four minutes from time was nothing short of a work of art.

It began deep in their own half and the catalyst was the outrageous skill of defender Clodoaldo, who beat four Italians to create space and momentum. Five more Brazilians had a touch as they moved inexorably forward, but, when the ball came to Pelé outside the penalty box, the attack appeared to have temporarily lost its impetus. Pelé, however, knew that Carlos Alberto was arriving at speed on the right and he caressed the ball into his path, the captain timing his surge to perfection and hitting a rocket of a first-time shot to complete Italy's misery.

Brazil had become the first team to lift the Jules Rimet Trophy for a third time and, as the late FIFA president who had given his name to the cup had stipulated, the South Americans became the proud owners of football's most coveted piece of silverware.

> "We felt very good before the tournament. Pelé was saying that we were going to win, and, if Pelé was saying that, then we were going to win the World Cup."
>
> CARLOS ALBERTO

Above: *A winner's medal presented to the players after Brazil's stunning 4–1 victory over Italy in the 1970 World Cup final.*

Left: *Carlos Alberto was the third Brazilian to lift the Jules Rimet Trophy, and started the tradition of the winning captain kissing the World Cup.*

WM 74

Fußball-Weltmeisterschaft 1974
FIFA World Cup 1974
Coupe du Monde de la FIFA 1974
Copa Mundial de la FIFA 1974

13.6. – 7.7.1974

Hamburg Düsseldorf Frankfurt
West-Berlin Gelsenkirchen Stuttgart
Hannover Dortmund München

THE 1974 FIFA WORLD CUP

The World Cup reached double figures in 1974 with the tenth edition of the tournament. West Germany played host to the finals for the first time and, although it was the "Total Football" of Johan Cruyff and the Netherlands that mesmerised the crowds, it was Die Mannschaft who were ultimately crowned champions on home soil.

DEUTSCHLAND WELCOMES THE WORLD

1974

There was change in the air as West Germany prepared to stage the 1974 World Cup: FIFA had a newly elected president, Brazilian João Havelange; the 16 finalists were competing for a brand-new trophy; and, in a break from the five previous tournaments, a different competition format was in place.

It was in London, five days before the opening game of the 1966 World Cup, that FIFA confirmed the competition would be heading to West Germany in 1974. Spain had expressed interest in hosting, but politics prevailed and they stepped aside in return for German support in their bid to host the tournament in 1982.

A record 98 nations took part in qualifying, and the preliminary phase was notable for the number of the game's bigger names who failed to reach the finals. Former champions England were toppled, as were two-time finalists Hungary, and also missing were France, Spain, Portugal and Czechoslovakia.

The USSR completed the catalogue of absent heavyweights, but their no-show in West Germany was the result of a political rather than football issue, the Soviets refusing to play Chile in a play-off game in Santiago in the wake of a violent *coup d'état* in the country two months earlier.

The 16 nations who gathered in West Germany in 1974 included debutants Australia, East Germany, Haiti and Zaïre (the first ever representatives from sub-Saharan Africa). They faced two very different challenges as they plotted their potential routes to the final.

The first was the weather. The previous World Cup in Mexico had been unrelentingly dry and oppressively humid, but the climatic conditions four years later were in stark contrast and much of the tournament was played out under dark skies and heavy rain.

The second significant difference was the tournament's format. The first round of four groups of four, playing on a round-robin basis to leave a last eight, remained but there was now a second round of groups, again of four teams, though no country would face a first-round opponent at this stage. Again played in a round-robin format, the winners of the two second-round groups would be the ones to contest the final.

History was made twice in the opening round. Carlos Caszely of Chile left an indelible mark on the World Cup when, 67 minutes into the second match of the tournament, he was dismissed against West Germany in Berlin's Olympiastadion. He became the first ever player to be shown a red card in a World Cup finals match following the red and yellow cards' introduction in Mexico.

Scotland also earned a dubious place in the record books when they became the first country to be eliminated from the competition without losing a game. Willie Ormond's side beat Zaïre, but only 2-0, and drew with Brazil and Yugoslavia in Group 2 but headed home early, courtesy of their inferior goal difference.

○○○

Left: *"Tip und Tap" were the 1974 World Cup finals' official mascots when West Germany became the sixth European host.*

Above: *As no players were sent off in 1970, Chile's Carlos Caszely was the first receive a red card in World Cup finals match.*

SILVIO'S GOLDEN CREATION

1974

With Brazil now in permanent possession of the Jules Rimet Trophy following their historic hat-trick of FIFA World Cup final triumphs, the game's governing body found itself in pressing need of new silverware to present to the eventual champions in West Germany.

It was at FIFA headquarters in Zürich in April 1971 that a group of football's finest, led by former president Sir Stanley Rous, first gathered to debate the design of the new World Cup. The committee's discussions, however, led nowhere, and it was agreed to put the all-important commission out to tender to the world's leading sculptors and artists.

FIFA subsequently received a total of 53 suggestions from seven different countries for the new silverware but, as its officials sifted through the many options, they were struck by the offering from an Italian sculptor called Silvio Gazzaniga.

He had begun working on his design in his Milan studio as soon as the FIFA tender was issued. He was, though, concerned that his preliminary sketches did not adequately convey the fluid lines of his work and, as a result, he also created a Plasticine model and plaster cast to bring his vision to life. Rous and co. were suitably impressed and Gazzaniga got the job.

The Cup was immediately cast in 18-carat gold and officially adopted by FIFA in January 1972, more than two years before the start of the next tournament.

Measuring 36.8 cm in height and tipping the scales at 6.175 kg, the piece is officially known as the FIFA World Cup Trophy and depicts two sporting figures holding aloft the world. Between 1994 and 2010, the names of the winners were engraved on a plate on the base of the trophy, but, following the tournament in South Africa, FIFA reconfigured the "winners' plate" in a spiral design to create space for future champions. Unlike in the era of the Jules Rimet Trophy, World Cup winners are not permitted to take the silverware home with them and instead take possession of a gold-plated replica known as the FIFA World Cup Winners' Trophy.

There are sceptics who doubt whether the original trophy, which is housed at FIFA HQ, is actually solid gold and in 2010 Professor Martyn Poliakoff of Nottingham University claimed part of the iconic cup must be hollow.

"According to my calculations, if it was solid all the way through, it would have somewhere between 70 and 80kg of gold," he said. "I think – and I have no means of knowing – that perhaps the ball at the top, which is the world, is probably hollow. I don't think that it would be light enough for people to wave above their heads."

"To create a universal symbol relating to sport and the harmony of world sport, I was inspired by two fundamental images: those of a triumphant athlete and of the world. I wanted to create a dynamic representation of an accomplishment that could express harmony, simplicity and peace simultaneously."

SILVIO GAZZANIGA

Left: Italian sculptor Silvio Gazzaniga won the commission from FIFA to design the new World Cup, replacing the iconic Jules Rimet Trophy.

Above: West Germany became the first country to lift the new World Cup trophy after their 2–1 victory over the Netherlands in the final in Munich.

EAST MEETS WEST

1974

The Cold War continued to rage unabated when West Germany hosted the World Cup in 1974. Political tensions provided a constant backdrop to the tournament, the prevailing atmosphere coming to be embodied in the group-stage clash between the hosts and their Soviet Bloc neighbour, East Germany.

There was only one talking point following the draw for the group stages of the 1974 World Cup. West Germany's Group 1 clash with tournament debutants East Germany at the Volksparkstadion in Hamburg on 22 June was the subject on everyone's lips and both teams were actually aware they were to be held up, albeit reluctantly, as the champions of competing ideologies. It was a battle between democracy and Communism.

It was not the first meeting between the two teams. They had most recently crossed swords at the 1972 Munich Olympics, a second-round game won 3-2 by East Germany. It must be remembered the Olympic Games were for amateurs in the West – Eastern Bloc nations selected players who were in the armed forces or civil servants, even if they never saw duty. Only Uli Hoeness for West Germany played in both matches, but five East Germans from 1972 started and four others were in the squad.

Both had already played two group games. West Germany had beaten Chile and Australia without conceding a goal, and had already secured their progress to the second

> "There was deadly silence. The stadium was quiet. Our 2,000 fans made a noise for 10,000, but it was accompanied by booing and whistling. We had hit the enemy where it hurts him most. It stung them badly."
>
> **JÜRGEN SPARWASSER**

group stage, while East Germany had been held 1–1 by the South Americans and still needed a point to ensure they prolonged their involvement in the tournament.

A crowd of 60,000 was in the Volksparkstadion for the match, but the home side found their guests from the East stubborn opponents and, despite the combined talents of Franz Beckenbauer, Gerd Müller, Hoeness and Wolfgang Overath, they could not unlock the East German defence.

In the 77th minute the visitors delivered their surprise counterpunch. East Germany broke swiftly from the back through substitute Erich Hamann and, when he looked up, he saw midfielder Jürgen Sparwasser in space between three West German defenders. Sparwasser controlled the resulting long-range pass with his head and, as Sepp Maier rushed out to smother the danger, he lifted the ball over the prostrate goalkeeper and into the back of the net. Georg Buschner's team had beaten the hosts 1–0. The result was celebrated far and wide behind the Iron Curtain, and East Germany went through to the next phase as group winners.

There was, though, a silver lining for West Germany despite their embarrassment: defeat ensured they avoided the triple threat of the Netherlands, Brazil and Argentina in the second group stage, presenting Helmut Schön's side with what proved to be a far easier route to the final.

ooo

Above: A boot worn by Gerd Müller during the 1974 finals. He played in the 1–0 defeat against neighbours East Germany in Hamburg.

Left: West Germany's match against East Germany had far more than football bragging rights at stake; it was a clash of political ideologies.

FLAGS OF INCONVENIENCE

1974

West Germany may have been the host nation but the free-scoring Netherlands were firm favourites ahead of the 1974 World Cup final. The fluid Dutch were the tactical innovators, the Germans the epitome of power, and, as befitted their contrasting collective characters, the two teams enjoyed very different build-ups to the final.

West Germany's World Cup began badly. Just five days before the start of the tournament, behind the scenes, a row had erupted between the squad and the Deutscher Fussball-Bund over bonus payments. The squad demanded financial parity with the Italian and Dutch players, who, they had learned, had been promised more money. When German officials refused to acquiesce and manager Helmut Schön threatened to call up second-string players who would proudly represent their country, Die Mannschaft was on the verge of implosion.

It took an 11th-hour intervention from captain Franz Beckenbauer to thrash out a compromise, but the dispute had done little to foster harmony and, when the team slumped to their shock defeat to East Germany, the alarm bells rang loud and clear.

That Schön's team did battle through to the final was to their credit but, as they spent the days in the build-up to the showdown with the players cocooned from the public eye at the training camp, it was difficult to gauge the mood among the squad. The good news was Die Mannschaft was still a tough nut to crack. Goalkeeper Sepp Maier had conceded just three goals in six games en route to the final, but a sense persisted that all was not well in the camp.

The Dutch, in contrast, were having quite the party, breezing through the two group stages unbeaten, scoring 14 goals in six matches and conceding just once in the process. The "Total Football" insisted upon by manager Rinus Michels was met with rave reviews, and, although the head coach was a perfectionist on the pitch, he had a distinctly *laissez-faire* attitude to what his players got up to off it. The Dutch were enjoying their football and free time in equal measure, leading, on one occasion, to lurid tabloid headlines detailing alleged naked pool parties in the company of local girls.

It was nothing more than a temporary distraction, though, and, as West Germany and the Netherlands took to the Olympiastadion pitch on 7 July for the final, the Oranje were justifiably confident of success.

There was, however, the small matter of the missing corner flags to be dealt with. Eagle-eyed English referee Jack Taylor had realised the flags were conspicuous by their absence, and the 77,833 in the stadium, not to mention the millions in front of televisions around the world, had to wait impatiently for a delayed kickoff as a member of the ground staff was hastily dispatched to locate them.

○○○
Left: West Germany's Sepp Maier was the tournament's standout goalkeeper in the 1974 World Cup.

○○○
Above: (Top) Netherlands skipper Johan Cruyff takes issue with referee Jack Taylor during the 1974 World Cup final. (Bottom) The kick-off in the final was delayed when Taylor realised the corner flags were missing.

> "We prepared to toss the coin with Franz Beckenbauer and Johan Cruyff and it was noticed that there were no corner flags. Can you imagine that happening now?"
>
> JACK TAYLOR

TAYLOR ON THE SPOT – TWICE

1974

The 1974 FIFA World Cup final began in spectacular and historic fashion when referee Jack Taylor awarded a penalty for the first time in the tournament's showpiece game. The Dutch converted from the spot for an early lead but, defying the pre-match predictions, West Germany fought back in Munich to claim football's most coveted prize.

The largely partisan 77,833-strong crowd inside the Olympiastadion for the final knew all about the threat the Netherlands (the Oranje) posed. Their "Total Football" starved the opposition of possession and German supporters were conscious that without the ball their team could be fatally on the back foot.

Their fears, however, were realised earlier than they could have dared imagine. The Oranje kicked off and, after a stylish 17-pass move, and with only a minute on the clock, the visitors were awarded a penalty after Johann Cruyff ghosted past Berti Vogts and was brought down in the area by Uli Hoeness. No German player had yet touched the ball and, after Johan Neeskens stepped forward to beat Sepp Maier with the resulting spot kick, the Dutch led 1–0.

Rinus Michels's side continued to toy with Die Mannschaft seemingly at will for the next 20 minutes, but the momentum suddenly shifted when Taylor pointed to the penalty spot for a second time. This time it was in Germany's favour after Wim Jansen was adjudged to have fouled the galloping Bernd Hölzenbein, and, as Neeskens had done earlier in the game, Paul Breitner held his nerve from 12 yards and, against the run of play, Helmut Schön's side were on level terms.

The goal rocked the previously impervious Dutch confidence and the hosts grew in stature as a result. The anticipated Oranje procession had become a genuine battle and, just before half-time, the Germans delivered what proved to be the knockout blow.

There was something distinctly Dutch about what proved to be the winner. Maier rolled the ball out from the back, Germany casually worked the ball to halfway and, out of nowhere, Jürgen Grabowski surged down the right wing. His cross found Gerd Müller and, although Der Bomber's first touch left the ball behind him, he reacted superbly and beat Jan Jongbloed with a low drive on the turn.

The Netherlands could find no way back in the second half, and West German captain Franz Beckenbauer became the first man to lift the new FIFA World Cup Trophy.

"The Dutch really were the best team at the tournament. But they were arrogant. They went into the lead and thought they'd easily get three or four. The two countries could barely stand each other. They wanted to show us up a bit but they didn't succeed."

SEPP MAIER

Left: The winner's medal collected by coach Helmut Schön after West Germany won the 1974 World Cup final against the Netherlands.

Above: West Germany's triumph in the final in Munich was the fourth time the host nation had been crowned champions.

DER BOMBER CALLS IT A DAY

1974

West Germany's victory over the Netherlands saw Die Mannschaft join an exclusive club alongside Uruguay, Italy and Brazil as multiple World Cup winners. The great and the good of German football were in Munich to savour the triumph, a match that also brought down the curtain on Gerd Müller's prolific, record-breaking international career.

It was particularly fitting that Fritz Walter, the man who had captained West Germany to victory in the 1954 World Cup final, was inside the Olympiastadion on 7 July 1974, to witness a new generation of German players crowned world champions.

Sitting in the stands, the 53-year-old would surely have approved of the tenacity displayed by Helmut Schön's team in Munich, while the parallels between his own side's victory against tournament favourites Hungary in Bern in 1954 and, two decades later, another final upset in Die Mannschaft's favour cannot have escaped him. West Germany had now twice ripped up the formbook on the game's greatest stage.

The post-match celebrations were merely intensified with the news that the hosts had lifted a second cup – the FIFA Fair Play Trophy, which had been inaugurated at the

> "Gerd Müller was a phenomenon. Thank God he played for the German national team. Without him, I don't think we would have won the World Cup. He understood better than anybody how to score goals."
>
> FRANZ BECKENBAUER

1970 tournament in Mexico – but there was one cloud in the sky and it was the news that Müller had played his last match for his country.

Der Bomber was still only 28 years old when he decided to hang up his boots. His winner against the Dutch in the final was his 68th goal in 62 internationals and he left a legacy as one of the most lethal and prolific strikers produced by any era.

His ten goals in the 1970 World Cup in Mexico earned him the coveted Golden Boot and he remains one of only three players in the history of the competition to have claimed the award with a double-figure haul. His four goals on home soil in 1974 took him to 14 tournament strikes, a proud record that stood for 32 years.

It was finally eclipsed by the Brazilian Ronaldo in 2006, ironically in Germany, when he netted his 15th World Cup goal. Müller's compatriot, Miroslav Klose, extended the milestone mark to 16 in Brazil in 2014, when he was target in the 7–1 demolition of the Seleção in the semi-finals.

To put Der Bomber's feat in proper context, however, it is worth remembering his 14 World Cup finals goals came in just 13 matches. Ronaldo played in 19 finals games for his 15 goals, while Klose made 24 World Cup appearances for his 16 tallies. Müller's strike-rate, however, is trumped by Frenchman Just Fontaine's 13 goals in six games in 1958.

○○○

Above: The ticket for the 1974 World Cup final, signed by Pelé, presented by the German FA to Fritz Walter, the 1954 World Cup-winning captain.

Left: Gerd Müller's status as a national hero in West Germany was assured after his 68th goal, in his 62nd appearance, won the 1974 World Cup.

Argentina '78

XI Campeonato Mundial de Fútbol

Junio 1978

**Buenos Aires
Cordoba
Mar del Plata
Mendoza
Rosario**

THE 1978 FIFA WORLD CUP

Argentina assumed hosting duties for the 1978 FIFA World Cup finals, the first one staged in South America for 16 years. The tournament was plagued by controversy, beginning before the opening game between West Germany and Poland kicked off, and continuing all the way through the finals.

MILITARY MANOEUVRES OUTFLANK FIFA

1978

Football's governing body awarded the 1978 World Cup finals to Argentina in 1966. Two years before the tournament, however, the country was rocked by a *coup d'état* that brutally enforced military rule and there quickly followed widespread and impassioned calls for FIFA to take the competition elsewhere.

Argentina became a military dictatorship on 24 March 1976, when General Jorge Videla led a successful coup against the elected government of President Isabel Perón. The country was plunged into turmoil and Videla's regime abducted and murdered thousands in a bid to strengthen its grip on power.

The events left FIFA with an unenviable dilemma. The Netherlands, supported by West Germany and Italy, called for a boycott on the grounds of conscience but it was too late in the day to relocate a tournament with such significant logistical requirements. Videla poured millions into ensuring the six stadia that were part of the Argentinian bid were ready for the World Cup and, with a thinly disguised sense of trepidation, FIFA decided to press ahead as planned.

Sixteen teams duly gathered in Buenos Aries and Córdoba, Mendoza, Mar del Plata and Rosario in the summer of 1978. For the first time more than 100 countries had entered the qualifying competition and, for the second tournament in succession, former champions England failed to reach the finals. The competition did welcome two newcomers in the shape of Iran and Tunisia and, despite the unpalatable political backdrop, the 11th World Cup was ready for launch.

There were to be no big shocks in terms of the eight teams who progressed to the second group stage, but were some notable events from the first round.

In Group 2, debutants Tunisia were expected to do little more than make up the numbers, but the Eagles of Carthage refused to be overawed by their unfamiliar surroundings and upset Mexico 3–1 in Rosario before holding reigning

Above: The front page of the official 1978 World Cup programme. It was the first time the finals had been staged in South America for 16 years.

Right: A selection of official player ID photos supplied by the Argentinean FA to FIFA ahead of the 1978 finals.

champions West Germany to a goalless draw at the Estadio Olímpico Chateau Carreras in Córdoba.

Group 3 witnessed a strange and controversial decision at the climax of Brazil's clash with Sweden. The game was deadlocked at 1-1 in second-half injury time, when Zico thought he had scored the winner from a corner with a header, but his joy quickly turned to disbelief when Welsh official Clive Thomas indicated he had blown for full time before Zico reached the ball and the goal was disallowed. In his defence, the referee observed Brazil had dithered for a significant period before finally taking the corner.

One of the most iconic of World Cup goals was scored in Group 4 in the meeting between Scotland and the Netherlands in Mendoza, Scottish midfielder Archie Gemmill beating three bemused Dutch defenders – the third with an outrageous nutmeg – en route to a mesmeric score. Scotland famously won 3-2 against the 1974 finalists but missed out on the second round on goal difference.

EL FLACO FAILS TO FLY

1978

For the second World Cup in succession, the Netherlands glided their way through to the final in Argentina in 1978. They did it however without the elegant influence of Johann Cruyff, the former captain's conspicuous absence from the tournament remaining a mystery for the next 30 years.

The world already knew "El Flaco" would not be getting off the Dutch plane when it landed in Buenos Aries in the summer of 1978. Cruyff's name was nowhere to be seen when manager Rinus Michels had announced his 22-man squad for the finals and the Netherlands were forced to look towards to the tournament shorn of the talents of their mercurial Number 14.

It is impossible to overstate Cruyff's importance to the team. In the 1974 tournament the Dutch FA had acknowledged this when it agreed to let the great man wear a specially modified shirt. The rest of the team wore Adidas shirts with the company's trademark three stripes in West Germany, but Cruyff sported a top with only two parallel lines because he was sponsored by rival Puma and he did not wish to upset the company.

Neither Michels nor the great man himself offered a public explanation for his absence in Argentina. He had played a characteristically influential and stylish part in the Oranje's successful qualification campaign and, although he was 31 years old when the finals kicked off, he continued playing club football for another six years, finally retiring in 1984 after winning the Eredivisie – the Dutch league title – with Feyenoord. This, in itself, was noteworthy because Cruyff had risen to fame playing for the Rotterdam club's biggest and most bitter rivals, Ajax of Amsterdam.

The void created by the lack of information inevitably led to speculation by the media and supporters alike. Many jumped to the conclusion that Cruyff's decision not to travel was in protest at the rule of Jorge Videla's military junta, and, with no one to refute the theory, it gained a degree of credibility. His no-show was on a matter of political principle.

However, 30 years later, Cruyff revealed the real reason for not taking the opportunity to play in a second successive finals. In 1977, when he was playing for Barcelona, Cruyff, his wife and his three children were the victims of an attempted armed kidnapping at their home in the Catalan capital. Cruyff managed to escape, raise the alarm and ultimately foil the attempt, but the ordeal was deeply traumatic and, in the months that followed, police were constantly stationed outside the family home and his children went to school accompanied by bodyguards.

El Flaco's decision not to fly to Argentina in 1978, then, was a deeply personal rather than political one, putting his family firmly before his football.

> "They put a gun to my head, my wife was tied up and our children were forced to watch it all. It was the moment to leave football and I couldn't play in the World Cup after this."
>
> JOHAN CRUYFF

Left: *The 1978 World Cup was poorer for the absence of Dutch superstar Johann Cruyff, who scored twice against Argentina in 1974.*

Above: *The 1978 Netherlands team, minus Cruyff. Three players kept his legacy by wearing two stripes on their shirt-sleeves, as Cruyff had in 1974.*

RONNIE'S RENDEZVOUS AT THE CASA ROSADA

1978

FIFA desperately hoped football and politics would be kept firmly apart during the 1974 finals given events two years earlier in Argentina. The governing body were doubtless disappointed, then, when three members of the Sweden squad became publicly embroiled in a controversial local issue in Buenos Aries.

The years between 1976 and 1993 are a period in the Argentinian history known as the "Dirty War". Thousands of alleged dissidents disappeared under the military dictatorship, never to return to their families, and it proved a constant source of conflict between the authorities and those affected.

One particularly vocal group who refused to let the actions of the regime go unchallenged were the Mothers of the Plaza de Mayo, who, outraged at the disappearance of their loved ones, began protesting outside the Casa Rosada presidential palace in Buenos Aries in defiance of the military junta.

They did not let the arrival of the World Cup disrupt their plans, and so it was that in 1978 they were joined by three players who, whether unwittingly or not, helped generate worldwide publicity for the cause.

The trio were Swedish goalkeeper Ronnie Hellström and his teammates Roy Andersson and Roland Andersson. According to French newspaper *Le Monde*, the threesome were spotted in the Plaza de Mayo in the Argentinian capital with the protestors and the story implied that they were there in explicit support of the demonstrators.

With the world's media in the country for the tournament, it was the kind of coverage neither the regime nor FIFA wanted, but *Le Monde* ran the story regardless, and the Mothers of the Plaza de Mayo had communicated the grievances to a wider audience.

The plot thickened some years later when an Argentinian journalist wrote an article in which he claimed Hellström had told a colleague he had never been at the protests against human-rights violations. The story, he insisted, was a myth.

Whatever the truth, the article in *Le Monde* was manna from heaven for the protestors and an acute embarrassment to the authorities, who were already under pressure from Amnesty International and other pressure groups.

Hellström's stay in Argentina, meanwhile, was not a prolonged one. The FC Kaiserslautern keeper was in typically belligerent form in the tournament, conceding just three goals in three first-round Group 1 games, but Sweden were unable to win any of them, finished bottom of the group behind Austria, Brazil and Spain and were on the next plane home to Scandinavia.

○○○
Above: *The "Mothers of the Plaza de Mayo" were vocal opponents of Argentina's military dictatorship and demonstrated vociferously during the 1978 World Cup, an eventuality which almost landed the Swedes in some trouble.*

Left: *Sweden goalkeeper Ronnie Hellström made as big an impact off the pitch as on it during the 1978 finals in Argentina.*

BRAZIL ROBBED IN ROSARIO

1978

Hosts Argentina prepared for their final second-round group fixture against Peru knowing only a handsome victory would secure their place in the 1978 World Cup final. La Albiceleste emerged 6–0 victors, but, even as the whistle for full time sounded, dissenting voices began questioning the authenticity of the result.

The second group phase of the tournament threw up a curious state of affairs. Four of the five European countries in the last eight found themselves drawn together in Group A, while South America's three qualifiiers – Argentina, Brazil and Peru – were paired in Group B, alongside Poland.

The battle between arch-rivals Argentina and Brazil was predictably fierce. The Seleção and La Albiceleste both took maximum points from their opening fixtures, Argentina beating Poland 2–0 and Brazil hitting three without reply against Peru. Poland's 1–0 victory over Peru ended La Blanquirroja's final hopes and Brazil and Argentina's goalless stalemate meant the finalists and third-place play-off teams would be decided in the final round of matches.

It was at this point that the seeds of suspicion over what would unfold were sown. All four of the final round of group matches were on 21 June. Both Group A games kicked-off at 1.45 pm, when the Netherlands sealed a place in the final and Italy a berth in the third-place play-off.

132

> "With what I know now, I can't say I'm proud of my victory. But I didn't realize, most of us didn't. We just played football. In hindsight, we should never have played that World Cup. I strongly believe that."

ARGENTINA'S LEOPOLDO LUQUE

However, the schedule for Group B had Brazil playing Poland in Mendoza at 4.45 pm – a match the Seleção won 3-1 – but Argentina did not kick-off against Peru, in Rosario, until 7.15 pm. Brazil's result meant La Albiceleste knew they had to win by at least four goals to edge out the Seleção on goal difference.

Knowledge, of course, is power; Argentina led 2-0 at half-time, made it 4-0 by the 50th minute and went on to win 6-0 and thus reach the World Cup final.

○○○

Above: Americo Gallego (No. 6) and Jorge Olguin (15) celebrate the fourth Argentina goal against Peru at Rosario's Estadio Gigante de Arroyito.

Left: Rain-soaked and dejected Brazilian supporters learn the news of Argentina's 6-0 victory over Peru to end the Seleção's final dreams.

For many, however, there was unease aurrounding the way the game had played out and dark mutterings about a possible "fix" were soon aired. Although a Peruvian politician alleged there had been a fix, at government level, this did not come out for 34 years. What is not in doubt is that Argentina would have been clear favourites to win the match under any circumstances. Peru's loss to Poland on 18 June meant they could not finish better than third in the group, so they had little to play for, but Argentina had the ultimate prize within their grasp.

Irrespective of what happened in Rosario, FIFA ruled that the circumstances were not acceptable and they brought a new regulation for four-team groups. From now on, the last round of fixtures in any group would always kick-off simultaneously, so no team could have an advantage.

KEMPES DOUBLE OUTGUNS THE ORANJE

1978

The 1978 FIFA World Cup was not a tournament bereft of incident on and off the pitch, and the day of the final in Buenos Aries was no exception as the hosts Argentina entertained the Netherlands. The big day began inauspiciously for the Dutch and then got steadily worse.

The Netherlands' journey to the River Plate Stadium for the final was not a smooth one. The team bus, taking them from their hotel outside Buenos Aries, was brought to a forcible halt en route by a crowd of rowdy Argentinian supporters and, for 20 minutes, the players had to endure the mob banging on the windows.

They eventually escaped unscathed, but inside the stadium more local hospitality awaited them in the form of the Argentina team, who moments before kickoff controversially protested to the Italian referee Sergio Gonella about the plaster cast worn by winger René van de Kerkhof.

Left: The 1978 World Cup final match ball, the "Tango Rosario" was the third made by Adidas for World Cup finals tournaments.

Right: René van de Kerkhof's plaster cast was the subject of much debate before the kick-off in the 1978 World Cup final.

The PSV player had been sporting the protection since he had injured his arm in the Oranje's first-round opener against Iran. FIFA had made no objection to his adornment but La Albiceleste seemed determined to unsettle the opposition by any means possible, and noisily argued that the cast was illegal. The Netherlands responded by threatening to refuse to play if van de Kerkhof was forced to remove it, or was not allowed to take part. An awkward compromise was finally struck when the winger applied an extra layer of bandages over the offending item.

The delay and febrile atmosphere initially played right into Argentina's hands and, the hosts took the lead in the 38th minute through leading scorer Mario Kempes. The Oranje regrouped and levelled with an 82nd-minute goal from substitute Dick Nanninga. Then, in injury time, they had a golden opportunity to win the match. Skipper Ruud Krol delivered the long free kick and Rob Rensenbrink stuck out an outstretched leg, but his instinctive effort hit the post and rebounded to safety.

The Netherlands' big chance had gone and in extra time La Albiceleste regained the ascendancy. Kempes was on target again moments before the end of the first period to make it 2–1 and, five minutes from time, right wing Daniel Bertoni put the result beyond any reasonable doubt when he beat Jan Jongbloed.

Argentina were the world champions for the first time, while the dismayed Dutch were left to contemplate defeat in the final for the second time in four years.

> **"Of course we felt the referee was not with us, that's for sure. Everybody knew that on the field."**
>
> NETHERLANDS CAPTAIN RUUD KROL

PASSARELLA'S FIRST WINNER'S MEDAL

1978

Argentina's triumph over the Netherlands in the River Plate Stadium saw the World Cup hosts crowned champions for the second tournament in succession and third time in four editions. The result proved to be a catalyst for contrasting fortunes for the protagonists over the next decade as La Albiceleste prospered while the Dutch descended into the doldrums.

Given their calculated antics before kickoff in the final, there was a certain sense of irony that Argentina were awarded the FIFA Fair Play award at the end of the tournament. La Albiceleste had another trophy to add to their collection and, when skipper Daniel Passarella collected the World Cup from dictator Jorge Videla, who was eager to extract as much propaganda capital from the proceedings as possible, a nationwide party erupted.

The undisputed hero of the hour was Mario Kempes, the only member of the squad in 1978 to play his club football outside Argentina. Despite not scoring in the team's three first-round games, his two goals in the final took his tally for the tournament to six and the Valencia striker was the recipient of the Golden Boot for his exploits.

Captain Passarella also became a national icon in the wake of the final. The River Plate, Fiorentina and Internazionale centre-back led the side again at the 1982 World Cup in Spain, and, although his involvement at the 1986 finals in Mexico was limited to the bench, he nonetheless collected a second winner's medal after victory over West Germany in the final.

Five of Argentina's starting XI from 1978 went on to forge managerial careers, but it was Passarella who enjoyed the greatest success in the dugout, coaching both the Argentina and Uruguay national teams as well as his old club River Plate.

Chastened by their unpleasant experience trying to get to the River Plate Stadium for the final, the Netherlands declined another coach trip across Buenos Aries to attend the post-match dinner and dejectedly flew home the next

○○○

Above: *A commemorative metal lapel badge from the 1978 finals when Argentina joined Brazil and Uruguay as South American World Cup winners.*

Right: *Daniel Passarella embarked on a successful managerial career after captaining Argentina to glory on home soil in 1978.*

day. Had Rob Resenbrink's injury-time effort gone in, they would have been champions, but instead they had fallen at the final hurdle for a second successive time.

The team's renowned coach, Ernst Happel, stood down shortly after the tournament and the 1978 World Cup, sounding something of a death knell for "Total Football". There were other factors, not least the absence of Johan Cruyff. The squad's age was another issue; all but two of the 1978 final starting 11 were past 30 by the 1982 World Cup.

The Netherlands failed to qualify for either the 1982 or 1986 finals but they emerged as a genuine force again in the late 1980s when the new Oranje generation of stars, including Marco van Basten, Ruud Gullit and Frank Rijkaard, won the 1988 UEFA European Championship.

> "If the trajectory of my shot had been five centimetres different, we would have been world champions. On top of that, I would have been crowned top scorer."
>
> **ROB RENSENBRINK**

COPA DEL MUNDO DE FUTBOL ESPAÑA 82

THE 1982 FIFA WORLD CUP

A significantly expanded tournament featuring 24 rather than the traditional 16 finalists of previous years, the 1982 FIFA World Cup saw Italy reign in Spain after beating West Germany in the final. The Azzurri were only the second nation after Brazil to become three-times world champions.

ANIMOSITY IN THE ATLANTIC

1982

FIFA promised a bigger, brighter World Cup in 1982 with eight additional nations joining the global football party in Spain. Unfortunately, the build-up to the revamped tournament was overshadowed by non-football events thousands of miles away in the South Atlantic Ocean.

The outbreak of the Falklands War in early April 1982 presented FIFA with a major diplomatic headache. The hostilities between the United Kingdom and Argentina may have been conducted a long way from Spain, but the repercussions were widespread, and it was only the day after the tournament kicked off at the Nou Camp in Barcelona that the conflict came to an end.

England, Northern Ireland and Scotland had already qualified for the finals, but considered boycotting the World Cup in protest at Argentina's invasion of the islands. FIFA had flatly refused to eject La Albiceleste from the tournament and it was only when the UK Prime Minister Margaret Thatcher was cautioned that a British boycott would present Argentina with greater propaganda potential than if they played that the three teams confirmed their attendance. Significantly, it meant England's World Cup absence, which had begun when they failed to reach the 1974 finals, would not be prolonged for another four years.

The British trio of teams joined a much-changed competition. The swelling of the group stage ranks to 24 certainly engendered a sense of renewal and the tournament boasted five debutants, with Algeria, Cameroon, Honduras, Kuwait and New Zealand all making their first appearances in the finals.

To accommodate 24 teams, there were six groups of four in the first round, with the top two advancing to the second-round phase. This stage comprised four groups of three teams but, unlike the 1978 tournament, only the group winners advanced. Once again, the semi-finals were the first knockout matches.

The first group stage was awash with shocks and milestones. In Group 3, El Salvador earned the dubious distinction of becoming the first team in World Cup history to concede double figures when they were dismantled 10–1 by Hungary in Elche. It was a one-sided fixture in which Hungary striker László Kiss also wrote his own name into the tournament record books with a hat-trick in only seven second-half minutes. It remains the quickest treble ever in the finals.

In Group 2, meanwhile, Algeria paid scant regard to reputation or pedigree with a 2–1 defeat of West Germany in Gijón, while in Group 4, Bryan Robson was on target for England against France in Bilbao after only 27 seconds. It was the World Cup's fastest goal until Hakan Sükür netted after 11 seconds for Turkey against South Korea in 2002.

The final record to fall went to Northern Ireland's Norman Whiteside when he appeared in the match against Yugoslavia in Group 5. He was the tender age of 17 years and 41 days, and thus eclipsed Pelé as the tournament's youngest-ever player.

> "Argentina would see British withdrawal not as putting any pressure on them but as an opportunity to make propaganda. The United Kingdom, not Argentina, would be the country set apart."
>
> CABINET SECRETARY ROBERT ARMSTRONG

Left: Hungary striker László Kiss's seven-minute hat-trick against El Salvador was the fastest ever and the first World Cup hat-trick for a substitute.

Above: Commemorative postcards featuring three of the 12 stadiums used in 1982 for a tournament which had swelled from 16 to 24 teams.

THE DISGRACE OF GIJÓN

(1982)

West Germany and Austria went into their final fixture in Gijón in the knowledge that a one or two-goal victory for Die Mannschaft would ensure both sides qualified for the next round and eliminate Algeria. The events that unfolded inside El Molinón were 90 of the darkest minutes in World Cup history.

West Germany's 2-1 reverse against Algeria in their Group 2 opener still ranks as one of the World Cup's greatest upsets. The North Africans had never sampled finals football before and their improbable victory still resonates in a country that had declared independence from France only 20 years earlier.

From a contemporary perspective, however, the result was hugely significant because it gave the Africans genuine hope of progressing through to the second round. Algeria lost to Austria next time out but beat Chile 3-2 in their third and last game, and, when West Germany took to the field 24 hours later, they knew they had to win to avoid an ignominious early exit from the tournament.

No one has ever conclusively proved that the Germans and Austrians colluded to ensure they produced a favourable result in Gijón, but the suspicion that that is exactly what transpired has never diminished after Die Mannschaft emerged 1-0 winners to leave the Algerians heartbroken.

The only goal of the infamous game came in the tenth minute, when Hamburg striker Horst Hrubesch pierced the Austrian defence; but, from the moment the ball rippled the net, a sudden and suspicious apathy seemed to descend on proceedings as both teams walked their way through the remaining 80 minutes.

The crowd certainly believed it was a stitch-up. The Spanish contingent screamed, "Out! Out!" in protest, while Algerian supporters waved banknotes at the players. One German fan joined the chorus of disapproval and burned the national flag.

The dismay was shared by the assembled media at the game. One German commentator, Eberhard Stanjek, refused to describe any more of the action to convey his disgust at what he was seeing, while an Austrian counterpart, Robert Seeger, urged his own viewers to switch off. A local Spanish newspaper printed its match report the following day in the crime section.

The Algerian FA protested to FIFA but the game's governing body refused to overturn the result. West Germany went through and the Algerians went home.

It was little solace to the Africans when FIFA subsequently ruled that the final group matches at all future tournaments would kick-off simultaneously to avoid a repeat of what became bitterly known as the "Disgrace of Gijón" and a similar situation, four years earlier, when hosts Argentina beat Peru 6-0 to reach the semi-finals.

> "(These are) quality players who should all be in the book of referee Bob Valentine for bringing the game into disrepute. This is one of the most disgraceful international matches I've ever seen."
>
> ITV COMMENTATOR HUGH JOHNS

○○○
Left: "Naranjito", the official mascot of the 1982 finals, had little to smile about after West Germany's infamous 1–0 victory over Austria in Gijón.

Above: Outraged Algerian supporters wave banknotes in the direction of West German and Austrian players after their team was eliminated.

SOLIDARITY IN CATALONIA

1982

At its best, football can be a unifying force and the beautiful game's ability to bring people together was very much in evidence at the 1982 FIFA World Cup, when Poland faced the Soviet Union in Barcelona in an emotional second-round clash.

In the early 1980s Poland was still in the grips of the hardline Communist regime that had been established in the country in 1947. Warsaw lived in the shadow of the Kremlin and, from the moment it became clear that Poland and the USSR would face each other in Spain, it was a fixture that went beyond mere sport.

Tensions in Poland had been heightened since the anti-Soviet trade union Solidarity had been formed in the shipyards of Gdansk in late 1980. Its leader, Lech Walesa, had become a symbol of national resistance and the calls for Polish independence from the Soviets gathered momentum as the months went by.

It was then a strange but serendipitous quirk of fate that the match between Poland and the Soviet Union was played at the Nou Camp in Barcelona, the capital of Catalonia and the epicentre for the Catalans' own calls for independence from Spain. Poland were playing in a spiritual home from home.

The predominantly Spanish crowd who assembled for the game chose to demonstrate their empathy for the

Poles in the form of half a dozen enormous banners. They featured the red and white stripes of the Polish flag and were emblazoned with the word "Solidarnosc", the Polish for Solidarity. In the centre was the unmistakable red and yellow of Catalonia's own flag.

A group of around 600 Polish supporters were inside the Nou Camp, vociferously chanting "Polska, Polska" throughout the match, but it was the Spanish fans shouting "Polonia" – the Catalan for Poland – that electrified the atmosphere in Barcelona.

This, of course, was played out in front of a television audience counted in the millions and at some stage the powers-that-be decided they were not comfortable with the politicisation of proceedings, and, midway through the second half, police were dispatched to confiscate the biggest, most prominent Solidarnosc flag. The stadium reverberated with boos and whistles.

On the pitch there was little to choose between the two teams, and the Group A encounter finished goalless. It was a result, however, that gave Poland cause to celebrate because it was enough to ensure that they progressed to the semi-finals for the second time in their history, and at the expense of the Soviet Union, courtesy of their superior goal difference.

○○○

Above: Oleg Blokhin (left) and Poland's Janusz Kupcewicz contest possession during the Soviet Union's goalless draw with the Poles.

Left: Catalan fans with their "Solidarity" banner – and their national flag also prominent – in front of a television audience counted in the millions.

SAVAGERY IN SEVILLE

1982

The 1982 World Cup semi-final between West Germany and France in Seville was an undisputed thriller, yielding six goals and a dramatic penalty shootout, but it is remembered first and foremost for one of the most infamous challenges – in the eyes of the referee, no foul was committed – in tournament history.

A crowd of 70,000 gathered in the Ramón Sánchez Pizjuán Stadium in Seville to watch the last-four encounter between two of the heavyweights of European football. It was a match that promised much, but the despite the assembled talents of Michel Platini and Felix Magath, Jean Tigana and Pierre Littbarski, it left a bitter taste in the mouth of the French team and supporters.

The villain of the piece was German goalkeeper Harald Schumacher and the victim was France's Patrick Battiston, a 50th-minute second-half substitute in Seville.

Battiston had been on the pitch for just seven minutes, the match tantalisingly level at 1–1, when he charged ahead in an attempt to latch onto a pass from Platini. He outpaced the German defence and was through on goal, with only the onrushing Schumacher to beat. The Frenchman was first to the ball but skewed his effort wide.

What happened next was sickening. Schumacher jumped in the air, twisting his body, and collided with Battiston. The Frenchman took the full weight of the challenge in the face and hit the ground unconscious. He immediately slipped into a coma; medics had to administer oxygen on the pitch and his team-mates thought he was dead. "He had no pulse," said Platini, "and he looked pale."

Incredibly, the referee, Dutchman Charles Corver, decided to take no action. He did not show Schumacher a yellow card or even consider the incident to be a foul, so once Battiston had been stretchered off, the game continued as if nothing had happened.

The damage to Battiston was as enduring as the incident was detrimental to France's hopes of reaching the final. He sustained a cracked vertebra in his neck, three broken ribs, lost a number of teeth and still suffers from persistent back pain as a result.

Les Bleus eventually succumbed 5–4 on penalties. When Christian Lopez was hastily brought on to replace Battiston, France had used up their quota of two substitutions and had to play the remaining 63 minutes without the option of introducing fresh legs. That Schumacher was still on the pitch for the penalty shootout that followed only heightened the sense of French outrage.

To complete the injustice the goalkeeper saved Maxime Bossis's spot kick – Horst Hrubesch subsequently scoring to send West Germany into the final – and France had only the consolation of a third-place play-off against Poland to look forward to.

○○○

Left: *Three teeth lost by France's Patrick Battiston after West German goalkeeper Harald Schumacher's reckless, unpunished challenge.*

Right: *The moment of contact between Battiston and Schumacher. Battiston was on his way to hospital when Schumacher and West Germany won a penalty shoot-out to reach the 1982 World Cup final.*

"I thought he was very hyped up, very excitable. All I know is that Schumacher was someone who wanted to win at all costs and he went way over the top that evening."

PATRICK BATTISTON

THREE GOALS, THREE WORLD CUPS

1982

Captained by veteran goalkeeper Dino Zoff, Italy went into the 1982 World Cup final hoping to lift the trophy for the first time since 1938. Those hopes were realised as the Azzurri became world champions for a third time with a dominant display against West Germany in Madrid.

The momentum was undeniably with the Azzurri as they prepared to cross swords with Die Mannschaft in the Estadio Santiago Bernabéu. Enzo Bearzot's side may have limped through the early stages of the tournament with three uninspiring first round draws, but victories over both Brazil and Argentina in the second phase and their 2-0 triumph in the semi-final over Poland underlined that Italy were a force to be reckoned with.

In contrast, West Germany's progress to the final had been far from serene. Their shock loss to Algeria in their tournament opener was followed by unconvincing displays against Spain and England in the second round, and their penalty shootout victory over France in the last four could have easily gone the other way. Jupp Derwall's team had stumbled rather than strode into the competition's showpiece game.

The final bore out the two teams' contrasting form. The first half in Madrid finished goalless as Italy contrived to reprieve their opponents when Antonio Cabrini fired wide from the penalty spot, but the Azzurri were not as profligate in the second period.

Their first goal came in the 57th minute, Paolo Rossi heading home from close range from a Claudio Gentile cross from the right. They doubled their advantage 12 minutes later, when Marco Tardelli found the back of the net with a fiercely struck, left-footed effort from the edge of the area. Tardelli's manic celebrations in the wake of his goal remains one of the most iconic images in World Cup history.

Any hopes of a West German fightback were extinguished nine minutes from the end, when Italy launched an incisive counterattack, and substitute Alessandro Altobelli was on hand to finish the incursion, beating Harald Schumacher with a low, left-footed shot.

There was time enough for Derwall's side to salvage a degree of pride, Paul Breitner scoring in the 83rd minute with an angled drive, but it was no more than a consolation. It also did nothing to diminish the joy for Italian players and fans when the full-time whistle sounded in the Bernabéu.

The Azzurri's 3-1 victory had finally ended their 44-year wait to complete a hat-trick of World Cup triumphs and saw them join Brazil as three-times world champions.

ooo

Above: The official 1982 World Cup finals programme, a tournament which climaxed with Italy's first triumph in 44 years

Right: Marco Tardelli's almost demonic celebration of his goal – Italy's second in the final – is one of the most iconic images of the World Cup.

THE REDEMPTION OF ROSSI

1982

Paolo Rossi's goal in the 1982 World Cup final took his tally in the tournament to six and earned him the Golden Boot award ahead of Germany's Karl-Heinz Rummenigge. His success in Spain represented a miraculous reversal in fortunes for the controversial Juventus striker.

When manager Enzo Bearzot announced his squad for the 1982 World Cup finals, the Italian media and supporters alike were stunned to see Rossi's name among the 22 Azzurri players selected for the tournament. The 26-year-old forward was nothing if not a divisive figure.

The national sense of surprise was the result of an infamous betting scandal that had rocked Italian football two years earlier known as the "Totonero affair". The scandal had seen attempts to fix Serie A and B games and, when it was uncovered, the repercussions were swift and far-reaching. AC Milan and Lazio were both relegated as punishment for their role in the affair. Other clubs were deducted a total of 25 points for their complicity, while individual players were banned for a combined 50 years for their part in Totonero.

The highest-profile victim of the investigation was Rossi, who was banned for three years. He protested his innocence but the Italian FA were not initially listening, and for two years the striker did not kick a ball in anger.

In 1982, however, his suspension was shortened by 12 months and, with the World Cup looming, he returned to the fray with Juventus and made three appearances for the club at the end of the 1981–82 campaign. It was a brief and unspectacular comeback, but Bearzot nonetheless decided Rossi was worth a gamble and he was on the plane to Spain.

The striker's tepid performances in the Azzurri's three first-round games – *La Gazzetta dello Sport* newspaper describing him as a ghost aimlessly drifting around the pitch – suggested his manager had made a grave error of judgement, but Rossi was determined to repay Bearzot's faith and he exploded into life in the latter stages of the tournament.

His sensational second-round hat-trick against Brazil in Barcelona ensured Italy topped Group C and progressed to the semi-finals at the expense of the three-times champions, while his brace in the last four against Poland in the Nou Camp was equally pivotal.

His opening goal in the final against West Germany displayed all his predatory instincts inside the box, heading home from close range, and earned him at the same time redemption and the Golden Boot. He was the first Italian player to claim the award.

Above: Soaking up the applause during the lap of honour, Paolo Rossi hold the World Cup trophy aloft in celebration.

Right: Paolo Rossi repaid the faith of coach Enzo Bearzot by scoring six goals in the 1982 World Cup, including Italy's first in their 3–1 final victory.

"It was a great feeling to know that we had made millions of people happy. I always wore the Azzurri shirt with a strong sense of belonging. I would even have played with just one leg"

PAOLO ROSSI

MEXICO 86

THE 1986 FIFA WORLD CUP

World Cup football returned to Mexico just 16 years after the Central American country had last staged the tournament. For the second time in eight years, Argentina were crowned world champions, their triumph built on the genius – and skulduggery – of inspirational captain Diego Maradona.

FIFA OPT FOR PLAN B

1986

Colombia were originally selected as the hosts for the 1986 World Cup but, four years before the finals, the South Americans reluctantly informed FIFA they could not stage the tournament, sparking a fierce battle between Mexico and the United States for the right to host the competition.

The summer of 1974 was a watershed moment for Colombian football. After a meeting of the FIFA Executive Committee in Frankfurt in June, it was announced the country had been chosen to host the World Cup, and, for the fifth time in the tournament's history, the eyes of the world would be fixed firmly on South America.

Colombia celebrated the news wildly, but all parties must inevitably come to an end and, when the euphoria subsided, reality dawned and the organisers realised the country's dire financial situation meant they could not afford to welcome the world. There was not enough money in the coffers to build the promised new stadia and the brainchild of former president Misael Pastrana Borrero was no more.

FIFA was officially told the bad news in November 1982 and, with less than four years' grace, the search for a new host hurriedly began. Three countries – Canada, Mexico and the United States – expressed an interest in replacing Colombia, but it was essentially a two-horse race for the finals between the Mexicans and the USA.

The United States was desperate to stage the competition for the first time and, when it dispatched delegates to lobby FIFA at a meeting in Stockholm in 1983, their number included the former Secretary of State Henry Kissinger, then the chair of the North American Soccer League's Board of Governors. The hope was that he would add political weight to their bid.

The game's governing body, however, had reservations. The USA's lack of football heritage proved something of a stumbling block, while its main rivals had proved themselves able hosts in 1970. The result was that FIFA ultimately decided to take the safe option and return to Mexico. It also menat that Mexico would become the first country ever to stage two World Cups.

There was, though, still time for one more tragic hurdle to overcome. In September 1985, Mexico City was shaken by a severe earthquake (it registered 8.0) that claimed the lives of many thousands of people. In the aftermath of the devastation, FIFA waited anxiously to hear whether the country could still fulfil its obligations.

For once, the news was good. The stadia had survived the natural disaster relatively unscathed and the Mexican FA confidently announced everything would be ready in time. After what had proved a fraught selection process, the World Cup was heading back to Mexico.

United States Soccer Federation
Affiliated with the Federation Internationale de Football Association

May 10, 1983

All Members of FIFA Executive Committee
and
Mr. J. S. Blatter, General Secretary
P. O. Box 85
Ch-8030
Zurich 30,
SWITZERLAND

Gentlemen:

As noted in our telex to you dated May 3, 1983 and pursuant to the suggestion set forth in Mr. Blatter's telex of April 28, 1983, enclosed are materials to support the application submitted to FIFA on March 10, 1983. These would have been given to the FIFA Special Committee had it carried out its terms of reference for an on-site inspection of the facilities available in the United States to stage the 1986 World Cup. These materials confirm that the United States has satisfied all the requirements established in the FIFA Terms of Reference for the 1986 World Cup. Specifically:

> We have formed an organizing committee with a large group of leading soccer, government and corporate leaders. To demonstrate his support, President Ronald Reagan is serving as Honorary Chairman of our Committee.
>
> We have secured all the required guarantees from Governmental officials in the United States, including specific guarantees from the White House. In addition, the United States Congress has unanimously adopted a resolution expressing its support for our efforts to host World Cup '86 and ensuring the successful completion of the tournament if held here.

350 FIFTH AVE. · EMPIRE STATE BLDG., SUITE 4010 · NEW YORK, NY 10118 · TELEPHONE (212) 736-0915-6-7 · CABLE "SOCCER" NEW YORK

[second page, partially visible:]

...and ...ments as to ...rtising, ...levision ...fically ...and to be ...ecutive

...supplement to our ...y tabs: the first ...understand to be ...Executive Committee; ...nation with respect ...rms of Reference, ...This information, ...respects with the ...stion that the ...to host the 1986 ...in its history ...e the World Cup ...r hope that the ...n placing the ...f a maximum of three ...World Cup could ...e. But, conducting ...r the first time ...e size of the United ...and conduct the ..., soccer is the ...t is projected that ...soccer than any ...lding the World Cup ...an extraordinary ...promoting the game ...Executive Committee should award the 1986 World Cup to the United States based on the information contained in our written submissions. Failing that, the United States should have its application considered on the same basis as the other applicants, namely, after an appropriate inspection of our facilities by a special committee. Accordingly, in the event the Executive Committee decides that it should not award the World Cup to the United

States ...
the Exe...
of the ...
United ...
the Exe...

We wil...
Committ...
to 'answ...
meeting...

Sincer...

Gene E...
Preside...

Henry ...
Chairma...
World C...

Werner Fricker
Executive Vice President, USSF
Vice Chairman, USSF
World Cup '86 Organizing Committee

○○○

Left: *A statuette of Pique, the official mascot of the 1986 World Cup. It was the second time in 16 years Mexico had hosted the finals.*

Above: *The United States' bid letter for the 1986 World Cup. The bid was headed by Henry Kissinger but failed to satisfy FIFA, with Mexico hosts again.*

DENMARK TOPPLE DIE MANNSCHAFT

1986

There were 22 nations which headed to Mexico – joining the hosts and reigning champions Italy – to vie for the title of world champions. In the early stages, it was two unheralded nations who made a mockery of reputation and competition pedigree as they topped their respective first-round groups.

The World Cup of 1986 welcome three debutants to the fold in the shape of Canada, Denmark and Iraq, and, of the trio of newcomers, it was Sepp Piontek's Danish side who made the most eye-catching mark on proceedings.

Before the start of the tournament, Piontek had promised that his charges would keep faith with the attacking philosophy that had seen Denmark score 17 goals in only eight outings in qualification, and his players followed his instructions to the letter in Mexico as they registered three wins from three in the first round.

They began their Group E campaign in relatively modest style, beating Scotland 1-0 in Ciudad Neza, courtesy of a goal from Verona striker Preben Elkjær, but they were in irrepressible form four days later as they ran riot against Uruguay, Elkjær registering a hat-trick as Piontek's team demolished the South Americans 6-1 in the Estadio Neza.

The crowning glory of their adventure, however, was saved until last, when they faced West Germany in what had become the group decider. Despite their two previous results, the Danes were still the underdogs ahead of kickoff in the

> "In Mexico we shall attack,
> like we always do."
>
> SEPP PIONTEK

Estadio La Corregidora against the two-times champions, but goals both sides of half-time from winger Jesper Olsen and striker John Eriksen sealed a famous 2–0 win and sent Denmark through to the last 16 at the first time of asking.

Piontek's men were thumped 5–1 by Spain in the knockout stages, but the defeat did nothing to detract from the entertaining impact on the tournament made by a team which became known as "Danish Dynamite".

○○○

Left: Jan Molby (centre) and his Danish team-mates made their World Cup finals debut memorable by topping Group E with a perfect record.

Above: The Azteca, the official match ball of the 1986 finals. It was the fifth consecutive tournament for which Adidas supplied the balls.

The other headline makers from the first round were Morocco. Drawn in Group F with the European trio of England, Portugal and Poland, the North Africans were thought to have little hope of progressing in the competition, but José Faria's side had evidently not read the script.

The Atlas Lions signalled their intent by holding Poland to a goalless draw in their opening game. Four days later, England were unable to pierce the Moroccan defence in another goalless outing, and Morocco made history when they beat Portugal 3–1 in Guadalajara, thanks to a brace from Abderrazak Khairi in the climax of Group F.

The result saw Morocco become the first team from Africa ever to reach the knockout stages of the World Cup as group winners.

THE HAND OF GOD

1986

The 1986 World Cup quarter-final between England and Argentina in Mexico City was a meeting between two nations with an acrimonious history both on and off the pitch, and one that was famously settled by the shameless audacity and then in turn the undisputed brilliance of Diego Maradona.

There was history between England and Argentina, on and off the field with the infamous World Cup quarter-final of 1966 rather dwarfed by the military conflict over the Falkland Islands in 1982. It was a game that none of the 114,580 fans inside the cavernous Azteca Stadium or the global television audience of millions will ever forget.

A goalless first half merely gave no indication of what was to follow. Six minutes into the second-half, Argentina went ahead with what remains one of the most controversial goals in World Cup history. A fluid Argentinian attack saw England midfielder Steve Hodge harried into making a lofted clearance that looped towards goal. Keeper Peter Shilton came out to deal with the danger, but, as he leaped so did Maradona – all five foot, five inches of him – and, as replays subsequently confirmed, he punched the ball into the net with his left hand. Maradona wheeled away in celebration. The England players remonstrated furiously with Tunisian referee Ali Bennaceur and Costa Rican linesman Ulloa Morera, but the goal stood and the "Hand of God" had been added to the football lexicon.

Four minutes later, Maradona went from the ridiculous to the sublime with one of the greatest individual goals the finals had ever seen. Taking possession in his own half, he began a mesmeric surge that saw him beat four bewitched, would-be tacklers with a dazzling mixture of poise and pace before taking the ball around Shilton and scoring.

Voted the Goal of the Century by a FIFA poll in 2002, it was an effort that illuminated the whole tournament and the catalyst for many to begin talking about Maradona in the same breath as the legendary Pelé.

England, however, regrouped in the Azteca after Maradona's remarkable salvo and, ten minutes from time, they cut their arrears when Gary Lineker headed home from close range. It was his sixth goal of the tournament – making him the first English player to win the Golden Boot at a World Cup and ultimately denying Maradona a share of the accolade – but his individual success was little consolation as England headed to the airport and Argentina looked ahead to the semi-finals.

ooo

Left: Diego Maradona's first goal against England in Mexico City remains one of the most controversial in the history of the World Cup.

Right: The shirt worn by Maradona in the Azteca. His performance in the quarter-final made him a hero in Argentina but a villain in England.

> "(The goal was scored) a little with the head of Maradona and a little with the Hand of God. Although we had said before the game that football had nothing to do with the Malvinas (Falklands) war, we knew they had killed a lot of Argentine boys there, killed them like little birds. And this was revenge."
>
> DIEGO MARADONA

ARGENTINA TRIUMPHANT IN THE AZTECA

1986

The 1986 FIFA World Cup final between West Germany and Argentina was only the third time two former champions had reached the climax of the competition. The Germans were hoping to avoid falling at the final hurdle for a second successive tournament, while La Albiceleste were dreaming of a second title in eight years.

Five goals and six yellow cards. The final in Mexico City was nothing if not eventful and, although the match was not quite the Diego Maradona masterclass that many had predicted, Argentina's captain did, nonetheless, have the final, decisive word in what was a pulsating encounter between South America's and Europe's finest.

Maradona's first contribution of note was when he was booked by Brazilian referee Romualdo Arppi Filho after only 17 minutes, but for much of the game he was intelligently marshalled by Lothar Matthäus, and La Albiceleste found themselves needing other players to stand up and be counted.

The first to do so was unheralded centre-back José Luis Brown, who opened the scoring with a resounding 23rd-minute header from a free kick. The next was striker Jorge Valdano, nine minutes into the second half, when he produced a stylish finish at the end of a flowing Argentinian counterattack, and, with little over half an hour to play, La Albiceleste were two goals to the good.

West Germany had rarely threatened the opposition goal, but they finally exposed the Argentinian Achilles' heel late in the match. That weakness was corners, and first skipper Karl-Heinz Rummenigge and then substitute Rudi Völler exploited it ruthlessly with goals from close range from dead balls to draw Die Mannschaft level against the run of play.

Just three minutes after the equaliser, however, Maradona held sway with a moment of brilliance, his instinctive, first-time pass from inside his own half elegantly dissecting the German defence and sending Jorge

○○○

Above: *Lothar Matthäus was the second player booked in the 1986 World Cup final, but the West German did keep Diego Maradona largely quiet.*

Right: *Jorge Burruchaga's 84th-minute winner in Mexico City saw Argentina crowned world champions for a second time in eight years.*

> "Diego was determined to improve on the 1986 World Cup and the image he had left. His motivation rubbed off on all of us. Going into the tournament, everyone thought Platini was the main man, but Diego was simply magnificent and proved he was the best in the world."
>
> JORGE BURRUCHAGA

Burruchaga clean through. Burruchaga made no mistake with his finish, and Argentina were 3–2 up.

There was still time for the referee to brandish a sixth and final yellow card in the Azteca, to Argentina goalkeeper Nery Pumpido – making the 1986 final the most undisciplined in World Cup history to date – but there was no salvation for West Germany, and Argentina were champions for a second time.

Maradona collected the trophy – as well the Golden Ball award for the tournament's best player – while Die Mannschaft boss Franz Beckenbauer became the first man to lose World Cup finals as both a player and then a coach.

CROWDS IN UNISON

1986

The 1986 finals are widely acknowledged as Diego Maradona's World Cup after his heroics inspired Argentina to glory. It was, however, a tournament that yielded another enduring sporting legacy in the form of the Mexican Wave.

For those who watched the 1986 World Cup, whether from the stands of one of the 12 stadia across Mexico or at home on their televisions, the tournament was an undeniably eye-catching experience.

Bathed in seemingly endless, glorious sunshine, the competition's 52 games produced an incredible 132 goals – an average of 2.54 goals for every fixture – and, although Maradona bestrode proceedings and dominated the headlines, it was a World Cup illuminated by the assembled talents of Michael Laudrup and Sócrates, Enzo Scifo and Michel Platini, Karl-Heinz Rummenigge and Hugo Sánchez.

It was of course also a tournament that became synonymous with the spectators' penchant for the phenomenon that became known as the Mexican Wave. The eponymous craze was ubiquitous in Mexico and the pictures of coordinated fans rising from their seats and throwing their hands in the air, the ripple of movement flowing around the stadia, was arguably the defining image of the World Cup.

It is intriguing then that many argue that the Mexican Wave (known locally as "La Ola") was not born in 1986 after all. There is no dispute it earned its moniker during the World Cup but, ever since the tournament enthusiastically embraced the wave, there have been dissenting voices insisting they invented the phenomenon.

Left: Despite its disputed origins, the Mexican Wave became inextricably associated with the 1986 finals.

Above: A commemorative silk flag from the 1986 World Cup Tournament, which attracted an average attendance of more than 46,000.

One of the most articulate counterclaims comes from a professional cheerleader in the United States, a man called George Henderson, who maintains he first instigated the wave in 1981 during a Major League Baseball game between the Oakland Athletics and the New York Yankees. "In the third innings I thought I would try this thing that no one had seen before," he said. "I found three sections and started explaining what I wanted. The place was going nuts."

Another American, Robb Weller, insists he started the wave in the same year as Henderson during an American Football game at the University of Washington's Husky Stadium. Other suggestions for the inception of the iconic wave include the Los Angeles Olympics of 1984, a National Hockey League game in Canada in the 1970s and a football match in the Mexican city of Monterrey in the same decade.

Whatever the truth, the incontrovertible fact is it was the 1986 World Cup that gifted the wave to the wider world and ensured that future generations of sporting fans would never want for match-day entertainment again.

> "An effect resembling a moving wave produced by successive sections of the crowd in a stadium standing up, raising their arms, lowering them, and sitting down again."
>
> WWW.ENCYCLOPEDIA.COM

ITALIA 90

THE 1990 FIFA WORLD CUP

The 14th edition of the FIFA World Cup was one dominated by a sense of *déjà vu* as Italy became only the second nation to host the finals twice, while West Germany and Argentina both reached the final as they had done four years earlier in Mexico. For the Germans it was a third final in a row, while the Argentinians enjoyed a third in four tournaments.

THE SEEDS OF DISCONTENT

1990

An eighth European World Cup, the 1990 finals were awarded to Italy ahead of competition from seven rival bids. The tournament was staged 56 years after the country had first hosted the competition but was dogged by controversy before a ball was even kicked.

The selection process for the host nation began in July 1983 with the FIFA deadline for initial applications. Eight countries – Italy, the Soviet Union, Austria, England, France, Greece, West Germany and Yugoslavia – all expressed an interest in throwing football's biggest party, and FIFA set about assessing the strengths and weaknesses of the various bids.

By the time the game's governing body reconvened in May 1984 to announce its decision, however, all but Italy and the USSR had withdrawn their applications. It had become a two-horse race and Italy won the final vote 11–5. The Azzurri would host the World Cup once again.

Accusations that the FIFA Executive Committee had been swayed by the Soviet-led boycott of the Los Angeles Olympic Games – it had been announced on the eve of the vote – were vehemently denied by FIFA President, João Havelange, but it was not the end of the controversy in the build-up to the finals.

In 1989 FIFA powerbrokers gathered to confirm the six seeded teams for the tournament. Italy, as hosts, received top billing while reigning champions Argentina were ranked second, but there was surprise when it was announced England and not Spain would be the sixth and final seeds.

The Spanish were furious. The FIFA formula clearly stated that seeding was based primarily on the team's performances in the last two World Cups and, with both the countries having reached the second round group stage in 1982 and the quarter-finals in 1986, it was difficult to understand how FIFA had made their decision.

Spain had an idea. Seeding England sixth meant they would play in Group F in Cagliari on the island of Sardinia, and this in turn, the Spanish argued, would ensure the hooligan element of England's support would be based

Above: *A silver statuette of Ciao, the official 1990 World Cup mascot. The stick figure, with a football head, looked as if it was about to kick a ball*

Right: *A special rail timetable and guide published for spectators heading to the 12 cities and stadia hosting Italia 90's 52 matches.*

away from the Italian mainland. They had, they felt, been the victims of a policing rather than football decision.

FIFA predictably denied it. "England merited the sixth position," insisted Herman Neuberger, the World Cup committee president. "They qualified for the sixth position according to the criteria which FIFA has decided. This is in no way a concession to English hooliganism."

The furore finally died down when the football started. England topped Group F as their contentious seeding predicted, but Spain were winners of Group E and also progressed untroubled to the knockout stages.

> "We feel we've been cheated. They wanted to seed England and to send it to Cagliari at all costs. So they invented this formula."
>
> SPAIN MANAGER LUIS SUÁREZ

THE MAGIC OF MILLA

1990

Italia 90 was tournament that saw a massive investment in infrastructure by Italy and debuts in the final for three new nations, but the early stages of the 1990 World Cup were notable for the performances from some of the competition's supposed lesser lights.

No expense was spared as Italy prepared to welcome football fans from across the world to the Mediterranean peninsula. Ten existing grounds across the country were given significant facelifts in readiness for the finals, while two new venues – the Stadio San Nicola in Bari and Turin's Stadio delle Alpi – were built in time for the World Cup.

A total of 116 countries attempted to qualify for the finals. Of the 22 who were successful, joining their Azzurri hosts and the champions Argentina, three were newcomers: Costa Rica, the Republic of Ireland and the United Arab Emirates. There was an early flight home for the team from the Middle East, but the Central Americans and Irish made quite an impact on debut.

Costa Rica made it to the last 16 after successfully negotiating Group C. An albeit turgid 1-0 defeat to Brazil in Turin was hardly unexpected, but defeats of both Scotland and Sweden were magnificent. Although the Ticos were outclassed 4-1 by Czechoslovakia in their second round match in Bari, they went home with their heads held high.

The Republic went one better in reaching the quarter-finals. Three Group F draws, with England, the Netherlands and Egypt, were enough to prolong their stay in the tournament before they accounted for Romania in the last 16 after a penalty shootout. Hosts Italy ended the Irish dream in the quarter-finals, but the squad was nonetheless fêted by supporters when their plane landed in Dublin.

The real fairy-tale of the tournament, however, was that of Cameroon, and their veteran striker Roger Milla. The Indomitable Lions kicked off their incredible World Cup with a shock 1-0 defeat of Argentina at Milan's San Siro thanks to a François Omam-Biyik goal and it was then over to the 38-year-old Milla, who was lured out of semi-retirement for the finals, to write his name in World Cup folklore.

His first age-defying contribution came from the bench in the group-stage clash against Romania, his two goals sealing a 2-1 triumph and sending Cameroon through to the last sixteen, while he repeated the trick with another double as a substitute in the 2-1 win over Colombia after extra time. It was the first time an African team had ever reached the last eight.

The Lions' quarter-final clash with England in Naples also went into extra time. Milla once again came off the bench but this time he could not perform a miracle and Bobby Robson's men emerged nervous 3-2 winners. The Cameroon adventure was over, but not before they'd left an indelible mark on the tournament.

○○○

Left: Veteran Roger Milla runs away from Colombia goalkeeper René Higuita before scoring the goal that sent Cameroon into the quarter-final.

Right: Italian car giant Fiat was a main sponsor of the 1990 World Cup finals and they helped to produce an interactive Supporters Guide.

"In Italy we did not know the impact we were having on football fans. We couldn't know. But back in Cameroon the reaction when we got back was crazy. It was delirium."

ROGER MILLA

THE SEMI-FINAL SHOOTOUTS

1990

The semi-finals of the 1990 World Cup brought together a quartet of the game's superpowers – all former winners – as Argentina faced Italy in Naples and England met West Germany in Turin a day later. All four sides scored, just the once, and it was accuracy from 12 yards out that decided the finalists.

The first of the semi-finals saw 60,000 predominantly Italian supporters pack the Stadio San Paolo in Naples to watch Azeglio Vicini's side in action against La Albiceleste, and the Azzurri dream of reaching the World Cup final on home soil, as their predecessors had done back in 1934, was alive and kicking when Salvatore "Toto" Schillaci opened the scoring in the 17th minute.

Optimism turned to anxiety in the second half when Argentina equalised through Claudio Caniggia. Remarkably, it was the first goal Walter Zenga had conceded in 517 minutes of the finals, a tournament record, and it was also enough to take the game into extra time. The additional half-hour, however, fail to yield another goal, and it was time for the dreaded penalty shootout.

Argentina were on target with all four of the penalties the needed in Naples, the last converted by Diego Maradona in the city where he had been worshipped by the Napoli faithful. In contrast, the Italians were profligate, and the villains of the piece were midfielder Roberto Donadoni and substitute Aldo Serena, whose spot-kicks were saved by Sergio Goycochea. The champions were 4–3 winners and Italy were out.

West Germany's encounter with England followed a similar script. Die Mannschaft drew first blood on the hour inside the Stadio delle Alpi when Andreas Brehme's free kick was deflected off defender Paul Parker and looped into the back of the net. England ensured that a second penalty shootout in twenty-four hours would be required when Gary Lineker levelled with ten minutes on the clock. Extra time couldn't separate the teams – though England's playmaker Paul Gascoigne was cautioned so would miss the next match – and they began to finalise who would have the courage to step up and take a penalty in the shootout.

Above: Paul Gascoigne comes, tearfully, to terms with the fact that his semi-final yellow card would mean he missed England's next match.

Right: Sergio Goycochea (12) leads the celebrations after his two saves took Argentina into the 1990 World Cup final and broke Italian hearts.

> "It was a really strong England team with a bit more creativity than other sides we have had. We were fractions from winning the World Cup. We hit the inside of the post, they scored a really lucky goal and we lost on a shootout."
>
> GARY LINEKER

Both sides converted their first three attempts, but Stuart Pearce then had his effort saved by Bodo Illgner. Olaf Thon beat Peter Shilton with his spot kick – the Germans' fourth – so Chris Waddle placed the ball on the spot, knowing he was in the unenviable situation of having to score to keep England in the World Cup.

He blasted high and wide. The Germans were through to a third successive final while England had their first, but far from last, bitter taste of the misery of a shootout defeat at a major tournament.

Three days later, England were in Bari to face Italy in the third-place play-off. Shilton won his 125th and final cap – he was captain too – but it was not a happy farewell for him. His error gave Roberto Baggio the opening goal after 71 minutes, David Platt equalised, but Schillaci scored the winner, a penalty – what else! – four minutes from time.

THIRD TIME LUCKY FOR DIE MANNSCHAFT

1990

A repeat of the final at Mexico City's Azteca four years earlier, the climax of the 1990 World Cup between West Germany and Argentina at Rome's Stadio Olimpico followed in the footsteps of the semi-finals and was settled from the penalty spot. Unlike in those two matches, however, the drama and inevitable agony of a shootout was not required in Rome.

When West Germany walked onto the pitch in front of a crowd of 73,000, the players were acutely aware Die Mannschaft had been beaten in the last two World Cup finals and a humiliating hat-trick of disappointments potentially awaited them.

For Argentina the challenge was to become only the third nation after Italy (in 1938) and Brazil (1962) to successfully defend their World Cup crown, and, although he was not at the majestic peak of his powers as he had been in Mexico in 1986, with Diego Maradona in their ranks hope sprang eternal for La Albiceleste.

Perhaps there was too much at stake for both sides because the final, in truth, was a turgid affair. There was a conspicuous lack of attacking, incisive football and cynical tactics held away over either team's fleeting attempts to display any creativity.

The momentum for much of the contest was with Germany and, in the 65th minute, their ascendency was accentuated when Argentinian defender Pedro Monzón, a half-time substitute, was sent off for a foul on Jürgen Klinsmann. Monzón thus became the first player ever to be dismissed in a World Cup final.

Die Mannschaft could not immediately make their numerical advantage pay dividends, but five minutes from time they finally found a way through. Rudi Völler surged into the area and went down under a sliding challenge from Roberto Sensini. Both sets of players held their collective breath and it was German joy and Argentinian dismay when Mexican referee Edgardo Codesal pointed to the spot.

The man charged with penalty duties was Andreas Brehme, and he proved to have nerves of steel as the stepped forward and drove a low effort past the despairing right hand of goalkeeper Sergio Goycochea and into the back of the net.

It was the only goal of the game. Argentina's Gustavo Dezotti contrived to get himself sent off before full time but, with or without him, La Albiceleste did not look like equalising and West Germany joined Brazil and Italy as three-times world champions.

In the process Franz Beckenbauer became only the second man to win the World Cup as a player and coach, after Mario Zágallo of Brazil while, for Lothar Matthäus and Pierre Littbarski, members of the defeated 1982 and 1986 squads, this victory was particularly cathartic.

○○○

Above: *A piece of the Stadio Olimpico pitch in Rome which staged the final between West Germany and Argentina.*

Left: *The most valuable ticket in world sport in 1990 was one of these, the World Cup final in Rome's Stadio Olimpico, but it witnessed a poor game.*

FIFA RINGS THE CHANGES

1990

The legacy of the 1990 World Cup in Italy was a mixed one and, while there was certainly drama and shock results, critics cited the negative tactics, indiscipline and dearth of goals as indicators that the tournament had failed to reach the heights of some of its predecessors.

Statistics do not always tell the full story of a sporting event, but, in the case of Italia 90, there appeared to be a direct correlation between the quality of football on display and the data that the competition yielded after West Germany had been crowned champions.

The finals produced only 115 goals from 52 games, a meagre average of 2.2 goals per match. No previous or subsequent competition has seen fewer goals per fixture. It was evidence, the critics argued, that the 1990 World Cup was not a great tournament. Those 115 goals – down by 17 on 1986 – was the lowest since the World Cup had expanded to 24 teams in 1982.

The Republic of Ireland, for example, found the back of the net only twice en route to the quarter-finals – and, more unusually, their only victory came via a penalty shootout. Also, no country has ever reached the final scoring fewer than the five goals Argentina mustered in six matches in Italy, though Spain scored seven, in six games, in 2010.

Indiscipline also plagued the tournament. The 16 red cards shown by the officials constituted a then record – more than in Spain in 1982 and Mexico in 1986 combined – and 1990's dubious distinction of witnessing the most red cards was not eclipsed until eight years later in France, when the tournament had been expanded to comprise 32 teams and 64 matches.

Other records set at Italia 90 further suggested that the competition had been gripped by a negative mentality. A record eight matches had required extra time to settle them, and the four penalty shootouts were also a historical high. Teams appeared more focused of not losing rather than winning matches.

FIFA was evidently mindful of what unfolded in Italy and moved decisively. Its first response came in 1992 when it outlawed the back pass to the goalkeeper, a bold move designed to encourage sides to play out of defence rather than repeatedly go backwards; while, by the time football's finest reconvened in the United States of America in 1994, there were now three rather than two points on offer for the winners of group-stage matches.

The other undeniably positive legacy from Italia 90 was felt keenly in Africa. Cameroon's historic progress to the quarter-finals and Egypt's solid displays in Group F – they managed two draws and lost only once – convinced FIFA that the continent had earned the right to greater representation at the top table, so three African nations would compete in the finals at USA 94.

○○○

Right: The only thing fourth-placed England won at the 1990 World Cup was the The FIFA Fair Play Trophy, created by Sport Billy Productions.

Below: FIFA introduced "Fair Play Please" banners for Italia 90, but their plea fell largely on deaf ears as the finals saw referees show 16 red cards.

FIFA
FAIR PLAY TROPHY
© SPORT BILLY PRODUCTIONS

© 1991 WC'94 TM

THE 1994 FIFA WORLD CUP

The beautiful game headed into relatively unchartered territory in 1994 after FIFA took the bold decision to award the World Cup to the USA. The experiment reaped handsome rewards with record crowds filling the stands of stadiums across the United States as they bore witness to Brazil claiming an unprecedented fourth world title.

SOCCER HITS THE STATES

1994

Mexico had beaten the United States for the right to stage the 1986 finals – this after original hosts Colombia had dropped out in autumn 1982 – but the country's reluctant wait to welcome the World Cup was not a prolonged one. A record-breaking average attendance of 68,991 during the tournament was compelling proof that football had found a new home.

There was never any doubt that the USA could host a suitably spectacular World Cup. The infrastructure and stadia were all in place before any of the 22 finalists even qualified (the hosts and last winners qualified by right), and the opening ceremony ahead of Germany's group game with Bolivia at Chicago's Soldier Field, attended by incumbent President Bill Clinton, only highlighted the country's sense of innate showmanship.

The only lingering doubts about USA 94 were the Americans themselves. FIFA had insisted on the formation of the Major Soccer League as part of the deal to secure the finals, but the first fixture was still two years from fruition, and how they would react collectively to the invasion of what was still largely a foreign sport remained debatable.

They answered in their millions. A crowd of 63,117 packed Soldier Field for Die Mannschaft's clash with the Bolivians, entertained more by the football than the notorious sight of Diana Ross failing to find the back of the net during the opening ceremony, and by the end of the tournament an incredible 3,587,538 spectators had watched the 52 games. No other World Cup before or since has put so many bums on so many seats.

On the pitch, history was made in Chicago when a unified Germany side ran out for a World Cup fixture for the first time since 1938. East and West had come back together in 1990 for a friendly with Sweden in Solna but the game against Bolivia, won 1–0 courtesy of a second-half goal from Jürgen Klinsmann, was their first assignment in the finals since Germany had faced Switzerland in Paris 56 years earlier.

Elsewhere in the group stage, Saudi Arabia made headlines in their World Cup debut. An opening 2–1 defeat to the Netherlands in Washington initially appeared to

confirm that the Green Falcons would, as many predicted, merely make up the numbers in the States, but they bounced back with a 2–1 victory over Morocco followed by a famous 1–0 triumph against Belgium to reach the last 16.

The win against the Belgians at the RFK Stadium in Washington also produced the goal of the tournament from Saeed Al-Owairan. The match was just five minutes old when the midfielder collected the ball deep inside his own half and set off on a surging foray forward. Al-Owairan left five Belgians in his slipstream as he powered towards goal before scoring an unforgettable solo effort with a sliding, close-range finish.

ooo

Left: A media ticket for the opening match of USA 94, between the newly unified Germany and Bolivia at Chicago's Solidier Field.

Below: Germany's Jürgen Klinsmann runs away after scoring the first goal of the 1990 World Cup finals. It gave Germany a win against Bolivia.

AN ERA OF INNOVATION

1994

FIFA broke new ground when it awarded the USA the World Cup but the choice of venue was far from the only significant innovation on display in 1994, as the game's governing body embraced new technologies, new rules and a new way of doing things.

In many ways, USA 94 was a watershed tournament for the World Cup. It was the first during which supporters were spared the tedium of players repeatedly passing back to the goalkeeper, and it was the first in which teams received three points rather than two for a victory in the group stages.

The rule changes had the desired effect. The negative football witnessed in Italy in 1990 duly gave way to a significantly more positive mindset from the majority of the 24 teams, and the tournament yielded 141 goals compared with the record low of 115 four years earlier as a result.

Other changes were in evidence everywhere. Injured players were no longer stretchered off the pitch manually but rather departed the pitch courtesy of electric carts – drawing, from some quarters, uncharitable comparisons with golf buggies and milk floats – while the tournament referees were no longer garbed in traditional black and but now ran out wearing burgundy, yellow or silver shirts, making sure there were no colour clashes. The appearance

> "We went a goal up and Cameroon started to chase the game and rush forward in great numbers. That meant the game really opened up and it created more scoring opportunities for us."
>
> OLEG SALENKO

Above: Five goals for Russia's Oleg Salenko against Cameroon at Stanford Stadium earned him a place in the World Cup record books.

Left: The introduction of electric carts to remove injured players from the pitch was one of a series of unusual sights during USA 94.

of the players also changed with teams now sporting shirts with numbers on the front of their kit for the first time.

Another significant first occurred on 18 June, when hosts the USA faced Switzerland in the opening game of Group A. The match was played at the Pontiac Silverdome under a fibreglass roof held up by air pressure, and the World Cup witnessed a first ever "indoor" fixture. Since then, only the Sapporo Dome in Japan in 2002 and the FIFA World Cup Stadium in Gelsenkirchen, Germany, in 2006 have subsequently staged World Cup matches under roofs.

On the pitch, USA 94 produced two individual records that still stand today, and both were set in the Group B encounter between Russia and Cameroon in Stanford, California, on 28 June. The Russians comprehensively dismantled the 1990 quarter-finalists, running out 6–1 winners, and striker Oleg Salenko became the first player to score five goals in a World Cup game. Cameroon's goal came from veteran striker Roger Milla, who became the finals' oldest ever scorer. His exact age was unknown – somewhere between 42 and 45 – but FIFA's records give his birthdate as 20 May 1952, making him 42 years and 39 days old..

THE SHAME OF MARADONA

1994

The 1994 World Cup was Argentina captain Diego Maradona's fourth finals, but, after the highs of 1986 and victory in the final against West Germany in Mexico City, the star's American adventure came to a premature and controversial conclusion, derailing the hopes of his football-mad countrymen.

The iconic Argentinian captain was already 33 years old when USA 94 began. The midfielder had played in just two of La Albiceleste's eight qualifying games en route to the finals and, as the World Cup approached, there were persistent doubts about his fitness and form. An increasing number of critics dismissed Maradona as yesterday's man.

He went some way to silencing his detractors with a brilliant performance and Argentina's third goal in the 4–0 demolition of Greece in their Group D opener, the catalyst for his famous, wild-eyed touchline celebration, and, when he lasted the full 90 minutes of the team's 2–1 win over Nigeria, the Argentinian faithful began to believe their hero could yet roll back the years.

Four days later, that hope turned to dismay when FIFA announced Maradona had failed a drugs test and was subject to an immediate suspension. The revelation was greeted with disbelief in Argentina – one Buenos Aries television station describing the news as "total madness, an absolute disaster" – but the stark reality was that the player's World Cup was over.

Maradona had tested positive for the weight-loss drug ephedrine. He claimed the source of the ephedrine was an American energy drink bought by his trainer, but FIFA later revealed that his blood sample had tested positive for five separate banned substances and the result could not have been caused by a single product or medication. His expulsion from the tournament stood.

The midfielder was only the third player to be sent home from a World Cup for violating doping regulations. In 1974 Ernest Jean-Joseph of Haiti was expelled from the finals – there were no bans in those days – for taking an unnamed banned substance, while Scotland's Willie Johnston was

Above: Diego Maradona made the headlines at USA 94 for all the wrong reasons when he was expelled from the tournament after a failed drugs test.

Right: A wild-eyed Maradona runs away in joy after scoring for Argentina against Greece in their 4–0 victory at Foxboro Stadium near Boston

> "They have retired me from football. My soul is broken."
>
> DIEGO MARADONA

banned in 1978 for using the stimulant fencamfamine.

Without their talisman, Argentina lost 2–0 to Bulgaria in the final group match and limped into the knockout stages as one of the best third-place teams, but Romania dispatched them 3–2 in the second round in Pasadena.

Maradona's appearance against Nigeria was his 91st and last for Argentina, an international career that spanned 17 years and brought him 34 goals. It was a sad end for the star who had hit unparalleled heights in Mexico in 1986 but who ultimately bade farewell ignominiously. He played domestically with Boca Juniors until 1997 and although his World Cup playing career was over, he did coach Argentina in the 2010 finals ... their first match was against Nigeria.

BAGGIO WILTS IN THE ROSE BOWL

1994

A repeat of the 1970 final in Mexico City, Brazil and Italy renewed acquaintances in Pasadena 24 years later in the climax of the 15th instalment of the World Cup. For the first time in the history of the tournament, the fate of football's most coveted silverware was decided by a penalty shootout.

The final of USA 94 was the ultimate clash of World Cup heavyweights. The Azzurri and the Seleção – along with West Germany – had each won three tournaments, so their meeting in California would see the winner recognised as the most successful team in World Cup history. Italy had lifted the Cup 12 years earlier, but for Brazil the wait had been twice as long, 24 years since they were victorious in Mexico. As the two sides took to the field at the Rose Bowl an eager crowd of 94,194 fans hoped to witness a classic.

Sadly, the game failed to live up to expectations. Both teams certainly possessed potent attacking threats – the Brazilian pairing of Romário and Bebeto had scored eight goals between them en route to the final, while Roberto Baggio's haul of five had almost singlehandedly propelled Italy through the knockout stages – but it was the respective defences that were in the ascendency in Pasadena.

Italy had issues, however, as centre-back Alessandro Costacurta was suspended – as he had been for the 1994 Champions League final – and skipper Franco Baresi was back just three weeks after undergoing knee surgery. Then, after 34 minutes, defender Roberto Mussi limped off

There were chances. Striker Daniele Massaro should have scored for Italy in the first half and Mauro Silva hit a post for Brazil after 75 minutes. In extra time, Bebeto and Baggio could have won it, but there was a sense that a shootout was inevitable. It became reality when Hungarian referee Sándor Puhl ended the 120-minute stalemate.

Baresi and Márcio Santos both missed with their team's first efforts. The next five attempts were all successful but, when Massaro failed to score and Dunga was on target, Brazil were 3-2 in front. It meant Roberto Baggio had to

score with Italy's fifth attempt, or the Seleção would be crowned champions.

The Juventus striker, known as *Il Divino Codino*, "the Divine Ponytail", lifted his effort over the bar. It was a cruel blow for the player, whose goals had dispatched Nigeria, Spain and Bulgaria in Italy's previous three games, but the stark reality was that the shootout was over and it was Brazil who lifted the World Cup for a record fourth time.

○○○

Above: Head bowed, Roberto Baggio comes to terms with his shoot-out miss in the 1994 World Cup final, a failure that gave Brazil a four world title.

Left: Baggio's boot may have brought him five goals at USA 94. and made him a global superstar, but his final touch was anything but golden.

> "Losing a World Cup final on penalties is something that I'll never agree with. Is it right that four years of sacrifice are decided by three minutes of penalties? I don't think so."
>
> ROBERTO BAGGIO

TRAGEDY OF ANDRÉS ESCOBAR

1994

Colombia's unexpectedly early exit from the 1994 World Cup was to have fatal consequences for the team's 27-year-old captain Andrés Escobar, who was murdered in his hometown of Medellín just days after La Tricolor were eliminated from the tournament.

Colombia headed to the United States in 1994 with justifiably high hopes of making a real impact on the tournament. They had been the standout team in their South America qualifying group, going undefeated in their six matches, which included inflicting a 5-0 thrashing on Argentina in Buenos Aries. They topped Group A with a golden generation of talent, including Carlos Valderrama, Faustino Asprilla, René Higuita and Freddy Rincón, and they firmly believed that they could improve on their last 16 showing in Italy four years earlier. Some experts went as far as to say that Colombia were in with a good chance of the winning tournament.

Things did not go according to plan in the USA. La Tricolor were beaten 3-1 by Romania in their Group A opener and then lost 2-1 to the tournament hosts. Their 2-0 victory over Switzerland in Stanford was not enough to repair the damage and Colombia, bottom of the group, were out of the World Cup.

It was the match against the Americans, however, that reportedly cost Escobar his life. The skipper slid in to intercept a cross by USA midfielder John Harkes towards striker Earnie Stewart, but he succeeding only in stabbing the ball into his own net. Many blamed him and that own goal for Colombia's 2-1 defeat and their premature exit.

Five days after beating the Swiss, Escobar was outside a nightclub in Medellín when he became embroiled in an argument with three men and was shot six times in the back at point-blank range. He was rushed to hospital but pronounced dead within the hour.

No one can be unequivocally certain that Escobar's murder was a direct result of his own goal, but there were contemporary reports that his assailants shouted "Gol!" ("Goal!") after each shot. Others speculated his death was ordered by drug cartels who had bet on Colombia. A man named Humberto Castro Muñoz, a bodyguard for one of the cartels, confessed to the crime and was sentenced to 43 years in prison, but the true motive behind the callous murder remains shrouded in mystery.

Escobar was affectionately known as "El Caballero del Fútbol" ("The Gentleman of Football") and 120,000 people lined the streets of Medellín on the day of his funeral to pay their respects. After his death, his family set up the Andrés Escobar Project to help disadvantaged children learn to play football, while many Colombian fans took pictures of their fallen hero to games during the 2014 World Cup in Brazil in his memory.

Above: Colombia's fans will never forget Andrés Escobar and, at major tournaments, many bring banners recalling their murdered former skipper.

Right: Just out of picture, Earnie Stewart's run forced Escobar into sliding John Harkes's cross into his own goal as the USA defeated Colombia 2-1

"Life doesn't end here. We have to go on. Life cannot end here. No matter how difficult, we must stand back up. We only have two options: either allow anger to paralyse us and the violence continues, or we overcome and try our best to help others. It's our choice."

ANDRÉS ESCOBAR IN HIS FINAL EL TIEMPO NEWSPAPER COLUMN BEFORE HIS DEATH

THE 1998 FIFA WORLD CUP

The World Cup welcomed a new member into its exclusive winners' enclosure in 1998 as the hosts France beat Brazil in Paris in the final and became the seventh nation since the inaugural tournament of 1930 to earn the coveted title of world champions.

NORWAY STUN THE SELEÇÃO

1998

It had been 60 years since France had staged what was then the third instalment of the World Cup. A modest 15 teams had taken part in the 1938 finals, but when the French became only the third country to be two-time hosts, after Mexico (1970 and 1986) and Italy (1934 and 1990), they had to accommodate more than double that number of teams in the last tournament of the twentieth century.

It was ahead of the 1982 World Cup in Spain that FIFA decided that the growing clamour for places in the finals demanded an expansion of the competition from 16 to 24 teams. For four successive tournaments two dozen teams duly did battle for the trophy but by 1998 the game's governing body realised it was again time for another expansion of the format.

The result was that 30 nations joined the hosts and the reigning champions Brazil in France for the quadrennial festival of football. All of the modern game's powers survived the cut to book their place in the finals, but for the first time Croatia, South Africa, Jamaica and Japan all received invitations after successfully negotiating for qualification.

Asia had four representatives, but Iran's victory over the United States was the only one for the four and the other three teams managed just two draws between them.

The presence of South Africa was good news for Africa, taking the continent's finals contingent to five teams for the first time, but 1998 was one of mixed feelings for CAF rivals Morocco. The Atlas Lions qualified for the tournament for a fourth time but, having lost out to France a decade earlier in the race to stage the finals, prolonging Africa's patient wait to host the competition, they arrived in Europe with a sense of what might have been.

There was further heartache for the Moroccans as Group A unfolded unpredictably. The North Africans did their bit in holding Norway to a 2-2 draw and then beating Scotland 3-0 in Saint-Étienne in their last game and only needed Brazil not to lose to the Norwegians in their last fixture to send them through to the last 16 for only the second time in their history.

The game in Marseille was following the script when Bebeto gave the Seleção a 78th-minute lead, but Norway were not finished and came storming back in the Stade Vélodrome to register an unforgettable 2-1 victory, courtesy of late scores from Tore André Flo and Kjetil Rekdal's last-gasp penalty. The Scandinavians were through and Morocco were heading home.

Elsewhere, Spain flattered to deceive in Group D and suffered the embarrassment of an early exit, while Romania were the surprise package in Group G, beating England in Toulouse to top the group ahead of the 1966 champions.

> "I think we all understand that what happened is rather incredible."
>
> NORWAY COACH EGIL OLSEN

Above: A selection of Panini stickers from the 1998 World Cup. The book containing the stickers had to be larger than ever before because France 98 was the first finals to have 32 teams participating.

Left: The official mascot of the 1998 World Cup finals was called Footix. A cuddly cockerel in the national shirt colour blue, his name went back to Gaul, which frequently used the "ix" suffix, added onto the French slang for football, le foot.

RED MIST DESCENDS IN FRANCE

1998

The 1994 World Cup in the USA witnessed a series of striking innovations but FIFA was determined not to allow the evolutionary momentum to stall in France four years later, introducing a raft of new rulings that would have a significant impact on both the finals and football in the future.

As with the tactics of the beautiful game, the laws of football are in a constant if controlled state of flux, and the 1998 World Cup was no exception, as FIFA decided to implement changes designed to placate supporters, players and managers alike.

The most visually striking difference in France from the finals four years earlier was the use of electronic boards, which were brandished by the fourth official at the end of each half – and potentially in extra time – to display exactly how many minutes of additional time would be played. For the first time in tournament history, fans were spared that peculiar agony of not knowing how long their side had left to score or hold out.

The coaches and managers of the 32 countries in the finals also widely welcomed FIFA's decision to allow three rather than two substitutions for the first time. The move gave them greater tactical flexibility and it was telling that, during the two semi-finals and the final, the managers of Brazil, the Netherlands, France and Croatia made 15 of the 18 substitutions possible between them in the three games. These electronic boards also displayed all the substitutions.

The introduction of the rather contentious golden goal rule (more of which later) had a minimal effect on the tournament and it was rather the outlawing of the tackle from behind and FIFA's general directive to referees to crack down on foul play that proved to have much greater impact on proceedings.

The officials followed their instructions to the letter and the result was a then record 22 red cards shown during the 33 days of the tournament, comfortably eclipsing the 16 brandished in Italy eight years previously. The referees

Above: Electronic substitution boards made their World Cup debut at France 98. They also displayed additional minutes at the end of halves.

Right: With a capacity of more than 80,000, the Stade de France in Saint Denis was the first stadium built specifically for a World Cup final in 44 years.

also displayed a grand total of 258 yellow cards. Cameroon and hosts France shared the dubious distinction as the teams with the most dismissals in 1998 with three apiece, while Croatia clocked up 19 bookings in their seven outings. Cameroon defender Rigobert Song set another unwanted record when he was sent off in his side's Group B clash with Chile. Having also seen red in the USA in 1994 – at 17 the youngest player to be dismissed – he became the first player to take an early bath at two different World Cups.

France 98's final claim to fame was an architectural one and the construction of the Stade de France. The 81,338-capacity ground was one of the first in a new generation of football stadia of the late twentieth and early twenty-first centuries and boasted covered seating throughout. It was also specifically designed to host the World Cup final, the first time a venue was constructed for that purpose since the Swiss built the Wankdorf Stadium in Bern for the 1954 showpiece match.

BLANC STRIKES GOLD

1998

In-form hosts France met Paraguay in Lens in the last 16 with the home nation anticipating a relatively comfortable passage through to the last eight after three comfortable wins in the group phase. The South Americans, though, proved tenacious opponents and were vanquished only by a moment of World Cup history.

The name of Anthony Carbone is an obscure but significant one in the story of the beautiful game. The midfielder enjoyed a modest professional career but he indelibly etched his moniker into the record books in March 1993 while on international duty for Australia, scoring football's first-ever golden goal in the 99th minute of the quarter-finals of the FIFA Under-20 World Cup.

Carbone's strike ushered in a new, if fleeting era for the game, in which games were settled by the first goal in extra time, a move designed to reduce the preponderance of penalty shootouts; and, although the rule had fallen out of favour with the game's administrators by 2004, it was nonetheless a milestone moment.

Five years after Carbone's watershed intervention, the World Cup witnessed its first golden goal. It was scored by Laurent Blanc and, had the France veteran not been on target against Paraguay, the 1998 World Cup could have been a very different tournament indeed.

Without suspended playmaker Zinedine Zidane, Les Bleus struggled to pierce Paraguay's well-marshalled defence. The game went into extra-time, and another 23 goalless minutes came and went, and French fans were

> "What a moment! I promised myself I'd score in the World Cup and I kept my promise."
>
> **LAURENT BLANC**

Left: Laurent Blanc's golden goal, in the second half of extra time in France's second round tie against Paraguay, was the first in World Cup finals history.

Above: The Tricolore was the official match ball of the 1998 finals. The balls found their way in the net a joint record of 171 times in 64 matches.

starting to dread the spectre of a penalty shootout. They won a corner, which was not properly cleared. Substitute Robert Pirès controlled the ball, dribbled down the right of the area and chipped into the box. Striker David Trezeguet rose highest to nod the cross down, and there was Blanc, too tired to run back to his defensive position, to meet the ball on the half-volley and direct his shot past Paraguay goalkeeper José Luis Chilavert from eight yards.

It was a golden reprieve for Aimé Jacquet's team and they made the most of their last-gasp escape, going on to reach the final on home soil, and in the process they transformed the whole mood of both the tournament and the country.

On a more personal note, the goal represented redemption for Blanc after France's inability to qualify for the 1994 World Cup. Les Bleus were vociferously criticised at home for their failure and Blanc announced his international retirement only to be coaxed back to the fold by Jacquet. His historic goal against Paraguay was a dramatic way in which to draw a line under the past.

THE SINNER OF SAINT-ÉTIENNE

(1998)

The fourth instalment of Anglo-Argentinian hostilities in the World Cup, the last-16 clash between the England and Argentina in 1998 was a predictably fiery affair that famously saw David Beckham sent off and Daniel Passarella's side subsequently emerge victorious from a penalty shootout.

The last time England faced Argentina, in the 1986 finals, the quarter-final had been decided by the left hand and then left foot of Diego Maradona. Twelve years later, the rematch was to turn on a moment of petulant madness from an Englishman and the calm nerves of the Argentinians from 12 yards out.

Held in the Stade Geoffroy-Guichard in Saint-Étienne, the match was only six minutes old when it exploded into life. David Seaman brought down Diego Simeone in the box and Gabriel Batistuta compounded the England goalkeeper's misery by converting the resulting penalty kick.

Four minutes later, England were level with a penalty of their own when teenager Michael Owen was fouled and England captain Alan Shearer converted. They went ahead in the 16th minute, when Owen mesmerised the Argentinian defence with a sublime solo surge and finish, but the sides went in at half-time on equal terms after a clever free-kick routine created time and space for Javier Zanetti to fire home.

Beckham's notorious red card came barely a minute after the restart. Forcibly floored by a cynical challenge from behind by Simeone, the Manchester United midfielder was lying prostrate on the pitch when he inexplicably flicked his right boot at his opponent. His illegal act of retribution was played out right in front of referee Kim Nielsen, and, although Simeone was booked for his original foul, the Dane then showed Beckham the red card.

Above: David Beckham was sent tumbling through the air by a rash challenge, but it was what happened next that decided the match.

Right: Red cards were a feature of France 98 and David Beckham saw only England's second red in the finals – Ray Wilkins was the first, in 1986.

His dismissal left England to contest the remainder of the second half – and it transpired the 30 minutes of extra time – with ten men against Argentina's full complement. Glenn Hoddle's men thought they had snatched an against-the-odds victory in the 81st minute when Sol Campbell beat Carlos Roa with a header, but Nielsen ruled out the centre-back's effort for a foul and, when a golden goal failed to materialise in extra time, the game headed for a shootout.

La Albiceleste missed just once from the spot in five attempts – Hernán Crespo's effort saved by Seaman – but England were twice thwarted by Roa as first Paul Ince and then, with the decisive fifth attempt, David Batty joined 1990 villains Stuart Pearce and Chris Waddle in England's pantheon of World Cup penalty-shootout failures.

Argentina progressed and, for the second time in eight years, England cursed their frailties from the spot.

> "As I was trying to stand up, that was when he kicked me from behind. And I took advantage of that. And I think any person would have taken advantage of that in just the same way."
>
> **DIEGO SIMEONE**

THE JOY OF SIX FOR ŠUKER

1998

One of a quartet of tournament newcomers in France, the Croatia team were born in 1992 following the disintegration of the former Yugoslavia, and, in their first appearance in the World Cup, Miroslav Blažević's team came agonisingly close to going all the way to the final.

It would have been wrong to dismiss Croatia as rank outsiders ahead of the finals of 1998. The Vatreni, an embryonic nation, may have existed for only six years, but the team had already reached the quarter-finals of Euro 96 in what was their first foray in a major tournament and arrived in France with a growing sense of self-confidence.

They were drawn in Group H and kicked off their campaign with victories over Jamaica and Japan, and, although they were narrowly edged out by a single goal by Argentina in Bordeaux in their final first-round fixture, they progressed to the last 16 with little alarm.

Romania, at Bordeaux's Parc Lescure, stood between the Vatreni and a place in the quarter-finals, and a 1–0 win took Blažević's team through to the last eight, where they faced the might of reigning European champions Germany. Croatia's 3–0 triumph in Montpellier was as stunning as it was unexpected, and, although they were defeated by France in the semi-final, they signed off by beating the Netherlands 2–1 in Paris in the third-place play-off game.

It was a sensational tournament debut – equalling the feat of newcomers Portugal in 1966 who also reached the last four in their first finals, though they had failed to qualify six times – and put Croatian football on the map.

The undisputed star turn for the Croatians was 30-year-old Real Madrid striker Davor Šuker. The forward had netted three times at Euro 96 in England but was in even more prolific form in France as he finished as the tournament's top scorer with six goals in seven appearances to earn the coveted Golden Boot award.

He hit the ground running in 1998 with a goal in the 3–1 defeat of Jamaica in Lens, and six days later was crucially on target again with the only goal of the match against Japan at the Stade de la Beaujoire in Nantes.

The momentum was now with Šuker and he scored in all four of Croatia's knockout-phase assignments, signing off with the winner against the Dutch at the Parc des Princes, a fitting climax to what was a stunning first tournament for the striker and his nascent nation.

○○○

Left: Davor Šuker's six goals at France 98 saw him claim the Golden Boot, the sixth tournament in a row the accolade was won with a six-goal haul.

Right: Šuker's fifth goal in the 1998 World Cup came against France in the semi-final, but a double from Lilian Thuram put the hosts in the final.

"Of all the unimportant things in the world, football is the most important. The charm is that a small country can beat a major one. We proved it and people respected us ever since."

DAVOR ŠUKER

THE TALE OF TWO TEAMSHEETS

1998

From a French perspective the 1998 FIFA World Cup final was a euphoric evening as Les Bleus were crowned champions and a million people thronged the Avenue des Champs-Élysées in celebration. For Brazil it was a miserable night dominated before kickoff by the mystery surrounding star striker Ronaldo.

When Brazilian officials revealed Mario Zágallo's starting XI to face the French in Saint-Denis 72 minutes before the scheduled start of the final, reporters were stunned when they realised Ronaldo was not on the teamsheet. The name of the Seleção's top scorer in France with four goals was nowhere to be seen, replaced by Edmundo, a player who had made one solitary appearance from the bench in the whole tournament.

Half an hour later, Brazil issued an updated teamsheet, which now did feature their prolific number nine, and the assembled media inside the Stade de France, not to mention Seleção supporters, speculated feverishly about what exactly was happening inside the Brazil camp. The South Americans' failure to take to the pitch for a pre-match warm-up only heightened the sense of confusion.

Whispers about an internal dispute within the squad were rife. Some believed the striker was nursing a serious ankle injury, while others heard in the information vacuum that he was suffering from severe stomach cramps after being poisoned.

Brazil did emerge for the game itself but Ronaldo and his team-mates were strangely anaemic in the final against Aimé Jacquet's men. Two headers from Man of the Match Zinedine Zidane gave Les Bleus a 2-0 half-time lead and the Seleção remained uncharacteristically toothless in the second period despite Marcel Desailly being sent off in the 68th minute and, rather than cut the deficit, they leaked a third goal in injury time when Emmanuel Petit scored, and their misery was complete.

The inevitable avalanche of questions about Ronaldo quickly followed and a troubling story emerged.

The 21-year-old had suffered some type of convulsive fit in his sleep on the afternoon of the final. He had been rushed to a Parisian hospital, but neurological and cardiac tests identified no underlying problems, and he was released. Ronaldo made his way to the Stade de France and, seeing Edmundo's name and not his own on the teamsheet, the striker remonstrated with Zágallo and insisted he was fit to play.

Whether Ronaldo should have been allowed onto the pitch is debatable but, fully fit or not, he was powerless to stop France storming to their 3-0 victory and Brazil succumbing to what was then their heaviest ever World Cup loss.

> "We lost the World Cup but I won another cup —
> my life. I don't remember what happened but I
> went to sleep and, like the doctor said, it seems I
> had a fit for about thirty or forty seconds."
>
> RONALDO

Right: Brazil's second team sheet for the 1998 World Cup final in Paris, this time with 21-year-old Ronaldo in the starting line-up.

Left: Zinedine Zidane celebrates one of his two goals in the 1998 World Cup final, a match made famous by the pre-game illness suffered by Ronaldo.

THE 2002 FIFA WORLD CUP

The 2002 World Cup, in Japan and Korea Republic (South Korea), was a momentous one for the beautiful game: never before had a tournament been hosted jointly by two nations; it was the first finals in Asia; and, for the first time, teams from five different federations reached the last eight. Brazil, however, reasserted the old order with victory in the final for an unprecedented fifth world title.

ASIA TAKES CENTRE STAGE

2002

In the first World Cup of the twenty-first century, the 2002 finals were the first to be played outside Europe or the Americas. The new millennium breathed new life into the tournament as a number of football's lesser lights emerged from the shadow of the game's established powerhouses.

Japan and South Korea had initially tabled separate bids to stage the World Cup, vying with Mexico for the right to host the finals, but as the process unfolded pragmatism prevailed and the Asian rivals became allies and petitioned FIFA to award the tournament to both countries.

Having savoured the recent success of USA 94, the game's governing body was only too aware of the potential benefits of taking the competition to new territories and, in May 1996, the FIFA Executive Committee announced that the World Cup was heading to Asia, the two countries providing ten stadia each to fulfil the 64 scheduled fixtures.

Qualification began with the preliminary draw in December 1999 and, at the end of the process, the tournament welcomed Brazil, England, Germany, France, Uruguay, Argentina and Italy, the first time since 1990 that all previous winners qualified and defending champions France made it the first finals with seven former champions. There were four debutants, China, Ecuador, Senegal and Slovenia, while the Dutch were the biggest name absentees.

It would be an exaggeration to say the game's hierarchy was comprehensively turned on its head in the group stages, but there were a series of surprises that certainly gave the tournament an air of unpredictability.

In Group D European football received a rude awakening as both Portugal and Poland were sent home early, joint hosts South Korea and the USA advancing at their expense. The Americans' 3-2 win over the Portuguese in Suwon was undoubtedly a shock, but even that was eclipsed by Korea's 1-0 triumph over the same opposition in the Incheon Munhak Stadium nine days later.

Three former winners fell at the first hurdle: Uruguay failed to get out of Group A as Senegal proudly flew the flag for Africa, joining Denmark in the next round; Argentina were eliminated from Group F; while France's defence

ended very quickly, and their travails are discussed later.

In Group H there was a further surprise package in Japan. The Samurai Blue had made their World Cup debut four years earlier in France, but lost all three games. On home soil, however, they were an altogether different proposition. They began their tournament with a daunting fixture against Belgium in Saitama but held Robert Waseige's side to a 2-2 draw, and then went from strength to strength, beating Russia 1-0 in Yokohama, courtesy of a second-half goal from midfielder Junichi Inamoto. They went on, improbably, to top the group after a comfortable 2-0 defeat of Tunisia in Osaka.

○○○
Above: The opening ceremony of the 2002 World Cup finals in Seoul.

Left: The official spectator guide to the 2002 finals, the first and, to date, only time the tournament has been jointly hosted by two countries.

FRANCE CAPITULATE IN KOREA

2002

The 2002 World Cup was the last in which the defending champions qualified by right for the finals. Winners on home soil four years earlier, France went into the tournament dreaming of becoming only the third team to defend their crown but, from the moment Les Bleus took to the pitch, their challenge imploded spectacularly.

The last time the World Cup's reigning champions failed to progress beyond the first round of the next instalment of the tournament was in 1966, when an ageing and injury-ravaged Brazil squad faltered in England and found themselves relinquishing their title with barely a whimper.

No one expected Roger Lemerre's star-studded France squad to follow suit in 2002, but, in the space of 12 agonising days in South Korea, Les Bleus went from world champions to a national disgrace. The Brazilians of 1966 at least won one of their three group games – 36 years later, France could not muster a single victory or a solitary goal.

The French began their ill-fated Group A campaign against debutants Senegal – their former colony – in Seoul. They was not supposed to offer significant resistance to Les Bleus. Although Zinedine Zidane was absent through injury, France still boasted the undisputed collective talents of, among others, Patrick Vieira, Thierry Henry, Youri Djorkaeff and Marcel Desailly.

Bruno Metsu's men, however, were clearly not in the mood to be overawed by their first ever game in the finals, and, when midfielder Pape Bouba Diop exploited uncertainty in the France defence after 30 minutes to steer home El Hadji Diouf's cross, the underdogs were in front.

It was the only goal of the match and left the palpably dazed champions in desperate need of points from their upcoming games against Uruguay and Denmark.

The clash with the Uruguayans in Busan began with Lemerre's side in pursuit of an elusive goal, but, when

Henry was sent off after only 25 minutes, attack gave way to defence and France clung on for a goalless draw.

The stalemate left Les Bleus needing to beat the Danes by two clear goals five days later to prolong their involvement in the tournament. They were buoyed by the news of finally fit Zidane but even the return of the Man of the Match from the 1998 final was not enough to save the day.

Denmark drew first blood in the 22nd minute through Dennis Rommedahl and rubbed salt into the wound midway through the second half, when Jon Dahl Tomasson doubled the advantage. The French were beaten 2-0, their first defeat in a competitive fixture with Zidane in the side in eight years.

The champions were heading home with their tails firmly between their legs.

> "It is the biggest moment ever for our team and a big moment for the World Cup. It's like a dream — not a miracle though."
>
> SENEGAL COACH BRUNO METSU

Left: *A press ticket from France's draw against Uruguay in Busan, Korea. A record 20 venues were used for the 2002 finals, ten in both host countries.*

Above: *Dennis Rommedahl celebrates after his opening goal for Denmark against France in Incheon piled on the misery for Roger Lemerre's team.*

BECKHAM'S REVENGE IN SAPPORO

2002

It has become mandatory for modern World Cups to feature a "Group of Death" and in 2002 that designation fell to Group F as England, Argentina, Sweden and Nigeria crossed swords in Japan. It was a draw that also tantalisingly threw together perennial foes, Sven-Göran Eriksson's England and Marcelo Bielsa's Argentina, for a second successive tournament.

The last time England had played Argentina in the finals in France in 1998, David Beckham saw red and the South Americans won on penalties. The then 23-year-old midfielder was widely vilified for his indiscipline in Saint-Étienne and it took the country time to forgive the errant Manchester United star.

Four years later it was an older and wiser player in evidence in Japan. Beckham was now the England captain and, as the Argentina game approached, it was the teams' second matches in the group, the feverish pre-match build-up, was dominated by talk of redemption and revenge in the Sapporo Dome.

Perhaps fittingly, Diego Simeone, Beckham's nemesis in France, was also in the Argentinian XI for the game and, as the teams emerged from their respective dressing rooms for a fifth World Cup finals meeting between the two countries, the atmosphere was electric.

Their clash in 1998 had produced four goals but one was enough to settle proceedings in 2002, and it was Beckham who scored it in the 44th minute after Michael Owen was hacked down by Mauricio Pochettino in the area. The skipper stepped forward to take the resulting spot-kick and smashed his penalty low and hard down the middle to give La Albiceleste goalkeeper Pablo Cavallero no chance.

Beckham wheeled away in delight, kissing the Three Lions badge in celebration of his act of atonement, and, although Argentina laid siege to the England goal for long periods of the second half, Sven-Göran Eriksson's side repelled all advances for a crucial 1–0 victory.

The result was as cathartic for England, as it was for the captain personally. In addition, after losing to Argentina in 1986 and 1998, it meant England led the World Cup head-to-head with La Albiceleste 3–2, having won in 1962 and 1966.

This win was pivotal as England completed the opening stage with a goalless draw against Nigeria in Osaka to finish second in the group. Simultaneously, Argentina shared two goals with Sweden in Miyagi, but this point was not enough to avoid an early tournament exit for La Albiceleste.

> "It is a fantastic feeling. It puts the ghosts of France 98 to rest once and for all."
>
> DAVID BECKHAM

Left: *David Beckham's penalty for England against Argentina in Sapporo was key in condemning La Albiceleste to an early exit from the finals.*

Above: *The Fevernova was the official match ball for the 2002 World Cup finals. It produced an entertaining average of 2.5 goals per game.*

THE AHN JUNG-HWAN AFFAIR

2002

South Korea's march through to the semi-finals of the 2002 World Cup was the fairytale of the tournament, but for one of the stars of the Red Devils' incredible journey the story had a darker side with unexpected repercussions thousands of miles away.

It took a 75th-minute strike from Germany's influential midfielder Michael Ballack to finally bring to an end South Korea's remarkable World Cup run. It was the only goal of the semi-final in Seoul, but, despite the initial disappointment of going out, the Red Devils could reflect on a truly incredible tournament.

They had never progressed beyond the group stage in five previous appearances in the finals, but after winning Group D they pulled off what many believed impossible by beating Italy in the last 16 and then Spain in the quarter-finals before finally succumbing to the Germans.

The famous victory over the Azzurri in Daejeon was dramatically sealed in the 117th minute when midfielder Ahn Jung-hwan rose above the Italian defence to head home Lee Young-pyo's cross past Gianluigi Buffon at the near post. It was a golden goal and, while South Korea

stormed into the last four, the Azzurri packed their bags for the flight home.

At the time of the match, however, Ahn Jung-hwan was playing his club football in Italy, on loan to Serie A side Perugia from South Korean club Busan FC. Perugia's owner, Luciano Gaucci, watched Ahn's heroics with anger rather than admiration and the day after the game he announced he had cancelled the player's contract with the club.

"That gentleman will never set foot in Perugia again," Gaucci raged. "I am a nationalist and I regard such behaviour not only as an affront to Italian pride but also an offence to a country which two years ago opened its doors to him. I have no intention of paying a salary to someone who has ruined Italian soccer."

The wider football fraternity reacted furiously to Ahn's treatment and, under severe pressure from all sides, Gaucci quickly did a *volte-face* and offered to take up the option to make the player's move from Busan to Perugia permanent in a £1.2 million deal.

The Korean star, however, was more than unimpressed by the owner's gesture and refused to report for preseason training with Perugia. Instead, he signed for Japanese club Shimizu S-Pulse. He did eventually return to European club football, playing for Metz in France and MSV Duisburg in Germany, but he never forgot or forgave Gaucci's behaviour.

ooo

Above: *Ahn Jung-hwan's golden goal for South Korea sent Italy home from the 2002 World Cup, but it set in motion a strange train of events.*

Left: *Perugia owner Luciano Gaucci was condemned around the world when he decided that Ahn was no longer welcome at his club or the town.*

THE RENAISSANCE OF RONALDO

2002

The outstanding player of the tournament in 2002, striker Ronaldo had unfinished business in the World Cup final when Brazil faced Germany in Yokohama. Ronaldo had been anonymous in the final of 1998 and the loss to France but four years on he was the difference between the two sides as the Seleção won a famous fifth title.

Ronaldo was 25 years old by the time the finals in Japan and South Korea came around. The striker was at the peak of his powers and, since he had suffered the nightmare of being rushed to hospital only hours before the 1998 final, many believed the time had now come for him to shine on the game's greatest stage.

He had scored four times in France before the drama of his impromptu medical emergency to propel the Seleção so close to the trophy, but in Asia he was in even more imperious form, netting six times en route to the showdown with Die Mannschaft. His haul included the all-important winner in the side's 1–0 semi-final success against Turkey in Saitama and, as the final approached, he was the Brazilian player Rudi Völler's team feared the most.

German trepidation proved well founded. They kept the striker at bay for 67 minutes in Yokohama but, when Oliver Kahn failed to sufficiently smother a speculative shot from Rivaldo, Ronaldo was on hand to pounce for the opening goal of the game. Twelve minutes later he doubled his tally and Brazil's advantage. Rivaldo's audacious dummy on the edge of the box created enough time and space for his team-mate, and Ronaldo beat Kahn for a second time with a clinical finish from just inside the area. There was no way back for Germany. Brazil had won the World Cup for a record-extending fifth time, and their 32-year-old captain Cafu had become the first player to appear in three consecutive finals. The Seleção party began in earnest.

His two goals in the final took Ronaldo to eight for the tournament. It was a haul that comfortably eclipsed the five scored by both Rivaldo and Germany's Miroslav Klose and earned him the Golden Boot. He was the first Brazilian to walk away with the coveted award since Garrincha and Vavá were involved in a six-way tie for the accolade at the 1962 finals in Chile.

His eight goals were the most in the finals since Gerd Müller scored ten in Mexico in 1970 and, after six successive tournaments in which the top scorer had finished on six, his return was all the more impressive.

> "Slowly I am starting to understand what has happened to me and this Brazil team. To hold the World Cup in my hands, which I have just experienced, is one of the most incredible experiences of my life."
>
> RONALDO

Left: Ronaldo (centre) and Ronaldinho (right) autographed their lockers in the dressing room in Yokohama before the kick off at the final.

Above: A crowd of 69,029 witnessed Brazil defeat Germany 2–0 in the final to cement their reputation as the greatest country in World Cup history.

FIFA FUSSBALL-WELTMEISTERSCHAFT
DEUTSCHLAND 2006

9. Juni – 9. Juli 2006

THE 2006 FIFA WORLD CUP

The tenth European edition of the tournament and the second to call Germany home following the first staging of the finals in what was then West Germany 32 earlier, the 2006 World Cup tells a story that was an Italian one, as the Azzurri were crowned world champions for a fourth time.

NEW FACES IN THE FINALS

2006

For the first time since the finals in Spain in 1982 and third time ever, all six confederations were represented at the World Cup in Germany. Eight of the 32 geographically disparate hopefuls were experiencing the tournament for the first time and the new boys enjoyed contrasting fortunes as the competition unfolded.

Never before in finals history had the competition welcomed so many debutants. Some 198 nations entered qualifying, and at the end of the process Angola, Czech Republic, Ghana, Ivory Coast, Serbia and Montenegro, Togo, Trinidad and Tobago and Ukraine had all earned the right to play in Germany.

The quartet of African newcomers bolstered the continent's contingent in 2006 to five and all three made a mark on the finals. The draw did the Ivorians no favours, as they were drawn in Group C against both Argentina and the Netherlands, and, although they lost both fixtures 2-1, the Elephants, to give them their nickname, went home celebrating the country's first ever win in the finals after a 3-2 triumph over Serbia and Montenegro in Munich. One week later, Serbia and Montenegro went their separate ways after the two nations declared independence from each other, making the match in the Allianz Arena the last ever international assignment for the amalgamated side.

In Group D, Angola proved a tough team to break down and, although they were beaten 1-0 by Portugal in Cologne, they registered creditable draws with Mexico and Iran in their tournament bow. In Group G, Togo were rather out of their depth and lost all three fixtures.

Ghana, however, were the standout African team. They were beaten by the Italians in Hanover in their Group E opener, but the Black Stars regrouped and made the last 16 at the first time of asking after beating the Czech Republic and then overcoming the USA 2-1 in Nuremburg, courtesy of goals from Haminu Draman and skipper Stephen Appiah. Their run was brought to an abrupt end by Brazil in Dortmund, but the Ghanaians had already flown the flag for African football in considerable style.

The other success story among the debutants was Ukraine who progressed to the quarter-finals. Oleg Blokhin's team finished second in Group H, behind Spain, after wins over Tunisia and Saudi Arabia and booked their place in the last eight by defeating Switzerland on penalties in Cologne. Italy proved too strong for them in the quarter-finals, but Ukraine had, nonetheless, defied expectations.

The other two first-time finalists both failed to get out of their respective groups. The Czech Republic finished third in Group E, but opened their World Cup account with a 3-0 demolition of the United States in Gelsenkirchen. Trinidad and Tobago were outgunned in Group B, finishing bottom, but took solace from an opening goalless draw with Sweden in Dortmund, before losing 2-0 to England in Nuremberg – both goals coming in the last seven minutes – and 2-0, again, to Paraguay in Kaiserslautern, who made the game safe with only four minutes of normal time remaining.

○○○

Left: Didier Drogba's Ivory Coast failed to go beyond the group stages on debut in Germany but still made a significant impact on the finals.

Above: A costume, in Brazil colours, worn during the opening ceremony of the 2006 World Cup finals in Germany.

EUROPEAN ASCENDENCY ON HOME SOIL

2006

The early stages of the 2006 World Cup were notable for the surprise progress of teams such as Australia, Ghana, Ukraine and Ecuador, but, once the last 16 gave way to the quarter-finals and beyond, the tournament assumed a decidedly more traditional tone as the heavyweights of the European game asserted their authority.

Germany came to a halt on 9 June, when the hosts began their World Cup campaign against Costa Rica in Munich. Jürgen Klinsmann's side ensured there was no upset in the Allianz Arena, running out 4-2 winners against the Central Americans, and it was a similar story of European dominance as the rest of the finals unfolded.

Die Mannschaft reached the quarter-finals with few alarms. They were joined by Continental rivals France, Italy, England, Portugal and Ukraine, and, although defending champions Brazil and Argentina remained in the hunt, the last eight was a bridge too far for the two surviving South American representatives.

Brazil surrendered their crown after going down 1-0 to France in Frankfurt, courtesy of a second-half strike from Thierry Henry, while Argentina were profligate from the penalty spot in Berlin, losing 4-2 in a dramatic shootout against Germany.

The 2006 World Cup was now an exclusively European affair for only the fourth time in finals history and for the first time since 1982.

The first of the semi-finals pitted Die Mannschaft against Italy in Dortmund. Germany was still dreaming of a repeat of the heroics of the team of 1974, winners on home soil, but the Azzurri were in no mood to accommodate their hosts.

Both defences stood resolute for 90 minutes. The first 15 minutes of extra time also failed to yield a goal and, with 119 minutes on the clock, the contest seemed destined to be decided from the spot, only for Fabio Grosso to finally break the deadlock with an exquisite left-footed effort from the edge of the area. Remarkably, there was still enough time for Alessandro Del Piero to score a second Italian goal and the hosts were left with only the third-place play-off to look forward to.

The second semi-final, 24 hours later, between France and Portugal in Munich, was another tense, tight encounter. The starting XI for Les Bleus boasted an average age of 30 years and ten days, the second oldest for a any team playing in a World Cup semi-final, and they needed all their experience to overcome the Portuguese.

The pivotal moment came in the 33rd minute, when Henry was fouled inside the area by Ricardo Carvalho and Uruguayan referee Jorge Larrionda immediately pointed to the spot. Up stepped Zinedine Zidane, who converted the penalty to send France into the final.

> "What a bitter pill to swallow. The dream didn't come true."
>
> JÜRGEN KLINSMANN

Left: A ticket form the opening match of the World Cup when a high-scoring match saw Germany see off their tricky Coast Rican opposition.

Above: The pennant presented by Costa Rica captain Luis Marín to Germany's skipper Bernd Schneider before the opening game in 2006.

KLOSE KEEPS SCORING

2006

Germany's heartbreaking defeat to Italy in Dortmund in the World Cup semi-finals was the catalyst for national dismay, but consolation was on hand for the hosts in the shape of the prolific exploits in front of goal of striker Miroslav Klose.

If the 2002 World Cup in Japan and South Korea was the tournament at which Klose first rose to international prominence, his five goals for Die Mannschaft included only the second World Cup hat-trick of headers, the 2006 instalment of the finals was the stage on which the striker cemented his reputation as a genuine world class finisher.

His five goals in the Far East were all headers, a record for the finals of the World Cup, and, although Klose expanded his scoring repertoire in Germany four years later, he was just as lethal inside the box.

The hosts began their tournament against Costa Rica in Munich in the opening fixture of the competition. It was the day of Klose's 28th birthday and the Werder Bremen player celebrated the occasion with two goals in an entertaining 4–2 victory for Jürgen Klinsmann's side.

His first was a predatory, sliding, left-footed finish from a Bastian Schweinsteiger cross, while the second almost came from his head, Klose's initial effort parried by the goalkeeper only for the striker to react more quickly to the loose ball and score at the second time of asking.

It took him only four minutes to add to his burgeoning tally in the Group A encounter with Ecuador in Berlin's Olympiastadion, Klose pivoting beautifully to convert another Schweinsteiger pass. He scored his second of the match moments before half-time, when he collected a ball from Michael Ballack and went around the Ecuadorian goalkeeper.

His fifth and final goal of the tournament was the most important in the finals and saw Klose revert to using his head to get the job done. With just ten minutes left on the clock, Germany were trailing Argentina 1–0 in the quarter-finals in Berlin, but Klose saved the day with a powerful header from Tim Borowski's flick, which sent the match into extra time. Die Mannschaft won 4–2 in the ensuing shootout and, not for the first time, they were heavily indebted to their remarkably reliable centre-forward.

Klose's five-goal haul earned him the Golden Boot at the end of the tournament. In collecting the award, he became only the second German player to claim the coveted prize and followed in the illustrious footsteps of Gerd Müller, the top scorer in the finals of 1970.

> "I'm not scared of any opponent. The only thing I'm scared of is injuries and sickness."
>
> MIROSLAV KLOSE

Left: Miroslav Klose's fifth goal in the 2006 final took Germany's quarter-final clash with Argentina to a penalty shootout, which the hosts won 4–2.

Above: The Golden Boot presented to Klose in 2006 after he joined Gerd Müller (1970) as the only German winners of the goalscoring trophy.

THE BATTLE OF NUREMBERG

2006

The 2006 World Cup was statistically the most undisciplined in the history of the tournament, and the players' lack of self-control on the pitch was embodied by the ill-tempered and acrimonious last-sixteen meeting between Portugal and the Netherlands inside the Frankenstadion in Nuremberg.

FIFA selected a total of 21 referees to officiate at the finals and they were all kept busy as the competition progressed in Germany. Argentinian referee Horacio Elizondo had cause to brandish just one yellow card in the opening game between the hosts and Costa Rica, booking the Ticos' midfielder Danny Fonseca, but the game in Munich proved to be the calm before the storm.

By the end of the tournament an unprecedented 28 red cards and 345 yellow had been issued by officials in the 64 fixtures. No finals before or since has witnessed such a deluge of dismissals and cautions.

The first player to get his marching orders was Trinidad and Tobago full-back Avery John in his side's Group B opener against Sweden, while France's Zinedine Zidane became the 28th and last player to be sent off following his infamous head-butt on Marco Materazzi during extra time of the final against Italy.

The nadir of the ill-discipline came in Nuremberg as Portugal and the Netherlands crossed swords. Russian Valentin Ivanov was the man charged with refereeing the contest and the tone of the game was set as early as the second minute when Dutch midfielder Mark van Bommel went into the book. Incredibly, Ivanov reached for his pocket a total of 20 times over the course of the 90 fractious minutes in the Frankenstadion, showing 16 yellow and four red cards in what has become known as the "Battle of Nuremberg".

Seven Portuguese and five Dutch players were booked. The first sending-off occurred in first-half injury time, when Portugal midfielder Costinha was yellow-carded for a second time and he was joined in the dressing room by team-mate Deco after 78 minutes. The Dutch also had two players dismissed for two bookable offences. Full-back Khalid Boulahrouz incurred Ivanov's ire for the second time in the 63rd minute, while fellow full-back Giovanni van Bronckhorst also saw red deep into second-half injury time.

The game did have one goal, scored by Portugal's Maniche, mid-way through the first half. The ugly scenes displeased FIFA president Sepp Blatter, who blamed Ivanov rather than the players for the unedifying events in Nuremberg. He was quickly forced to apologise for his remarks.

> "I consider that today the referee was not at the same level as the participants, the players. There could have been a yellow card for the referee."
>
> SEPP BLATTER ON THE "BATTLE OF NUREMBERG"

Left: Russian referee Valentin Ivanov was criticised by the FIFA hierarchy after showing 20 cards in a last-16 tie between the Netherlands and Portugal.

Above: Luis Figo and Mark van Bommel go head to head during the feisty encounter at Nuremberg Stadium. Both received yellow cards.

ZIDANE'S MOMENT OF MADNESS

2006

The 2006 World Cup final was only the second in tournament history to be settled by a penalty shootout, Italy holding their nerve from the spot to triumph over France in Berlin, but the match will for ever be remembered for Zinedine Zidane's infamous extra-time red card.

The first exclusively European final since 1982, the climax of the 2006 finals at the Olympiastadion in the German capital was watched by a crowd of 69,000 and was a game dominated by two very different players.

The first was the mercurial Zidane, the talisman of French football and one of four survivors from France's final triumph in Paris eight years earlier. The second was Italy's Marco Materazzi, a rugged centre-half well versed in the game's darker arts.

Zidane had scored twice in the Stade de France in 1998 to dispatch Brazil and he was on the scoresheet in the final once again in 2006. Materazzi was adjudged to have brought down Florent Malouda in the box after only six minutes and the French skipper converted from the spot with an audacious chip, which went in off the underside of Gianluigi Buffon's crossbar.

Twelve minutes later, Materazzi atoned for his error. Andrea Pirlo delivered an inviting corner kick from the right and the defender rose above the French defence to power home the equaliser from close range. Both sides had chances to win inside 90 minutes, but it was 1–1 when the full-time whistle sounded and the final headed into extra time. The world was about to witness a moment of inexplicable indiscipline from the tournament's best player.

It came in the 110th minute. Materazzi tugged at the Frenchman's shirt, the two exchanged angry words but Zidane initially walked from the scene. But he then suddenly turned around and headbutted the Italian in the chest and sent the defender tumbling to the ground.

Argentinian referee Horacio Elizondo did not see the incident but after consulting with fourth official, Luis Medina, he reached for his pocket and Zidane saw red, the fourth player to be dismissed in a World Cup final and the first in extra-time.

Whether Zidane – playing in the final match of his illustrious career – could have saved Les Bleus in the shootout that followed is a moot point. Italy were on target with all five of their penalties in Berlin, while striker David Trezeguet, the man who had scored the golden goal for France when they beat the Azzurri in the Euro 2000 final, hit the crossbar with France's second attempt to hand the title to Marcello Lippi's team.

The post-match headlines should have been dominated by stories of Italy's fourth World Cup triumph. Instead, sadly, it was the incredulous reaction to Zidane's attack on Materazzi that everyone was talking about.

ooo

Above: "Goleo'" (a lion) and "Pille" (a football) were the two joint official mascots of the 2006 finals.

Right: "Coup de tête" ("the headbutt"), a statue depicting Zinedine Zidane's infamous attack on Marco Materazzi, on display at Paris's Pompidou Centre.

"He said very harsh words to me and repeated them several times. The words he said concerned my mother and sister. I heard them once, then twice, and the third time I couldn't control myself."

ZINEDINE ZIDANE

THE 2010 FIFA WORLD CUP

FIFA took the World Cup to a fifth different continent when it chose South Africa to host the finals in 2010. The new destination also yielded new winners as Spain became the eighth nation to be crowned world champions and first European team to lift the trophy outside their home continent.

THE BLACK STARS SHINE

2010

Africa had arguably waited too long to stage the World Cup finals, but, when football's biggest party finally came to the continent in 2010, South Africa provided the backdrop for a tournament that was awash with incident, entertainment, controversy and atmosphere.

The first time an African nation bid to stage the finals, Morocco lost out to the USA in the battle to host the 1994 tournament. The North Africans tried again four years later but they were outmanoeuvred by France and the continent's exclusion from finals football was prolonged.

FIFA, however, realised such a state of affairs was untenable and, when the bidding process for the 2010 finals was announced, the game's governing body confirmed it would entertain applications only from African countries. Egypt, Morocco, South Africa, as well as Libya and Tunisia jointly, all threw their hats into the ring and, in 2004 in Zurich, the South African bid was revealed to be the victorious one.

An incredible 204 nations entered qualifying, making the 2010 World Cup, along with the 2008 Summer Olympics, which also had 204 competing nations involved, the event with the most competing countries in sporting history. Slovakia were the only debutants in the finals in the Rainbow Nation, but it was the story of the competition's Africa contingent, as well as the fate of the two finalists of 2006, that generated the most column inches.

For the first time Africa had six teams in the competition and, to recognise football South African style, FIFA allowed fans to bring into the stadium their vuvuzelas, small horns. The result was matches played to a cacophony of noise. There was huge disappointment as South Africa failed to get out of Group A, becoming the first hosts to fail to progress beyond the first group phase, but the continent nonetheless had cause for celebration after Ghana finished second behind Germany in Group D and marched into the

last 16. With Nigeria, Algeria, Cameroon and Ivory Coast also falling at the first hurdle, the Black Stars were the only African team through to the knockout stages.

Ghana then beat the USA 2-1 in Rustenburg and, although they were controversially beaten by Uruguay in the quarter-finals, cruelly denying Milovan Rajevac's team the distinction of becoming the first African side ever to reach the last four, the Black Stars' exploits were perfectly timed as the continent took centre stage.

It was to be a chastening World Cup for France and Italy, the two finalists four years earlier. The French were beset with internal indiscipline and animosity between manager Raymond Domenech and his players, and the disharmony off the pitch was reflected on it as Les Bleus bowed out of Group A with barely a whimper, losing to both Mexico and South Africa, their solitary point coming after a goalless draw with Uruguay in Cape Town.

The defending champions Italy fared little better, finishing rock bottom of Group F. Draws with Paraguay and New Zealand in their first two games were not initially fatal, but a 3-2 loss to Slovakia in Johannesburg in their last game sent Marcello Lippi's team home unexpectedly early.

ooo

Above: The opening ceremony of the 2010 finals at Soccer City in Johannesburg was a fitting celebration of Africa's first World Cup.

Left: The vuvuzela proved to be an always noisy and ubiquitous, if not universally popular, feature of the 2010 World Cup finals in South Africa.

THE GREAT JABULANI DEBATE

2010

The 1970 World Cup finals in Mexico were the first for which Adidas supplied the official match ball, the iconic black-and-white, 32-panel Telstar. The German sportswear giant had manufactured the balls for every tournament since, but none of its creations had ever generated as much controversy as the Jabulani ball in South Africa in 2010.

Developed by Adidas in conjunction with academics from Loughborough University in England, the Jabulani ball was made from eight moulded panels with a textured surface, which the company claimed would improve its aerodynamic performance.

A Zulu word meaning celebration, the Jabulani actually made its tournament debut at the FIFA Club World Cup in the United Arab Emirates in 2009, and was subsequently used during the 2010 African Cup of Nations in Angola. But it was at its appearance at the World Cup, later the same year, that serious questions were raised about the quality of the ball.

The alleged problem was that the flight of the Jabulani was too unpredictable. Players were adamant that the ball was too light and too aerodynamic, and such was the talk of its failings in South Africa that it almost became a self-fulfilling prophecy as every minor deviation or deflection was blamed on the design of the Jabulani.

Unsurprisingly, members of the goalkeeping fraternity were the most vociferous in their criticism of the ball. "It's very sad," said Spain keeper Iker Casillas, "that a competition so important as the world championship will be played with such a horrible ball." Italy custodian Gianluigi Buffon was equally unimpressed. "The new model is absolutely inadequate," he said. "I think it's shameful letting [us] play such an important competition, where a lot of champions take part, with a ball like this."

The Jabulani did, however, have some, albeit only a few, supporters. "For me, contact with the ball is all important," said Brazil playmaker Kaká. "That's just great with this ball." Portugal coach Carlos Quieroz was another convert, although his endorsement was doubtless heavily influenced by the fact his side had just thrashed North Korea 7-0 in Cape Town. "We love the ball," he insisted. "We need to be engaged to produce great entertainment and forget this discussion about the ball. A World Cup is all about entertainment, football skills and goals. Not about these secondary things."

Adidas's official line was that the company was "surprised" by the negative feedback and its defence of the Jabulani was lent some weight when the tournament finished and the goals were added up. A total of 145 were scored in South Africa, the second lowest tally in the 32-team era of the finals, suggesting the Jabulani was not quite the spherical demon its many critics maintained.

○○○

Above: Germany's Thomas Müller shoots the Jabulani past Australian goalkeeper Mark Schwarzer, but the ball was a source of controversy.

Right: The Jabulani ball did strange things when struck, but few critics took account of the altitude, especially in Johannesburg and Pretoria.

> "It's like one of those balls you buy in the supermarket."

BRAZIL GOALKEEPER JÚLIO CÉSAR

ECSTASY AND AGONY FOR THE ALL WHITES

2010

The third-lowest ranked side at the finals in 2010, New Zealand's expectations at the World Cup were nothing if not modest. Bizarrely, the Kiwis returned from South Africa as the only unbeaten team in the tournament and yet they failed to progress past the group stage.

Boasting a lowly FIFA world ranking of 78, only hosts South Africa and North Korea were considered weaker opposition. Ricki Herbert's New Zealand squad arrived in South Africa for what was only the country's second World Cup foray.

The All Whites' first appearance in the finals had come in Spain in 1982 and it was not a successful adventure. Drawn in Group 6 alongside Brazil, the Soviet Union and Scotland, New Zealand leaked 12 goals in three heavy defeats and bade farewell to the competition without a single point to their name.

Herbert had been part of that outclassed Kiwi squad in 1982 but, when he returned to the World Cup stage as manager 28 years later, the Aucklander experienced an altogether different tournament as his unheralded side shone in South Africa.

They began their Group F campaign against Slovakia in Rustenburg. They went behind in the Royal Bafokeng Stadium five minutes into the second half, but three minutes into injury time they staged a dramatic, last-gasp fightback when defender Winston Reid headed home the equaliser.

Five days later they faced four-times world champions

Italy in Nelspruit. The Azzurri manager Marcelo Lippi had warned of New Zealand's aerial threat in the build-up to the match, and his concerns proved prophetic in the Mbombela Stadium as the All Whites took a shock lead. Midfielder Simon Elliott struck a free kick from the left. Reid rose highest to flick the ball on and striker Shane Smeltz was in the right place at the right time to score.

Italy equalised on the half-hour, thanks to a Vincenzo Iaquinta penalty and, although the Azzurri laid siege to the Kiwi goal in the second half, Herbert's side held firm for the draw. It was by a considerable distance the most famous football result in the history of a country that did not even boast a professional domestic league.

What was to cruelly prove to be the All Whites' final assignment was against Paraguay, and they maintained their unbeaten record with a goalless draw in Polokwane. At the same time, however, Slovakia were, against the odds, beating Italy 3-2 to earn the three points that sent them through to the last 16 at the expense of Herbert's heroes.

As the eventual champions Spain lost their opening group match, 1-0 to Switzerland in Durban, it made New Zealand the only unbeaten team in the 2010 World Cup.

> "We will not go through another World Cup unbeaten. It is only our second time at the World Cup so to come here and completely reverse what we did before is amazing."
>
> RICKI HERBERT

○○○
Left: *The shirt worn by New Zealand captain Ryan Nelsen in the All Whites' opening game of the 2010 finals, a 1–1 draw against Slovakia.*

Above: *Shane Smeltz's goal against Italy earned New Zealand a famous draw, but Ricki Herbert's undefeated team were still heading home early.*

SUAREZ OFF, GYAN OFF TARGET

2010

Africa was dreaming of a first-ever World Cup semi-final for an African side as Ghana faced Uruguay in Johannesburg in the last eight in 2010, but the host continent's hopes were dashed by a notorious act of cycnical professionalism from unrepentant La Celeste striker Luis Suárez.

Ghana's march into the quarter-finals in South Africa was exactly what the first tournament to be held in Africa needed. The hosts' early elimination was not unexpected and in the absence of the Bafana Bafana – the South African side – the Black Stars were adopted as the continent's flag bearers.

The clash with the Uruguayans in Soccer City was highly charged from the very first minute, but it was Ghana who drew first blood, in first-half injury-time, when Sulley Muntari scored with a long-range effort, which beat Fernando Muslera.

The South Americans were back on level terms ten minutes after the break, courtesy of a Diego Forlan free-kick, and, although Uruguay enjoyed the lion's share of possession and territory, Ghana stood tall to take the match into extra time.

The prescribed 30 additional minutes had all but expired in Johannesburg when Suárez made his first entry onto the list of the World Cup's most infamous villains.

Ghana pressed for a dramatic late winner. Stephen Appiah was legitimately denied by Suárez's knee on the line but Uruguay failed to clear their lines and substitute striker Dominic Adiyiah rose above a mêlée of bodies to head what seemed certain to be the winner. Suárez was still stationed on the goal line but the header was too high for him to legally block and he threw up a hand to palm the ball to safety.

Portuguese referee Olegário Benquerença saw the incident clearly and did what he had to do: show the Uruguayan a straight red card and award a penalty, but it was heartbreak for Ghana as Asamoah Gyan's resulting

Above: Ghanaian Makarapa hats were in evidence at South Africa in 2010 as their supporters roared the Black Stars into the World Cup last eight.

Right: Asamoah Gyan (3) and his Ghanaian team-mates sit disconsolately after losing the quarter-final penalty shoot-out against Uruguay.

> "I made the best save of the tournament. It was worth being sent off in this way for because at that moment there was no other choice."
>
> LUIS SUÁREZ

penalty struck the top of the crossbar and went over.

To his credit Gyan showed his courage when he volunteered to take Black Stars' first attempt in the penalty shootout which followed, this time scoring, but team-mates John Mensah and Adiyiah were not as accurate, and it was Uruguay who went through to the semi-finals.

It was the cruellest way imaginable for Ghana to say goodbye to the tournament and their justifiable sense of outrage was compounded only by Uruguay's obvious lack of contrition. "Saying that Ghana were cheated out of the game is too harsh," insisted La Celeste manager Óscar Tabárez. "We have to go by the rules." Ghana boss Milovan Rajevac, however, spoke for much of the rest of the sporting world when the labelled the result a "sporting injustice".

INIESTA'S LATE, LATE SHOW

2010

The first World Cup final in 32 years to feature two sides yet to lift the trophy – the Dutch had lost to hosts Argentina in 1978 – the clash between Spain and the Netherlands in Johannesburg was the fourth in tournament history to require extra time to separate the two protagonists.

When Spain and the Netherlands' teams took to the pitch inside Soccer City, the watching public already knew the World Cup would shortly be engraved with a new name. The Dutch, beaten finalists in 1974 and again four years later, dared to dream it would be third time lucky in South Africa, while only Spain supporters of a particular vintage could remember the team's best finals finish – fourth in Brazil in 1950 – but they were the current European champions.

The reputation of both nations for stylish football preceded them, but in the final it was indiscipline rather than invention that dominated proceedings in Johannesburg, as English referee Howard Webb found himself in a recurring battle to stay in control of the match.

Webb reached into his pocket to show a yellow card 14 times during the final. It eclipsed the previous record of six yellows brandished back in 1986 in Mexico when Argentina and West Germany met in the showpiece game. Eight Dutch players and five from Spain were cautioned and the Netherlands had to play the last 11 minutes of extra-time with ten men after defender John Heitinga was shown a second yellow and the inevitable red card to be sent off.

It was in the wake of Heitinga's extra-time dismissal that Spain made the most of their numerical supremacy and struck the killer blow and avoided the vagaries of what seemed a certain penalty shootout.

Winger Jesús Navas began the attack four minutes from the end with an injection of pace down the right flank. The Dutch midfield brought him to a stop but the ball bounced Spain's way and they moved further forward and pumped the ball into the box. It was only half cleared. Substitute Cesc Fàbregas picked up possession, and then picked out Andrés Iniesta, and the industrious midfielder beat Maarten Stekelenburg with a resounding half-volley, which rocketed into the far corner.

Iniesta's winner was the latest ever opening goal of a World Cup final. More significantly, it was a stunning finish to a match that had failed to live up to expectations, but Spain cared little about the quality of the contest as they finally lifted the elusive trophy for the first time, seventy-six long years after they'd made their tournament bow, and in the process became the first European side to triumph in the finals outside Europe.

> "I can't quite believe it yet. It is something absolutely incredible. I simply made a small contribution to a match that was very tough, very rough."
>
> ANDRÉS INIESTA

Above: *The shirt worn by English referee Howard Webb in the 2010 World Cup final, when he showed a record 14 yellow and one red card.*

Left: *Andrés Iniesta's extra-time winner in the final was his second goal in South Africa 2010 and saw Spain crowned world champions for the first time.*

2014 Copa do Mundo da FIFA™ Brasil

12 junho – 13 julho

FIFA WORLD CUP
Brasil

THE 2014 FIFA WORLD CUP

The World Cup returned to South America in 2014 after a 36-year absence as Brazil hosted the competition for a second time. Europe, however, ruled the roost for a third consecutive tournament as Germany narrowly overcame Argentina in the final in Rio de Janeiro.

SPAIN DETHRONED IN RIO

2014

Brazil, generally acknowledged as the world's most fervent football nation, had last hosted the World Cup in 1950 and, after more than half a century of waiting to throw the party again, the finals headed back to South America's most populous country and the most successful nation in the tournament's history.

When FIFA turned its thoughts to the destination of the 2014 finals, the game's governing body was adhering to its now defunct policy of rotating the competition between its constituent confederations. Argentina had been the South American Football Confederation – CONMEBOL's – most recent country to stage the tournament back in 1978, and FIFA ruled the World Cup would return to South America.

Only Brazil and Colombia tabled official bids to host the finals, but the Colombians subsequently withdrew, offering no explanation for their sudden change of heart, and in 2007 FIFA confirmed Brazil had been elected unopposed as the venue for the World Cup. In the wake of the finals in South Africa in 2010, the decision meant for the first time ever two consecutive finals would be staged outside Europe.

A grand total of 820 qualifying matches were played by 203 countries to determine the 31 teams to join the Seleção, but, after such a labyrinthine process, the finals had a rather familiar feel to them, as 24 of the 32 sides who

had been on show in South Africa four years earlier made the cut. Only Bosnia and Herzegovina were making their tournament debut.

All eight former world champions were in Brazil but, while the hosts cruised through the group stages with little alarm, three previous winners suffered embarrassingly early exits. The most high-profile casualties were defending champions Spain. Vicente del Bosque's side were also the two-time reigning European champions, but they were poor in South America. They opened their Group B campaign with a humiliating 5–1 defeat to the Netherlands – the team they had beaten in the 2010 final – in Salvador. Their 2–0 loss to Chile five days later in the Maracanã confirmed La Roja were in terminal decline and, although they beat Australia – the lowest-ranked side in the finals – in their last fixture, it was not enough to avoid the ignominy of surrendering their title at the earliest opportunity.

England and Italy also crashed out as Costa Rica and Uruguay unexpectedly dominated Group D and gave European football pause for thought.

Elsewhere, Africa had reason to celebrate as the continent saw two of its teams progress to the knockout stages for the first time. Nigeria came second behind Argentina in Group F to reach the last 16 and they were joined by Algeria, runners-up behind Belgium in Group H. For Asia, however, there was only misery as their four representatives went home without a win between them.

> "In this World Cup, we have all failed. Blame it on all of us."
>
> **VICENTE DEL BOSQUE**

○○○

Left: *The iconic Christ the Redeemer statue overlooking Rio de Janeiro gave a stunning backdrop to the games played in the Maracana Stadium.*

Below: *Before Brazil and Croatia kicked off the 2014 World Cup in São Paulo, the Opening Ceremony provided a vivid feast of colour and verve.*

THE SPECTRE OF THE GHOST GOAL

2014

The 2014 finals brought two significant innovations as for the first time FIFA introduced goal-line technology at a World Cup. Referees in Brazil were also equipped with vanishing foam spray as the governing body bid to ensure players finally stopped encroaching on free kicks.

The name of Yuichi Nishimura is one that went down in World Cup history in 2014. Admittedly, the Japanese referee is little more than an obscure footnote in the story of the finals but the Asian official nonetheless was the man behind a tournament first in Brazil.

His claim to minor fame came in the 41st minute of the opening game between Brazil and Croatia in São Paulo. Croatia's Ivan Rakitić fouled Neymar outside the area and, after awarding the free kick, Nishimura reached to a belt around his waist for his can of vanishing spray to mark out where the ball should be placed and where the Croatian wall should stand. It was the first time ever in the finals the

spray had been deployed.

The problem of defending sides surreptitiously stealing a few yards to narrow the gap between the free-kick taker and the wall was a longstanding one. The introduction of the spray went a long way to discouraging such encroachment and the interminable pantomime of players edging forward the moment the referee turned his back.

The advent of the goal-line system was equally overdue. The technology may not have been available to make a definitive ruling on Geoff Hurst's famous goal in the 1966 World Cup final, but it could have benefited England in South Africa in 2010, when Frank Lampard notoriously was not given a goal in Bloemfontein against Germany despite the ball bouncing a clear distance beyond the line.

○○○

Above: Honduras's Noel Valladares scored the first goal decided by goal-line technology. It was, sadly for the 'keeper, an own goal against France.

Left: Vanishing foam spray made its World Cup debut in Brazil in 2014 in an effort to ensure teams could no longer encroach at free-kicks.

It was no surprise, then, that FIFA decided to roll out the German-manufactured GoalControl in Brazil four years later to avoid such injustices. It was a system that used 14 high-speed cameras feeding into a main image-processing centre to create a virtual representation of the path of the ball.

It was first called into use during France's Group E clash with Honduras in Porto Alegre but, unfortunately, the technology did not work quite how FIFA had hoped. French striker Karim Benzema hit the post with a second-half shot, the ball travelled across the face of the goal and Honduras goalkeeper Noel Valladares inadvertently scored an own goal knocking the ball over the goal-line he failed to safely gather it. GoalControl, however, initially ruled no goal because it was only analysing Benzema's initial effort and it was only on second inspection that the truth emerged.

The system did redeem itself later in the tournament, when it correctly adjudged Bryan Ruiz's header had crossed the line for Costa Rica against Italy in Recife. It was the only goal of the game and a result that ultimately saw Los Ticos top Group D and eliminate the Azzurri.

SUAREZ CHOWS DOWN ON CHIELLINI

2014

Luis Suárez's reputation preceded him when he arrived in Brazil in 2014. The Uruguay striker's infamous handball against Ghana in South Africa four years earlier was the tournament's most notorious incident, but it was his shocking penchant for biting opponents that was to make headlines in South America.

The Uruguayan's dental-crime sheet was already extensive when he was selected for the finals by La Celeste. In 2010 while playing for Ajax he was banned for seven matches after biting PSV player Otman Bakkal, an attack that earned him the nickname the "Cannibal of Ajax" from Dutch media, and in 2013 he was suspended for ten games while on Liverpool duty after attempting to take a chunk out of Chelsea defender Branislav Ivanović.

Suárez managed to successfully control himself in La Celeste's first two Group D fixtures in Brazil, against Costa Rica and England, scoring the two goals that sank the latter in São Paulo, but the red mist dramatically descended for a third time in his career when Uruguay faced Italy in Natal.

The match, in the Arena das Dunas, was 79 minutes' old when Suárez and Azzurri defender Giorgio Chiellini came together as Uruguay prepared to take a corner. It was no more than the most minor of collisions, but Suárez reacted by biting the left shoulder of Chiellini and as the stunned defender went down the Uruguayan also took a tumble, clutching his face, in a desperate attempt to muddy the waters.

Chiellini rushed to Mexican referee Marco Rodríguez, his shirt pulled down to reveal the bite marks, but the official had not seen the incident. Evidently, neither had either of the assistant referees or the fourth official, and, despite replays clearly showing what he had done, Suárez was not even booked. The Italian sense of injustice was exacerbated only when Uruguay scored the only goal of the match two minutes later through captain Diego Godín.

After the match Suárez claimed that he "had contact with [Chiellini's] shoulder, nothing more", but FIFA

Above: Posters of Uruguay's Luis Suárez baring his teeth in Brazil in 2014 proved eerily prophetic after the striker's attack on Giorgio Chiellini.

Right: Suárez scored twice as Uruguay beat England 2–1 in São Paulo before his tournament was brought to an abrupt and controversial end.

immediately began disciplinary proceedings and two days later retribution was forthcoming when the striker was banned for nine international matches and suspended from any football-related activity for four months. It was the longest ban handed out in World Cup history, eclipsing the eight-match suspension served to Italy's Mauro Tassoti after he broke the nose of Spain's Luis Enrique in the finals of 1994.

Suárez's World Cup was over, and so was that of Uruguay, who, without their leading scorer in Rio de Janeiro, were no match for Colombia in the first knock-out round, losing 2–0.

> "The referee should have shown him a red card. There's a clear simulation after, a clear sign that he had done something that he wasn't supposed to."
>
> GIORGIO CHIELLINI

RODRIGUEZ TOPS THE SCORING CHARTS

2014

Alongside Costa Rica, Colombia were the surprise package of the 2014 World Cup, reaching the quarter-finals for the first time in the country's history in only their fourth appearance in the tournament, and the standout performer for José Pékerman's side was Golden Boot winner James Rodríguez.

World Cups have always had a tendency to create new stars and the finals in Brazil were no exception as Rodríguez dazzled the competition's global audience of millions with a series of stunning displays for La Tricolor and the goal of the tournament.

The attacking midfielder was just 22 years old when Colombia kicked off in Group C against Greece in Belo Horizonte and he signalled his arrival at the tournament in some style, scoring his team's third goal in the Estádio Mineirão, an elegantly struck left-footed drive from the edge of the area.

The youngster was on target again five days later with a bullet header from a corner as Pékerman's impressive team defeated Ivory Coast in Brasilia and Rodríguez made it three goals from three group matches against Japan in Cuiabá, mercilessly turning the last defender inside and then out before deftly chipping the goalkeeper.

In the last 16, against Uruguay, he was again on fire, and his 28th-minute strike in the Maracanã was a work of art. With his back to goal and ten metres outside the box, Rodríguez delicately controlled a looping pass with his chest. In the same moment, he turned and unleashed a thunderbolt volley with his left that screamed past Uruguayan keeper Fernando Muslera into the top corner. He scored again in the second half to take his tally to five for the tournament and Colombia into the quarter-finals.

This double made him the first player to score in the first four games of a World Cup since Brazilians Ronaldo and Rivaldo in 2002. Rodríguez also emulated Italy's Christian Vieri – at France 1998 – by scoring in his first four career appearances in the finals.

Colombia faced hosts Brazil in the last eight, and although Rodríguez scored again, converting an 80th-minute penalty, it was not enough to save the La Tricolor, and they were beaten 2–1 in Fortaleza. The image of a huge grasshopper landing on Rodríguez after his spot kick was one of the most iconic of the tournament, closely followed by his tears when the final whistle sounded.

Rodríguez's six goals earned him the Golden Boot, the first South American not playing for Brazil or Argentina to win the coveted award. Later that summer, he left Monaco for Spanish giants Real Madrid in a multi-million-euro move.

○○○

Left: James Rodriguez and the grasshopper in Fortaleza. His six goals earned the 22-year-old the 2014 FIFA World Cup Golden Boot award..

Right: Colombia's World Cup adventure was came to an end at the hands of Brazil and Neymar, 2–1 in the quarter-finals in the Estádio Castelão.

THE MASSACRE IN BELO HORIZONTE

2014

The 2014 World Cup was meant to be the tournament at which Brazil banished the ghosts of 1950 when they were beaten on home soil by Uruguay in the Maracanã in the *de facto* final but, 64 years later, the nation mourned once again as the hosts were put to the sword by Germany in the semi-finals.

Brazil and Germany had both limped rather than romped into their last-four showdown in Belo Horizonte's Estádio Mineirão. The Seleção had needed penalties to beat Chile in the last 16 while, at the same stage, Die Mannschaft had seen off Algeria only after extra time.

Both countries subsequently won their respective quarter-finals by a solitary goal and, although Brazil were without star player and talisman Neymar after he suffered a broken bone in his back during the quarter-final victory over Colombia, millions of Seleção supporters still dreamed of a record-breaking eighth appearance in the final.

What unfolded in Belo Horizonte was as humiliating as it was unprecedented for the hosts and stunned the world of football.

FULL TIME

BRAZIL 1 – 7 GERMANY

90' OSCAR

11' MUELLER
23' KLOSE
24' 26' KROOS
29' KHEDIRA
69' 79' SCHUERRLE

"It is the worst day. I will be remembered as the coach to lose 7–1 but I knew that risk when I took the job."

LUIZ FELIPE SCOLARI

It took Germany only 11 minutes to pierce the Brazilian defence, Thomas Müller volleying home Toni Kroos's corner. The goal silenced the partisan 58,000-strong crowd, but much worse was to follow, as Joachim Löw's rampant side ripped the Seleção to shreds.

Germany could not stop scoring, grabbing another four in six minutes before the half-hour mark, with Miroslav Klose and and Sami Khedira book-ending a two-minute double from Kroos. In the second half, substitute André Schürrle grabbed himself a double and, although Oscar scored for the hosts in the 90th minute, his goal provided no solace whatsoever for Luiz Felipe Scolari and his dejected players.

Klose's strike was his second of the tournament and took him past Ronaldo's previous record mark of 15 goals in the finals, but even his prolific feat was eclipsed by the sense of utter disbelief that engulfed Brazil.

The list of records the Seleção set that night was as long as it was unwanted: the incredible 7–1 scoreline equalled the side's biggest ever margin of defeat, a 6–0 loss to Uruguay in 1920; it was their heaviest ever World Cup beating; it was the most comprehensive reverse for any host nation in any finals fixture; and it was the biggest defeat for any side in the semi-final stage of the tournament.

Brazil also conceded 14 goals in total in 2014, becoming the first hosts to suffer the embarrassment of recording the finals' worst defensive record, a statistic that merely rubbed salt into the country's already gaping wound.

○○○

Above: The Estádio Mineirão scoreboard made bleak reading for Brazil fans: their worst defeat and the most one-sided World Cup semi-final ever.

Left: Toni Kroos (18) scored twice in two minutes as Germany raced into a 5–0 lead over shell-shocked Brazil in the opening 30 minutes in Belo Horizonte.

GLORY FOR GÖTZE IN THE MARACANÃ

2014

A third meeting between Germany and Argentina in a World Cup final, following their clashes in 1986 and 1990, the climax of the 2014 tournament was similar to the latter one, in that it was a cagey encounter, but it was eventually decided by a dramatic extra-time winner from substitute Mario Götze.

Germany may have hit seven past Brazil in their incredible semi-final victory in Belo Horizonte, but, as Die Mannschaft prepared to face La Albiceleste in Rio de Janeiro, their tilt at a fourth World Cup crown – but first as a unified Germany – manager Joachim Löw knew Argentina would offer significantly more stubborn resistance at the back.

The South Americans had dispatched Switzerland, Belgium and the Netherlands en route to the final and none of the European trio had been able to pierce the Argentinian defence in the knockout stages. La Albiceleste had not exactly been prolific in front of goal in Brazil but Alejandro Sabella's side were nothing if not a formidable defensive unit.

It came as no surprise, then, that Germany struggled to break through in the final. Their cause was certainly hampered by losing Sami Khedira to a calf injury in the warm-up and, as the game unfolded, it became obvious that clear-cut opportunities for either side would be at a premium.

The closest the first half came to yielding a goal came moments before the whistle sounded when German defender Benedikt Höwedes's header hit the post from

> "I always had a good feeling about Götze. Argentina were becoming more and more tired, but we had players who could make a difference. Götze is a miracle boy, a boy wonder."
>
> JOACHIM LÖW

a corner; but, as the second half developed, the growing consensus was that the match was destined for extra time. For the third World Cup in a row, the additional 30-minute period was required.

The pivotal moment came in the 113th minute in Rio and was the creation of two German substitutes. André Schürrle's cross from the left found fellow replacement Götze in the box and the midfielder controlled the ball perfectly with his chest and then beat Sergio Romero with a sublime, sliding left-footed volley from, close range.

Germany held firm for the remaining seven minutes in the Maracanã and, when Philipp Lahm lifted the trophy, Die Mannschaft were world champions for the fourth time. They were also the first European side to claim a World Cup in South America and the third in a row from the continent to be crowned champions.

In scoring, Götze became the first substitute to score the opening goal of a World Cup final and the youngest player since compatriot Wolfgang Weber at Wembley in 1966 to find the back of the net in the climax of the tournament.

○○○

Left: The adidas Brazuca was the official tournament match ball in 2014, the name selected after more than half a million Brazilians voted.

Below: The 1–0 extra-time victory over Argentina in Rio saw Germany crowned World Cup kings for the first time since reunification in 1990.

INDEX

(page numbers in *italic* type refer to illustrations)

A

Ademir 48
Adiyiah, Dominic 234, 235
Ahn Jung-hwan 210–11, *211*
Al-Owairan, Saeed 179
Alberto, Carlos 108, *108*
Albertosi, Enrico 108
Allchurch, Ivor 67
Altobelli, Alessandro 148
Amarildo 82
Andersson, Roy 130
Appiah, Stephen 216, 234
Armstrong, Robert 141
Arppi Filho, Romualdo 160
Asprilla, Faustino 186
Astle, Jeff 102
Aston, Ken 80

B

Baggio, Roberto 171, 184–5, *184*
Bahr, Walter 44
Baker, Josephine 15
Bakhramov, Tofiq 94, *94*, 95
Bakkal, Otman 244
Ballack, Michael 210, 220
Banks, Gordon 93, 102, 104
Barbosa, Moacir 48
Baresi, Franco 184
Barreau, Gaston 35
Batistuta, Gabriel 196
Batteaux, Albert 66
Battiston, Patrick 146–7, *146*, *147*
Batty, David 197
Bearzot, Enzo 148, 150
Bebeto 184, 190
Beckenbauer, Franz 97, 98, 104, 106, *106*, 117, 118, 119, 120, 123, 161, 173
Beckham, David 196–7, *197*, 208, *208*, 209
Bennaceur, Ali 158
Benquerença, Olegário 234
Benzema, Karim 243

Bertoni, Daniel 135
Betchley, Edward 89
Bielsa, Marcelo 208
Blanc, Laurent 194–5, *194*
Blatter, Sep 222
Blažević, Miroslav 198
Blokhin, Oleg 145, 216
Bonetti, Peter 104
Boninsegna, Roberto 106, 107, 108
Borowski, Tim 220
Bossis, Maxime 146
Botasso, Juan 20
Boulahrouz, Khalid 222
Bozsik, József 54
Brehme, Andreas 170
Breitner, Paul 120, 148
Brown, José Luis 160
Buffon, Gianluigi 210, 224, 230
Buggy, Di Len 88
Burgnich, Tarcisio 106
Burruchaga, Jorge 160–1, *160*

C

Cabrini, Antonio 148
Cafu 212
Campbell, Sol 197
Caniggia, Claudio 170
Carbone, Anthony 194
Carvalho, Ricardo 218
Casillas, Iker 230
Castro, Héctor 20
Caszely, Carlos 112, *113*
Cavallero, Pablo 208
Cea, Pedro 20, *22*
César, Júlio 231
Chaliapin, Fyodor 15
Charlton, Bobby 90, 96, 104
Chiellini, Giorgio 244, 245
Chilavert, Jose Luis 195
Clinton, Bill 178
Codesal, Edgardo 173
Colaussi, Gino 35, 38
Corbett, David 88, *89*
Corver, Charles 146
Costacurta, Alessandro 184

Crespo, Hernán 197
Cruyff, Johan 119, *119*, 128, *128*, 137
Czibor, Zoltán 59

D

David, Mario 80
Deco 222
del Bosque, Vicente 242
Del Piero, Alessandro 218
Delfour, Edmond 15
Derwall, Jupp 148
Desailly, Marcel 200, 206
Dezotti, Gustavo 173
Dienst, Gottfried 94
Diop, Pape Bouba 206
Diouf, El Hadji 206
Dittborn, Carlos 79
Djorkaeff, Youri 206
Domenech, Raymond 229
Donadoni, Roberto 170
Dorado, Pablo 20
Draman, Haminu 216
Drewry, Arthur 44
Drogba, Didier *216*
Dunga 184

E

Edmundo 200
Eklind, Ivan *28*
electronic boards 192, *192*
Elizondo, Horacio 222, 224
Elkjær, Preben 156
Elliott, Simon 233
Ellis, Arthur 54, 55
Enrique, Luis 245
Eriksen, John 157
Eriksson, Sven-Göran 208
Escobar, Andrés 186–7, *187*

F

Fàbregas, Cesc 236
Feola, Vincente 72
Ferrini, Giorgio 80
FIFA World Cup Trophy 114
 creation of 114 (*see also* Jules

Rimet Trophy)
Flo, Tore André 190
Fonseca, Danny 222
Fontaine, Just 74
Friaça 48

G

Gaetjens, Joe 44, *44*
Gallego, Americo *133*
García, Amadeo 26
Garrincha 68, 72, 82, 212
Gascoigne, Paul "Gazza" 170, *170*
Gaucci, Luciano *210*, 211
Gazzaniga, Silvio 114, *114*, 115
Gemmill, Archie 127
Gentile, Claudio 148
Gérson 102, 108
Ghiggia, Alcides 48, 49
Gianpiero, Combi 28
Gilmar 82
GoalControl 243
Godín, Diego 244
Gonella, Sergio 134
Götze, Mario 250, 251
Goycochea, Sergio 170, *171*, 173
Grabowski, Jürgen 104, 120
Graham, George 42
Grosics, Gyula 54
Grosso, Fabio 218
Gullit, Ruud 137
Gyan, Asamoah 234–5, *235*

H

Haller, Helmut 92
Hamann, Erich 117
Hamrin, Kurt 70, 71
"Hand of God" 158–9
Happel, Ernst 137
Harkes, John 186
Heitinga, John 236
Hellström, Ronnie 130, *130*
Henderson, George 163
Henry, Thierry 206, 207, 218
Herberger, Sepp 56, 59, 60, *60*, 61, 70
Herbert, Ricki 232, 233
Herkenrath, Fritz 70
Hidegkuti, Nándor 54
Higuita, René *168*, 186
Hoddle, Glenn 197
Hodge, Steve 158
Hoeness, Uli 116, 117, 120

Hölzenbein, Bernd 120
Höwedes, Benedikt 250
Hrubesch, Horst 142, 146
Hunt, Roger 94
Hurst, Geoff 90, 92, 94–5, *95*, 96, 243

I

Iaquinta, Vincenzo 233
Illgner, Bodo 171
Inamoto, Junichi 205
Ince, Paul 197
Iniesta, Andres 236, *236*
Iriarte, Santos 20
Ivanov, Valentin 222, *222*
Ivanović, Branislav 244

J

Jabulani ball 230–1, *230*, *231*
Jacquet, Aimé 195, 200
Jairzinho 102, 108
Jansen, Wim 120
Jarir, Houmane 100
Jean-Joseph, Ernest 182
Jeffrey, Bill 44
John, Avery 222
Johns, Hugh 143
Johnston, Willie 182
Jongbloed, Jan 120, 135
Jules Rimet Trophy *17*
 creation of 16–17 (*see also* FIFA World Cup Trophy)
 theft of 88–9
Juskowiak, Erich 70

K

Kahn, Oliver 212
Kaká 230
Kempes, Mario 135, 136
Khedira, Sami 249, 250
Kiss, László 140, *140*
Kissinger, Henry 154
Klinsmann, Jürgen 173, 178, *179*, 218
Klose, Miroslav 123, 212, 220–1, *220*, 249
Kocsis, Sándor 52, 54
Kopa, Raymond 74–5, *74*, *75*
Kreitlein, Rudolf 90
Krol, Ruud 135
Kroos, Toni *248*, 249
Kupcewicz, Janusz *145*

L

Lafleur, Abel 16
Lahm, Philipp 251
Lampard, Frank 243
Landa, Honorino 80
Lantos, Mihály 54
Larrionda, Jorge 218
Laudrup, Michael 162
Laurent, Lucien 18–19, *18*
Lee, Francis 104
Lemerre, Roger 206
Leonidas 36
Libérati, Ernest 18
Liedholm, Nils 70, 72
Lineker, Gary 158, 170
Lippi, Marcello 224, 229, 233
Littbarski, Pierre 146, 173
Löhr, Hannes 104
Lopez, Christian 146
Lóránt, Gyula 54
Löw, Joachim 249, 250
Luque, Leopoldo 133

M

McGhee, Bart 18
Magath, Felix 146
Mai, Karl *61*
Maier, Sepp 100, 104, 106, 117, 118, *118*, 120
Malouda, Florent 224
Maniche 222
Maradona, Diego 158–9, *158*, 160, 161, 162, 170, 172, 182–3, *182*, *183*
Maraini, Dacia 15
Martinez, William 49
Maschio, Humberto 80
Masopust, Josef 82
Massaro, Daniele 184
Materazzi, Marco 222, 224, *225*
Matthäus, Lothar 160, *160*, 173
Matthews, Stanley 44
Mears, Joe 88
Meazza, Giuseppe *36*, 38, *39*
Medina, Luis 224
Medwin, Terry 67
Mensah, John 235
Metsu, Bruno 206, 207
Mexican Wave 162–3, *162*
Michels, Rinus 118, 120, 128
Milla, Roger 168, *168*, 169, 181

Molby, Jan 156
Monzón, Pedro 173
Moore, Bobby 89-90, 92, 96, *102*
Moreira, Aymoré 82
Morera, Ulloa 158
Morlock, Max 59
Müller, Gerd 100, *104*, 106, 107, 117, 120, 122-3, *122*, 212, 220
Müller, Thomas *230*, 249
Mullery, Alan 102, 104
Muñoz, Humberto Castro 186
Muntari, Sulley 234
Murphy, Jimmy 67
Muslera, Fernando 246
Mussi, Roberto 184
Mussolini, Benito 28, 30, *30*, 35

N

Nanninga, Dick 135
Nasazzi, José 16, 20
Navas, Jesús 236
Neeskens, Johan 120
Nejedlý, Oldřich 26
Nerz, Otto 60
Neuberger, Herman 167
Neymar 242, 248
Nielsen, Kim 196-7, *197*
Nishimura, Yuichi 242

O

Olguin, Jorge *133*
Olivieri, Aldo 38
Olsen, Egil 191
Olsen, Jesper 157
Omam-Biyik, François 168
Orsi, Raimundo 28
Oscar 249
Overath, Wolfgang 117
Owen, Michael 196, 208

P

Pak Doo-Ik 86
Parker, Paul 170
Parling, Sigvard 73
Passarella, Daniel 136, *137*, 196
Pastrana Borrero, Misael 154
Pearce, Stuart 171, 197
Pékerman, José 246
Pelé 68, *68*, 72-3, 78, 86, *102*, 108, 140
Perón, Isabel 126
Peters, Martin *90*, 92, 104

Petit, Emmanuel 200
Petrů, Karel 28
Peucelle, Carlos 20
Pickles (dog) 88-9, *89*
Pinheiro 54
Piola, Silvio 35, 38
Piontek, Sepp 156
Pirès, Robert 195
Pirlo, Andrea 224
Pizzinelli, Corrado 80
Plánička, František 28, *29*
Platini, Michel 146, 161, 162
Platt, David 171
Pochettino, Mauricio 208
Posipal, Jupp 59
Pozzo, Vittorio 28, 35, 37, 38
Puč, Antonín 28
Puhl, Sándor 184
Pumpido, Nery 161
Puskás, Ferenc 54, 58-9, *62*

Q

Quieroz, Carlos 230

R

Rahn, Helmut 59
Rajevac, Milovan 229, 235
Rakitić, Ivan 242
Ramsey, Alf 90, 96, 104
Rattin, Antonio 90, *91*
Raynor, George 70
Reid, Winston 232, 233
Rekdal, Kjetil 190
Resenbrink, Rob 137
Rijkaard, Frank 137
Rimet, Jules 14-15, 16-17, *16*, 48
Rincón, Freddy 186
Riva, Giga 106-7
Rivaldo 212, 246
Rivelino 102
Rivera, Gianni 106
Roa, Carlos 197
Robson, Bobby 168
Robson, Bryan 140
Rodriguez, James 246, *246*
Rodríguez, Marco 244
Romário 184
Romero, Sergio 251
Rommedahl, Dennis 207, *207*
Ronaldo 123, 200, 201, 212, 246, 249
Rooney, Wayne *223*

Ross, Diana 178
Rossi, Paolo 148, 150-1, *151*
Rous, Stanley 114
Ruiz, Bryan 243
Rummenigge, Karl-Heinz 160, 162

S

Sabella, Alejandro 250
Salenko, Oleg 181, *181*
Sanchéz, Hugo 162
Sánchez, Leonel 80
Santos, Djalma 54
Santos, Márcio 184
Santos, Nilton 54
Sárosi, Györgi 36, 38
Schafer, Hans 70
Scherer, Adolf 82
Schiavio, Angelo 29
Schillaci, Salvatore "Toto" 170, 171
Schnellinger, Karl-Heinz 106
Schön, Helmut 60, 97, 104, 117, 122
Schrojf, Viliam 82
Schumacher, Harald 146, *147*, 148
Schürrle, André 249, 251
Schwarzer, Mark *230*
Schweinsteiger, Bastian 220
Scifo, Enzo 162
Scolari, Luiz Felipe 249
Seaman, David 196, 197
Sebes, Gusztáv 52
Seeger, Robert 142
Seeler, Uwe 97, 100, 104, 107
Sensini, Roberto 173
Serena, Aldo 170
Shearer, Alan 196
Shilton, Peter 158, 171
Silva, Mauro 184
Simeone, Diego 196, 197, 208
Simonsson, Agne 73
Skoglund, Lennart 70
Smeltz, Shane *231*, 233
Sócrates 162
Song, Rigobert 193
Sparwasser, Jürgen 117
Stábile, Guillermo 20
Stanjek, Eberhard 142
Stekelenburg, Maarten 236
Stewart, Ernie 186
Suárez, Luis 167, 234, 235, 244-5, *244*, *245*
Šuker, Davor 198, *198*, *199*

Sükür, Hakan 140
Sutcliffe, Charles 26
Svensson, Kalle 72
Svoboda, František 28
Szabó, Antal 38

T

Tabárez, Óscar 235
Tardelli, Marco 148, *149*
Tassoti, Mauro 245
Taylor, Jack 118, 119, *119*, 120
Thatcher, Margaret 140
Thépot, Alex 18
Thomas, Clive 127
Thon, Olaf 171
Tichy, Lajos 67
Tigana, Jean 146
Tilkowski, Hans 92, 94
Titkos, Pál 38
Tomasson, Jon Dahl 207
Tostão 102
tournaments:
 Argentina (1978) 124–37
 final: Argentina–Netherlands 134–5
 Brazil (1950) 40–9
 final: Uruguay–Brazil 48–9, *49*
 Brazil (2014) 238–51
 final: Germany–Argentina 250–1, *251*
 British nations' first 42
 Chile (1962) 76–83, 90
 final: Brazil–Czechoslovakia 82–3, *82*, *83*
 electronic boards introduced into 192, *192*
 England (1966) 84–97
 final: England–West Germany *88*, *89*, 92–3, *95*
 first goalscorer in 18
 France (1938) 32–9
 final: Italy–Hungary *36*, 38–9
 France (1998) 188–201
 final: France–Brazil 200–1, *201*
 Germany (2006) 214–25
 final: Italy–France 224–5
 and GoalControl 243
 Italy (1934) 24–31
 final: Italy–Czechoslovakia 28–9, *28*
 Italy (1990) 164–75
 final: West Germany–Argentina 172–3
 Japan, South Korea (2002) 202–13
 final: Brazil–Germany 212–13, *213*
 Mexico (1970) 98–109
 final: Brazil–Italy 108–9, *108*
 Mexico (1986) 152–63
 final: Argentina–West Germany 160–1
 South Africa (2010) 226–37
 final: Spain–Netherlands 236–7
 Spain (1982) 138–51
 final: Italy–West Germany 148–9
 Sweden (1958) 64–75
 final: Brazil–Sweden 72–3, *73*
 Switzerland (1954) 50–63
 final: West Germany–Hungary 56, 58–9
 United States (1994) 176–87
 final: Brazil–Italy 184–5
 Uruguay (1930) 12–23
 final: Uruguay–Argentina 20–1, *21*, *22*
 and vanishing spray 242–3, *242*
 West Germany (1974) 97, 110–23
 final: West Germany–Netherlands 97, *115*, *119*, 120–1, *121*
Tozzi, Humberto 54
Trezeguet, David 195, 224

V

Valcareggi, Ferruccio 106, 108
Valdano, Jorge 160
Valderrama, Carlos 186
Valladares, Noel 243, *243*
van Basten, Marco 137
van Bommel, Mark 222
van Bronckhorst, Giovanni 222
van de Kerkhof, René 134–5, *135*
vanishing spray 242–3, *242*
Varallo, Francisco 20
Varela, Obdulio 48
Vavá 68, 72, 82, 212
Videla, Gen. Jorge 126, 128, 136
Vieira, Patrick 206
Villaplane, Alexandre *15*
Völler, Rudi 173, 212

W

Waddle, Chris 171, 197
Walesa, Lech 144
Walter, Fritz 62, *62*, 122
Walter, Ottmar 62
Waseige, Robert 205
Webb, Howard 236, *237*
Weber, Wolfgang 92, 251
Weller, Rob 163
Whiteside, Norman 140
Williams, Bert 43, 44
Wilson, Ray 92
Winterbottom, Walter 42, 44

Y

Young, George 42

Z

Zagallo, Mário 73, 108, 173, 200
Zanetti, Javier 196
Zenga, Walter 170
Zico 127
Zidane, Zinedine 194, 200, *200*, 206, 207, 222, 224–5, *225*
Zito 82
Zizinho 48
Zoff, Dino 148

CREDITS

The publishers would like to thank the following sources for their kind permission to reproduce the pictures in this book.

Key: T = top, B = bottom, C = centre, L = left and R = right

Action Images: /Alessandro Bianchi/Reuters: 210. **Alamy**: /EPA: 91; /Wolfgang Kumm/EPA: 146. **Carlton Books**: 105, 178, 201, 218. **Colorsport**: /Stewart Fraser: 143. **Getty Images**: 221; /AFP: 18, 68, 131; /AMA/Corbis: 236; /Luis Acosta/AFP: 245; /Allsport: 119T, 129; /Rodrigo Arangua/AFP: 235; /The Asahi Shimbun: 208, 213; /Nicolas Asfouri/AFP: 223; /Daniel Berehulak: 63; /Nestor Beremblum/LatinContent: 238; /Bettmann: 133; /Shaun Botterill: 179, 181, 185, 186, 216, 220, 232; /Marcus Brandt/Bongarts: 192; /Bridge Lane Library/Popperfoto: 116; /David Cannon: 171; /Fabrice Coffrini/AFP: 242, 246; /De Agostini Picture Library: 14-15B; /Carl de Souza/AFP: 230; /Jacques Demarthon/AFP: 205; /John Downing/Express/Hulton Archive: 89B; /Franck Fife/AFP: 243; /Stu Forster: 94, 200; /Romeo Gacad/AFP: 187; /Daniel Garcia/AFP: 196; /Antoine Gyori/Sygma: 184; /Ferdi Hartung/ullstein bild: 107; /Alexander Hassenstein/Bongarts: 194; /Haynes Archive/Popperfoto: 80; /Richard Heathcote: 231; /Mike Hewitt: 233; /Hulton Archive: 88, 115; /Imagno: 36; /Karim Jaafar/AFP: 225; /Alexander Joe/AFP: 234; /Gerard Julien/AFP: 193; /Keystone-France/Gamma-Keystone: 30, 78; /Christof Koepsel: 229; /Christof Koepsel/Bongarts: 61, 112; /Michael Kunkel/Bongarts: 182; /Philippe Le Tellier/Paris Match: 73; /Buda Mendes/LatinContent: 240; /Ralph Orlowski/Bongarts: 222; /Cem Ozdel/Anadolu Agency: 247; /Metin Pala/Anadolu Agency: 244; /Michel Piquemal/Onze/Icon Sport: 132; /Popperfoto: 12, 15T, 21T, 21C, 21B, 22, 28L, 28R, 32, 34, 39, 40, 44, 47, 54, 60, 70, 72, 75, 83, 95, 102, 108, 135; /Ben Radford: 197; /Andreas Rentz/Bongarts: 211; /Rolls Press/Popperfoto: 90, 104; /Gabriel Rossi/LatinContent: 250; /STF/AFP: 128; /Schirner/ullstein bild: 58; /Christophe Simon/AFP: 249; /Michael Stahlschmidt/SSP/The LIFE Images Collection: 207; /Billy Stickland: 170; /Patrick Stollarz/AFP: 117, 248; /Mario Tama: 79; /Bob Thomas: 145, 150, 151, 156, 158, 161, 168, 180, 183, 212; /Bob Thomas/Popperfoto: 26, 49; /Mark Thompson: 198; /Omar Torres/AFP: 199; /Pedro Ugarte/AFP: 241, 251; /ullstein bild: 16, 53, 56, 62; /Universal/Corbis/VCG: 74; /VI Images: 137; /Bernd Wende/ullstein bild: 122. **Istituto Luce – Cinecitta s.r.l.**: /Archivio Storico Luce: 31. **Hagen Leopold**: 52, 57, 59, 66, 71, 87, 120, 123, 172, 173, 217, 219. **Courtesy of the National Football Museum**: 3L, 3R, 4, 6, 7, 8, 9, 11, 17, 19T, 19B, 20, 23, 27, 29, 37, 38, 42, 43, 46, 48, 55, 67T, 67B, 69, 81, 82, 86, 89T, 92, 93TL, 93BR, 96L, 96R, 97, 100, 101, 103L, 103R, 109L, 109R, 126, 127TL, 127TC, 127TR, 127BL, 127BC, 127BR, 134, 136, 141T, 141C, 141B, 142, 148, 154, 155T, 155R, 155BL, 157, 159, 163, 166, 167TL, 167R, 169, 175, 190, 191TL, 191BR, 195, 204, 206, 209, 224, 228, 237TL, 237BR. **Offside Sports Photography**: /Farabolafoto: 24, 50, 176; /Kishimoto: 119B; /L'Equipe: 147, 202; /Mark Leech: 144, 174; /Witters: 138, 152, 164, 188, 214. **PA Images**: /Giuseppe Aresu/AP: 114; /DPA: 113, 118, 160; /Carlo Fumagalli/AP: 64; /Panoramic: 106; /Duncan Raban/Empics: 162; /Peter Robinson/Empics: 76, 84, 98, 124, 130, 140, 149; /Schirner Sportfoto/DPA: 35; /Sven Simon/DPA: 110; /Werek/DPA: 121. **Peter Pesti**: 45

Every effort has been made to acknowledge correctly and contact the source and/or copyright holder of each picture and Carlton Books Limited apologises for any unintentional errors or omissions, which will be corrected in future editions of this book.

○○○
Right: The vuvuzela proved to be an always noisy and ubiquitous, if not universally popular, feature of the 2010 World Cup finals in South Africa.